WEST of EDEN

A History of the Art and Literature of Yosemite

Plate 64. Frontispiece. Ted Orland. Self-Portrait. 1977. Courtesy Ted Orland.

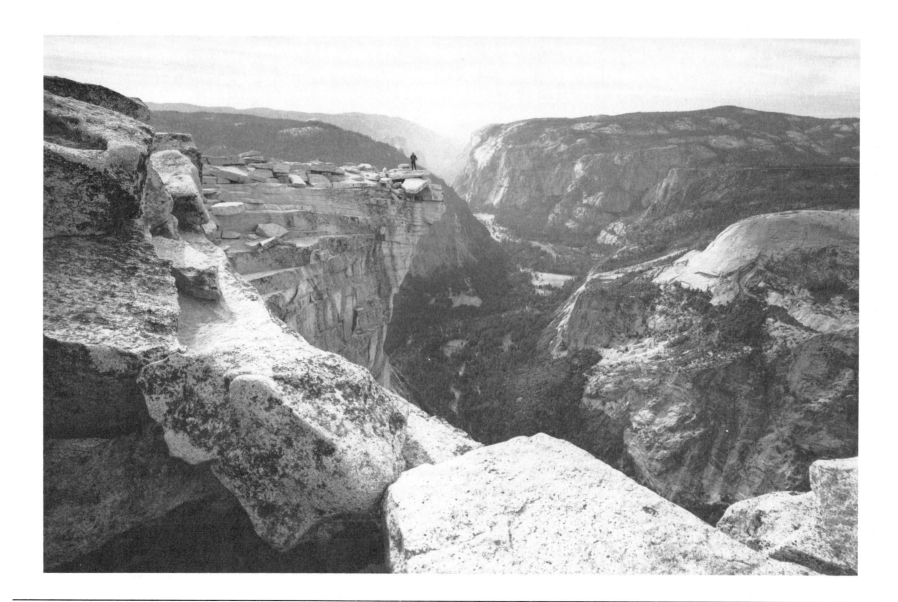

WEST of EDEN

A History of the Art and Literature of Yosemite

David Robertson

Copublished by

Yosemite Natural History Association
and
Wilderness Press

Library of Congress Card Catalog Number 83-51539

Yosemite Natural History Association
 Cloth Edition ISBN 0-939666-40-5
Paperback Edition ISBN 0-939666-41-3

Wilderness Press
 Cloth Edition ISBN 0-89997-035-4
Paperback Edition ISBN 0-89997-043-5

Design: Terry Down

Front Cover: Thomas Hill. Yosemite
Valley (From below
Sentinel Dome, as Seen
from Artist's Point).
(Detail)

Back Cover: Eadweard Muybridge.
To-coy-ae (Shade to
Indian Baby Basket).

Preface

IN 1977 I decided that my next research project (previously I had dealt with the Bible as literature and modern American poetry) would center on Place and treat the visual as well as the literary arts. I wanted the place to be an extension of my own living space, the Sacramento River Valley and the mountains on either side that make it a valley. For two years I thought grandiosely of including in my study the painting, photography, prose, and poetry of the entire western American landscape. But I could not get situated in so big a place. I poked my mind into this and that smaller place searching for a way to narrow the boundaries but always pulled it out again unsatisfied.

Then in 1979 I attended the Annual Members' Meeting of the Yosemite Natural History Association. In the chaos and clatter of the Happy Isles Nature Center, everyone having been forced inside by the deluge outside, I heard Leonard McKenzie, Chief Interpreter of Yosemite National Park and Executive Director of the Association, report that a book on the art of Yosemite was in the works. The next day I joined McKenzie's bird-watching excursion and during a lull in the action asked him who was writing this book. "We don't have an author yet," he replied. The rest of the story is easily guessed.

I did not intend to deal so exclusively in *West of Eden* with the major artists and writers of Yosemite. I wanted to include a large number of minor figures as well as sections on popular and folk art. Limits of both time and space worked against me. It was agreed that the book would be published no later than 1983 and that it should be around 200 pages in length. These parameters, it turned out, permitted me neither the time to explore artists out of the mainstream nor the space to report my findings. I consoled myself with the possibility of turning my attention to them in the future.

Aside from the stress of trying to do too much in too little time, *West of Eden* was a sheer joy to write. I had, of course, to go frequently to Yosemite to work in the Research Library. A more pleasant fate I can hardly imagine. I went mostly in the winter. Typically I arrived at the library about 8:30 in the morning and worked for two or three hours. The middle of the day I spent wandering about taking photographs and exploring the little, out-of-the-way places most people do not make time for. I returned to the library around two in the afternoon and read manuscripts and letters until closing time at 4:30. I beat the crowds at the Lodge Cafeteria by eating early and, after dinner, spread my notes out on a table in the nearby lounge and began writing. When it came time for the evening naturalist program at 7:30, I retreated to the Ahwahnee Hotel, where I sipped the complimentary coffee, smoked a cigar, and went on writing. My guess is that at least half of the good ideas in the book came to me during these winter evenings. Around

11:00 I hiked over to Lower Pines, climbed in my Travelall, and slept, amazingly contented with the world.

West of Eden was also such a pleasure to write because of the people who helped me. Most important of all was Jeannette Robertson. She encouraged me when I wanted, back in 1977, to change the basic direction of my research. She was enthusiastic when the opportunity arose to write a book on Yosemite. Her support was all the more crucial because both of these decisions were, to some extent, professionally risky. Again and again, after sitting at a typewriter for hours paralyzed by problems of organization and interpretation, I have found clarity in the process of talking the issues through with her.

There are many other people I want to thank. In Yosemite are Henry Berrey, Director of the Yosemite Natural History Association, and Mary Vocelka, Research Librarian. Henry's interest, advice, and know-how made the book happen. Mary initiated me into the intricacies of Yosemite archival materials, put into my hands document after invaluable document, read part of the manuscript, xeroxed source material, and gave constant encouragement with her friendliness and generosity. Leonard McKenzie gave the project the go-ahead and has been constant in his support of it, Jack Gyer guided me through the Yosemite Collection of paintings and photographs and gave advice on which works of art to discuss in depth. Craig Bates frequently substituted for Jack and offered invaluable suggestions on my discussion of the Yosemite Miwok. David Forgang and Barbara Beroza helped me examine the Thomas Ayres oil of Tuolumne Meadows. Michael Dixon was an indefatigable copier of paintings and photographs, whose patience never wore thin despite my numerous requests. B Weiss helped me with the Yosemite slide collection. Linda Osborne, because she was Mary Vocelka's right-hand woman, was also mine. Ed Hardy gave me permission to explore the archives of the Yosemite Park and Curry Company, and Rick Vocelka, Greg Owens, Dorothy Richards, and Karen O'Neill facilitated my access to them. Claire Haley, Richard Reitnauer, Penny Otwell, and Lori Beck, all staff of the Natural History Association, made my dealings with the Association a great pleasure. Jeanne Adams and Rene Wineland opened the portfolios of the Ansel Adams Gallery to me and gave me access to the paintings of Harry Cassie Best. A special thanks goes to Shirley Sargent, who shepherded me through the Curry Company archives, lent me original and unpublished material on James Hutchings, let me look through her collection of stereographs, permitted me to turn her living room in Foresta into a temporary workshop, and read much of the manuscript.

In Davis I want to thank Gary Konas for typing the manuscript; Delfina Redfield for the administration of research grants; Jim Snyder, Donald Kunitz, and Donald Hagerty for bibliographic guidance; Harvey Himelfarb and Arthur Hermann for help in understanding the history of photography; Bonnie Wilson for reading the manuscript twice and making copious suggestions for improvement in style and content; and David Wilson for rearranging and giving precision to ideas that came shotgunning out of my brain. Elsewhere Thomas Winnett was enthusiastic about the book from the moment he read the manuscript and offered helpful criticism on both stylistic and substantive matters. Frank Buske of the University of Alaska helped with John Muir, and Peter Palmquist of California State University, Humboldt, aided my understanding of Carleton Watkins and Charles Weed. I also want to thank Larry Dinnean of the Bancroft Library, Beverly Bubar of the California Historical Society, Barbara Bowman and Odette Mayers of the Oakland

Museum, Allen Jutzu of the Henry E. Huntington Library, Hilda Boehem of the University of California, Los Angeles, Kathryn Funk of the Fresno Arts Center, Robert Woolard, Bill and Mary Hood, and Mrs. Marjorie Farquhar, all of whom gave me indispensable help at one stage or another of my research.

And, finally, a very special thanks goes to the students of English 187 and English 233, midwives all, fellow travelers to Yosemite, fellow believers in wilderness, who educated me more than I them, and whose ideas I have shamelessly stolen, having given them ample warning that I would do just that.

For My Parents

Frances Dailey and Martin Cecil Robertson

Table of Contents

List of Illustrations

COLOR PLATES

BLACK AND WHITE PLATES

Introduction

THE APPEAL of the wilderness to people living in the modern world, especially to people living in modern cities, is one of the astounding facts of our time. Not tens, not hundreds, but millions feel an urge to flee the city for the wild places of the earth. While the urge has proved contagious and is now spreading around the world, it has always been predominantly an American phenomenon. In other times and places, as in ancient Rome or in modern Europe, when people have wanted to escape from over-civilized cities, they have typically traveled only as far as the countryside, stopping there to enjoy the calm of slow-moving cattle tucked in the folds of gentle hills. Even Americans at first, because they desired living room, saw the wilderness as a place to be brought down to size with an ax and cleared of its wild things with a gun. But once great tracts had been cleared and cities began to sprawl, in ever increasing numbers they turned their axes into walking sticks and their guns into cameras, and not only made peace with the wilderness but sought it out on its own terms. Future historians may say that this transformation in attitude was one of America's most important contributions to world culture.

The fact of this great sojourn in the wilderness raises the question of why. Why do people take inordinate pains to obliterate in their cities virtually all traces of wild, ungardened nature, then turn around and in their leisure moments seek out nature at its wildest? Americans, possibly because of the role the frontier has played in our history, love to be out in front, on the edge between the known and the unknown where discoveries are made. Explorers in deed and in thought have consistently been among our most beloved heroes, and most of us give up only reluctantly the fantasy that one day we will be counted in their number. Yet where in this day and time are we going to explore? Not only has our own west been settled but even the most inaccessible places on earth have been thoroughly charted, and tickets to the moon and beyond cost too much; the government can hardly afford one, much less an individual.

One possibility is not to move on, nor to fly up, but to go out—into the wilderness, into those places we circled around as we settled the west. Here we are at the most remote edge of civilization, far from the comforts of home. And danger is present, not necessarily imminent but sufficiently close to quicken our pulse and heighten our senses. Freud once said that life is most real when enough danger is present to make us more than ordinarily alert but not to throw us into panic. In this state of heightened awareness we are more than ever sensitive to the extraordinary physical delights the eyes and ears and nose can feast upon. Thus to go to the wilderness is not to take just another vacation, one in which campsite is exchanged for the more usual motel room. Rather, it is to go

on a special type of emotional journey. Not merely do we forsake a permanent home for a temporary one, but we also travel from a place where we feel at home to a region where wild things imagined or real may startle us.

Out in the wilderness, away from the urban swaddling clothes we have wrapped around ourselves to keep us cozy, we feel we can get in touch with a wilder part of ourselves, more free-spirited than the tame self that we put on to carry out business as usual. Many people feel that they confront in the wilderness awesome, mysterious powers that transcend the human. Some explain these powers as purely natural: nature itself is wonderful and within it are forces that heal and make us whole. Others believe they are supernatural. Religious traditions of the world are full of stories of heroes and saints fleeing the confines of civilization to encounter the gods. Jewish and Christian tales are most familiar to Americans. Moses fled from Egypt to meet the God of Abraham, Isaac, and Jacob in the wilderness of Sinai. Elijah escaped the clutches of the vengeful Jezebel by fleeing to the desert, where he met the God who spoke in a "still, small voice." John the Baptist came eating the food and wearing the clothes of the wilderness and preaching repentance. Jesus spent forty days there resisting temptation and preparing himself for the ordeal ahead. Clearly the modern exodus to the wilderness is in part the latest episode in an old, old story.

Perhaps what we seek most in the wilderness is a return to a new and different Eden. When Adam and Eve were banished from the Garden, they went east—to the sometimes painful and cruel world we ourselves live in. Human history and human story-telling are filled with efforts to turn around and go back—west to a land flowing with the milk of human kindness and the honey of ecological harmony. The wilderness areas of America are, of course, quite different from Eden.

Eden was a garden, not a wild place, designed for human convenience, not inconvenience. Yet, our journey to wilderness may, at a deep and even partly unconscious level, be a peculiarly American way of seeking paradise. After all, we have never really wanted life too easy. A garden might be too comfortable, whereas a paradise in the wilderness might be just the right paradise for us, satisfying our need to be in territory still untamed listening for the call of the wild.

A trip to the wilderness is, then, at its fullest, a journey to a special type of frontier, where a more authentic self and some kind of transcendent forces are to be found. Accordingly, the wilderness is a place not merely physical but emotional and spiritual as well. Precisely for this reason, we are sure to find artists there, making poems and paintings, essays and photographs out of the landscape. For of all the activities of humankind none is more thoroughly devoted than art to the exploration of all aspects of our lives, the physical, the emotional, and the spiritual.

Among wilderness art[1] the art of Yosemite occupies pride of place, for Yosemite holds a distinctive position among the wilderness areas of the world. Not only was it the first to be specially protected,[2] but from the moment of its discovery by Caucasians its special beauty has been recognized. People have considered it an inner sanctum of the mountains, a holy of holies of natural paradises. Here if anywhere on earth human beings might find natural regeneration and mental and spiritual well-being. Yet its very popularity may be its undoing. The conveniences we require, whether trail and tent or highway and motel, are taming the valley. In fact, domestication has proceeded so far by the 1980s that the status of Yosemite as wilderness is seriously questioned.

Artists were part of almost every one of the early excursions into the valley, and throughout the last 130 years they

have been on hand to explore the possibilities of regeneration and to engage in the struggles over domestication. Some of them have been highly trained, some amateurs; some are famous, more are unheralded, even unknown. But all have sought to record in pencil or paint, on film or on paper their response to an incomparable phenomenon of nature. This book is about these artists and the works they have produced. My method is partly biographical and partly critical. My plan is to begin with the earliest Caucasian artists, and, after a brief look at the legends of Yosemite's native inhabitants, to follow history's footpath until it arrives at the brink of our own time. My ultimate purpose is to make Yosemite artists better known and better understood, so that their work can more effectively serve as guideposts to those who want to discover new emotional and spiritual frontiers in the Park.

1 It is curious that the English language has no word for the class of things to which paintings, photographs, poems, novels, and essays belong, the word "art" generally referring to the first two items in this list and the word "literature" to the last three. Because this book deals with all five, and in order to avoid cumbersome repetition, I use the word "art" as an all-embracing term. It refers to the activity or to the product of any of the various creative efforts of human beings.

2 A bill signed by President Lincoln in 1864 granted Yosemite Valley and the Mariposa Grove of Big Trees to the State of California. The bill's purpose was "to commit [these areas] to the care of the authorities of [California] for their constant preservation, that they may be exposed to public view, and that they may be used and preserved for the benefit of mankind." (*Congressional Globe,* May 17, 1864, p. 2301).

Plate 1. Thomas A. Ayres. *The Yosemite Valley.* 1855. Black chalk on charcoal drawing on white paper. 34.5 × 53.2 cm. Courtesy The Bancroft Library.

First Artists in Yosemite

ON MARCH 27, 1851, a detachment of the Mariposa Battalion, with James D. Savage in command, entered Yosemite Valley. Although they were not the first Caucasians to see the valley,[1] they were, in effect, its discoverers, since publicity of their find led directly to the removal of its native inhabitants and to the migration of white settlers into it. The previous day Captains Boling and Dill had assembled their companies near present day Wawona and asked any who wished to track the Yosemite Indians into their mountain stronghold to step forward. So great was the desire to see this place known to them only by hearsay that each company moved out as if on parade. The resourceful Boling then organized a footrace to separate camp guard from detachment duty. Among the winners was Lafayette Houghton Bunnell. Born in Rochester, New York, in 1824, Bunnell arrived in California in 1849 and was in Mariposa County in time to join Savage's Battalion. Almost thirty years later, in 1880, he published his version of the Battalion's short but momentous history in *Discovery of the Yosemite, and the Indian War of 1851 Which Led To That Event.*

Bunnell's narrative begins with the disputes in 1850 between the settlers and tribes of native Americans living along the Merced, Fresno, and San Joaquin rivers. The Mariposa Battalion was organized to round up tribes who would not come voluntarily to a reservation set up on the Fresno River. In late March it took by complete surprise a small village on the South Fork of the Merced River, near the present Wawona. Runners were then sent out to other villages in the vicinity, principally to Yosemite, where a tribe of Miwok-Paiute lived who called themselves the Ahwahneechees, or people of Ahwahne. A few days later their chief, Tenaya, appeared at the Battalion camp on the South Fork. Although he promised that his people would give themselves up, after several days only about 70 of an estimated population of 200 appeared. Savage decided to enter their mountain redoubt and bring the rest out with military escort. And so on March 27[2] from a place high on the south rim near Old Inspiration Point, members of the special detachment got their first look at Yosemite Valley.

Their attempt to capture the remaining members of Tenaya's people proved almost fruitless, and when food began to run low, they were forced to return to camp and eventually to Fresno. But before they arrived there the 70 Ahwahneechees in custody, including Tenaya, escaped and returned to their homeland. This escape made necessary another trip into Yosemite, this time by the Battalion's Company B under the command of Captain Boling. Once again Bunnell was among those selected to go, and so, probably on May 9, he entered Yosemite for the second time. The company succeeded in rounding up most of Tenaya's

clan, including the chief himself, at a lake in the high country which Bunnell promptly named for the old warrior. Once detachment and charges arrived back in Fresno, the Battalion was mustered out.

Bunnell's book has stood up rather well under cross-examination by historians.[3] His facts are accurate by and large, even though he apparently kept no diary and almost thirty years elapsed before publication of his book. Nevertheless, his account must not be taken uncritically. The testimony of various other eyewitnesses contradicts his version at numerous points,[4] and in fact the different narratives he himself wrote do not always agree with one another.[5] Even more important, his understanding of the words and attitudes of the native Americans is highly suspect. A Spanish-speaking mission Indian accompanied the Battalion into Yosemite. He only imperfectly understood the dialect spoken by the Miwok-Paiute tribe who lived there. Thus, words he did not fully grasp he translated into Spanish, and a Spanish-speaking member of the detachment then translated them into English. Hence Bunnell stood at the tail end of a chain of communication, each of whose links was weak. He could have understood no more than the basic import of what was said.

Bunnell's virtues as a writer are his acute powers of observation and the depth of his feelings for both mountains and people. His characterization of Tenaya is particularly powerful. On a number of occasions he paraphrases speeches of the old chief. When Savage tries to talk Tenaya into coming voluntarily to the reservation, he replies, "My people do not want anything from the 'Great Father' you tell me about. The Great Spirit is our father, and he has always supplied us with all we need. We do not want anything from white men."[6] Later Tenaya denounces in a wild frenzy the wanton killing of his favorite son by guards who deliberately let him escape in order to shoot him down:

Kill me, sir captain! Yes, *Kill me,* as you killed my son; as you would kill my people if they were to come to you! . . . Yes, sir, American, you can now tell your warriors to kill the old chief; you have made me sorrowful, my life dark; you killed the child of my heart, why not kill the father? But wait a little; when I am dead I will call to my people to come to you, I will call louder than you have had me call; that they shall hear me in their sleep, and come to avenge the death of their chief and his son. Yes, sir, American, my spirit will make trouble for you and your people, as you have caused trouble to me and my people. With the wizards, I will follow the white men and make them fear me."[7]

During this speech Tenaya seems suddenly to grow much younger and to acquire magical powers, a "medicineship." Yet less than an hour later, while the famished chief is stuffing himself with food supplied by the soldiers, Bunnell notices that the "spiritual man had disappeared," leaving only a "dirty old Indian" behind.[8]

While Bunnell gives rough sketches of a number of other people, it is Yosemite itself that he is most interested in portraying. When we step back to look at the overall design of the portrait, it is clear that he makes of the valley a holy place, built by God and inhabited by his spirit. From the moment Bunnell steps foot in it, he feels as if he has walked into church. Because trees partially obscure his very first look at the valley from near Old Inspiration Point, he leaves the rest of the Battalion and climbs to a granite outcropping to get an unobstructed view. So lost is he in his reverie that he does not notice that his colleagues have moved on until Major Savage calls to him:

You had better wake up from that dream up there, or you may lose your hair; I have no faith in Ten-ei-ya's statement that there are no Indians about here.

He hurriedly rejoins the group and as he pulls up alongside Savage, he says:

If my hair is now required, I can depart in peace, for I have seen the power and glory of a Supreme being; the majesty of His handy-work is in that 'Testimony of the Rocks.' That mute appeal—pointing to El Capitan—illustrates it, with more convincing eloquence than can the most powerful arguments of surpliced priests.

To this Savage replies:

Hold up, Doc! you are soaring too high for me; and perhaps for yourself. This is rough riding; we had better mind this devilish trail, or we shall go *soaring* over some of these slippery rocks.[9]

It is as if two men entered a building in order to catch some outlaws hiding there. One of them is so intent on the business at hand that he does not look at the building. The other realizes that the building is in fact a church, whose walls and columns speak of God the way priests do, only more eloquently. As he listens, earthly things, even his own death, seem unimportant.[10] The entire passage is almost a parable of the difference between the practical person, too goal-directed to look anywhere but straight ahead, and the artistic person, sensitive to the emotional overtones of a place.

This difference is humorously illustrated in an interchange between Bunnell and Savage as the Battalion is about to leave the valley after their unsuccessful first visit. Bunnell has just returned from a fruitless search up Tenaya Canyon, and after describing the glories of the scenery there, suggests that some new tactic will have to be devised. At this point Savage looks up from the charred remains of an acorn cache he has set fire to, and says, "This affords us the best prospect of any yet discovered; just look!" Thinking Savage is applauding

the view, Bunnell turns, looks, and exclaims, "Splendid! . . . Such cliffs and waterfalls I never saw before, and I doubt if they exist in any other place." [11] Only after Savage bursts out in laughter does Bunnell realize that he is talking about the prospect of starving the Ahwahneechees out of the valley by burning their groceries.

An aspect of Yosemite's holiness that fascinates Bunnell is its mystery. The everpresent haze, that shows the outline but not the details of the far-distant monoliths, seems both to reveal and yet conceal a divine presence:

The grandeur of the scene was but softened by the haze that hung over the valley—light as gossamer—and by the clouds which partially dimmed the higher cliffs and mountains. This obscurity of vision but increased the awe with which I beheld it, and as I looked, a peculiar exalted sensation seemed to fill my whole being, and I found my eyes in tears with emotion. [12]

Yosemite, in this respect, differs markedly from places like the Grand Canyon that can be assimilated in one sweeping look and whose features, even the ones farthest away, are usually clear and distinct.

Bunnell's feeling that Yosemite is, in essence, a church explains his disgust with his comrades when, around the evening campfire they begin to joke about the valley and to make fun of the serious way he has responded to it:

The coarse jokes of the careless, and the indifference of the practical, sensibly jarred my more devout feelings . . . as if a sacred subject had been ruthlessly profaned, or the visible power of Diety disregarded.[13]

Interestingly enough the soldiers, by their own admission, feel that Yosemite is nothing less than hell itself. So, in a sense, they agree with Bunnell that it is an out-of-this-world place. But, whereas his thoughts in search of an explanation go up,

theirs go down. After listening to Chief Tenaya's description of it, the soldiers conclude that "it must be a devil of a place" and feel as they march toward it that they will soon arrive "at the residences of his Satanic Majesty's subjects."[14] Of course, Tenaya has a vested interest in coloring it dark and gloomy, since he does not want the soldiers so much as to cross its threshold. But after a time there they do not revise their notions. Bunnell reports that their "*general* verdict was that it was gloomy enough,"[15] and after he remarks that Chief Tenaya was right about the Great Spirit providing bountifully for his people, Savage retorts:

[the valley] is what we supposed it to be before seeing it, a h—— of a place.... Hemmed in by walls of rock, your vision turned in, as it were, upon yourself—a residence here would be anything but desirable for me."[16]

Bunnell's importance goes far beyond the fact that he was the first writer in Yosemite. Hardly an enlightened man by 20th century standards, he was, nevertheless, genuinely sensitive to native Americans as people and regarded them as more than a nuisance to be rid of. He, like so many others, responded to Yosemite as the artistic masterpiece of a Supreme Being and believed that when there we should behave ourselves accordingly. But most important in terms of art, he was acutely aware of the natural wonders around him, he responded with great and profound emotion to them, and he was able in competent though not brilliant prose to describe them for us. While not every artist who has followed his footsteps into Yosemite has been as impractical, nor has entered the valley weeping, each has shared with him a fine sensibility to landscape, large emotional resources, and the skill to embody these emotions in a concrete work of art.

Not until four years after Bunnell's visit did the first visual artist, Thomas Ayres, enter Yosemite. Ayres arrived in San Francisco in August, 1849, and spent much of 1850-54 sketching in Northern California. By June of 1855 his work had come to the attention of James Mason Hutchings, a 49'er from England, who planned to begin publication of an illustrated magazine. Hutchings notes in his diary for June 1, 1855:

Spent the evening in pleasant conversation with Mr. Ayres, on pictures, artists, and drawings. He has some beautiful views. I ordered one view of his sketching of the Golden Gate . . . for which I am to pay $75 and have the right to publish it.

Hutchings knew of the scenic wonders of Yosemite and realized how impressive an illustrated article on the valley would look in the first issue of his magazine. So in July he organized the first tourist party to visit Yosemite and invited Ayres to accompany the group.

As the Mariposa Battalion had done before them, Hutchings' party used the old Indian trail from Mariposa via Wawona and first looked on Yosemite from Old Inspiration Point. The date, according to Hutchings' diary, was July 27, 1855.[17] The thoughts of the group, as had Bunnell's before them, immediately turned heavenward. Hutchings reported in his account of the trip for the *Mariposa Gazette:*

. . . as the scene opened in full view before us, we were almost speechless with wondering admiration at its wild and sublime grandeur. "What!" exclaimed one at length, "have we come to the end of all things?" "Can this be the opening of the Seventh Seal?" cries another. [Probably Hutchings himself; he was deeply religious and had a detailed knowledge of the Bible.][18]

Yosemite was so beautiful the group thought that perhaps in the twinkling of an eye the earth had passed away and they

were entering heaven on Judgment Day. One of the party brought the others back down to earth. "This far, very far, exceeds Niagara," he said, and Ayres immediately set about the practical task of making a sketch that would prove to the world the truth of that statement. So far as we know his drawing is the first visual representation of Yosemite (Plate 1).

The group stayed in the valley for another three days, and Ayres made five more sketches: "El Capitan," "Yosemite Domes," "Cascades of the Rainbow" (Bridalveil Fall), and "The Ford Entrance to the Yo-Hemity Valley."[19] Unfortunately, Hutchings' entries in his 1855 diary reveal virtually nothing about the activities of Yosemite's first tourist party:

Friday, July 27th: Fine—a little more than warm, yet not too hot. From South Fork of Merced River (Wawona) to Yohamite Valley 22 miles.

Saturday, July 28th: Fine and warm—Yohamite Valley.

Sunday, July 29th: Fine and warm. Explored the Yohamite Valley to head [vicinity of present day Pines Campgrounds]—10 miles.

Monday, July 30th: Fine and warm. Yosemite Valley to Camp, 10 miles.[20]

Once Ayres had returned to San Francisco he put the finishing touches on his sketches. For the two drawings held by the Bancroft Library on the Berkeley campus of the University of California, "The Yosemite Valley" (Plate 1) and "The Yosemite Falls" (Plate 2), he used a "prepared board," that is, a mat board coated with whiting in size medium to make its surface hard, glossy, and somewhat toothy.[21] The background of "The Yosemite Valley" he rendered in light charcoal or black chalk, which he then smudged in places to soften the effect. Probably the outlines of the entire picture were executed in this fashion, and it is possible, though hard to prove, that this much of the drawing was done in the field.

However that may be, the finishing touches were definitely applied after he returned to San Francisco.[22] First he added the foreground details using a much heavier application of charcoal or chalk than he had used for the background. By making foreground noticeably contrast with background not only in shading but also in number of clearly visible details, he was able to render the effects of the everpresent haze. Next, to produce highlights on some of these details he applied a very thick layer of charcoal or chalk and then using a sharp instrument scratched through it to the white coating underneath. Finally he added white paint, an opaque body color, to the clouds, giving them more substance.

His rendition of the foreground of "The Yosemite Falls" was accomplished by essentially the same methods and materials: charcoal or chalk drawing, scratchboard technique, and painting with body color. Some of the trees show an especially elaborate combination of outline drawing, smudging, scratchboard technique for highlights, and black paint for substance. But the background of this drawing he did in an extremely fine ink wash, going over the outlines of cliffs and trees with a charcoal or chalk pencil to give them clarity. As a final step he added white paint to the smoke, the river, and most importantly to the falls themselves. Clearly, then, Ayres worked over both of these drawings a number of times using a variety of techniques. The results are impressive.

In the fall of 1855 Hutchings published the first picture of Yosemite ever made public, "The Yo-Semite Falls," a lithograph based on Ayres' drawing (Plate 3). The following year he also published four engravings based on Ayres' work in the first issue of *Hutchings' California Magazine* (July, 1856), and shortly thereafter issued a lithograph based on Ayres' drawing of the valley from Old Inspiration Point. Now, for the first time, the world could see what Yosemite looked like.

In the summer of 1856 Ayres returned to Yosemite, this time not in the employ of Hutchings. It is possible that he wanted to make sketches for a projected showing of his work in New York City. To the great delight of historians, Ayres' own account of this trip was published in the *Daily Alta California* on August 6, 1856. He entered Yosemite from Coulterville via the trail newly constructed by George Coulter, Lafayette Bunnell and others. Passing Bridalveil Fall and El Capitan he came upon the party of Judge Walworth at the base of Yosemite Falls. This party, which included Bunnell, had just "completed a frame house," possibly the first Anglo structure in the valley and designed to accommodate the tourists expected to arrive the next year. Ayres remained at the Judge's camp for the duration of his stay.

Since he had not traveled up any of the forks of the Merced River the previous year, he spent most of his time on this trip doing just that. All four of the known 1856 sketches are done in these areas: "Falls of Ca-ya-no-pah" (Vernal Fall), "Falls of Awanee" (Nevada Fall), "Falls of Ta-sa-yve" (Illilouette Fall), and "Lake of the North Fork" (Mirror Lake). Then, after a stay of about ten days observing "all . . . as Nature . . . made it, fresh and beautiful from the hand of the Creator," and after being "treated to a salute from Nature's artillery" on, appropriately enough, the 4th of July, he left the Merced River Valley "bound on an exploring trip to its head waters, far among the snow-clad peaks of the Sierra Nevada."

Until very recently it seemed improbable that Ayres actually took this trip into Yosemite's high country. He did not fulfill a promise to give an account of it in a second letter to the *Alta.* But in 1983 the National Park Service purchased from Dr. Clay Barham an oil painting, ostensibly of Tuolumne Meadows, signed "T A Ayres" and dated "1858" (Color plate 1). Apparently no good reasons exist for doubting its authenticity. Its style is similar to that of extant drawings by Ayres, particularly in the manner clouds are rendered, and the canvas is of the type made in his time. The painting has been in the family of Dr. Barham for five generations, having been originally owned by his great-great-grandfather, Charles H. Chamberlain. In 1855 and 1856 Chamberlain was successively Justice of the Peace in Sonora and Columbia, towns just north of Yosemite. He moved to the San Joaquin Valley in 1857 and, after serving in the California legislature as senator and assemblyman, spent his latter days in Oakland.

That the subject matter of the painting is Tuolumne Meadows is likely, though far from certain. From the western entrance, beside the modern Tioga Road, the configuration of nearby Pothole Dome on the left, the distant Kuna Crest, and the downslope of the Cathedral Range on the right matches the landscape in the painting exactly. Ayres seems to have blocked out his painting from a sketch made at this point. The vast expanse of the meadow is, however, not visible from here. Perhaps he ascended Pothole Dome and sketched the meadow as a whole from there. When he combined the two drawings in the oil painting, he moved Pothole Dome into the distance to make room for the meadow, and altered its character considerably. The slant is right, but the details more resemble Lembert Dome or possibly even Clouds Rest. Nothing he could have seen from the western end of the meadow resembles the chimneylike formations on the painting's right. Protuberances somewhat like these do occur in the general vicinity, especially on Mt. Hoffman and in parts of the Cathedral Range.

Ayres probably left Yosemite Valley by going up Indian Canyon and took the Miwok-Paiute trail to Tuolumne Meadows by way of Tenaya Lake. On route, he likely sketched many different landforms, including Mt. Hoffman from the

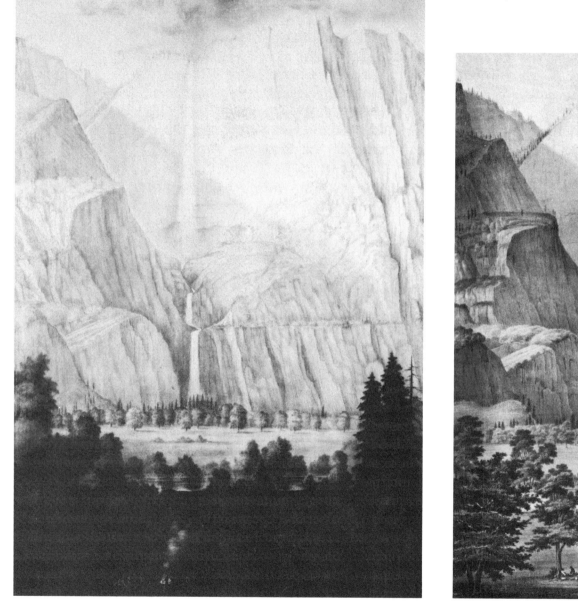

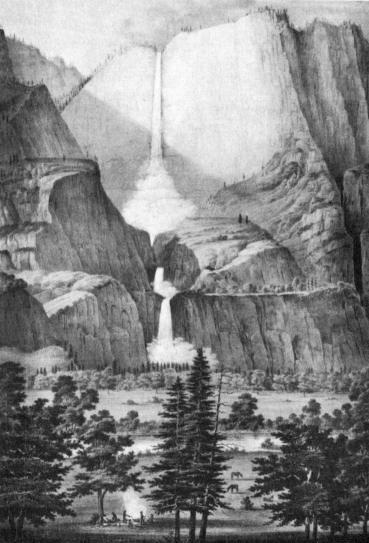

Plate 2. Thomas A. Ayres. *The Yosemite Falls.* 1855. Black chalk on charcoal drawing on white paper. 50.7 × 35.6 cm. Courtesy The Bancroft Library.

Plate 3. Thomas A. Ayres. *The Yo-Semite Falls.* 1855. Lithograph. 22¼ × 14½ inches. Courtesy California Historical Society, San Francisco/Los Angeles.

Yosemite Creek drainage and Clouds Rest from Olmstead Point. Once in Tuolumne he made additional sketches from its western end. Two years later he executed from his field studies an oil painting that was a composite of his entire trip. Tuolumne furnished the ground plan, but individual structures were amalgams of diverse Yosemite rocks. That he gave such faithful renditions of Yosemite Valley in his drawings while making a composite oil painting of Tuolumne has a ready explanation. When working in oil he followed the contemporary practice of constructing on canvas an ideal landscape based on field sketches.

What little we know about the rest of Ayres' short life we learn from two articles that report his death. The earliest appeared in the *Daily Alta* on May 27, 1858. Five days later the *Sacramento Union* reprinted the *Alta* article and added a paragraph with some additional and fascinating information. According to the *Union* article Ayres' "celebrated panorama of the Yosemite Valley and Falls was exhibited in this city [Sacramento] some three years ago [1885] at McNulty's Hall, opposite the Forrest Theatre." So, shortly after returning from his trip with Hutchings, he must have held a one-man showing of his work in Sacramento. He also had other plans to show off the scenery of California. According to an advertising poster now in the Bancroft Library a series of 46 views (none of which were of Yosemite) "drawn from nature by Thomas A. Ayres" and "painted by Thomas A. Smith" were assembled in a large exhibition entitled, "California on Canvas." The fate of these paintings (if indeed they were ever executed) is unknown, though a number of Ayres' drawings still exist.

From the *Alta* article we learn that in 1857 Ayres' Yosemite views were exhibited at the Art Union on Broadway in New York City, and that he was "engaged by Harper and Brothers to illustrate several forthcoming articles on California." But early next year, just as he had finished a tour of Southern California gathering a portfolio of sketches for Harpers, fate played a cruel trick on him. Arriving at San Pedro in order to return to San Francisco, he was induced to quit the vessel on which he was booked, "owing to her reputed bad condition, and took passage in the Laura Bevin." Soon after sailing the worst northwester of the season hit. The Laura Bevin, with Ayres aboard, sank; the other schooner arrived safely in San Francisco. The *Alta* reporter philosophizes, "Truly, the ways of Providence are inscrutable and none can calculate the chances of the great deep."

In understanding the art of Thomas Ayres, "picturesque" is the key word. He uses it repeatedly in the *Daily Alta* article, and the context makes clear what he means: a combination of contrasting scenic elements, the whole making up an arrangement pleasing to the eye. Here, for example, is the arrangement he saw as he descended into the valley from the Coulterville trail:

The Cascade of the Rainbow [Bridalveil] descend[s] into the valley on our right from a height of nine hundred and twenty feet. The water comes over the sharp granite edge of the precipice, then descending, is broken into fleecy forms, sometimes swayed hither and thither by the wayward winds; at other times the sun lights up its spray with all the colors of the rainbow, hanging like a prismatic veil from the sombre cliff. The surrounding peaks are riven into varied forms, most picturesque in their outlines, contrasting beautifully with the emerald meadows and masses of pine, cedars and oaks at their base.

The cliffs are "sharp," "sombre," and "riven," while the falls, on the other hand, are "fleecy" and the meadows "emerald." An artist of the picturesque "wander[s] with pencil and sketch book" up mountains and down valleys, over rocks and through trees, "hunting" for the "choice points of view," precisely those vantage points that yield arrangements like the

one that Bridalveil Fall presents. Presumably Ayres, as an artist of the picturesque, spent most of his time on both trips to Yosemite engaged in this kind of "hunting."

How he attempts to draw the picturesque can be seen in his "Cascade of the Rainbow," done on his trip with Hutchings (Plate 4). He places the most important contrast, the one between the massive rocks and the "fleecy" falls, in the center of the picture. To emphasize the contrast he exaggerates the height of the rocks, makes them considerably more sheer than they actually are, and simplifies them by omitting almost all details. The result is a steep, rather blank wall down which the water falls and against which it stands out sharply. Also, the smooth surface of the cliffs contrasts nicely with the tree-filled talus slopes at their feet.

Above the falls rise the three "riven" peaks of Cathedral Rock, silhouetted sharply against a sky cloudless except for the airy wisps in the top left corner. These peaks interrupt a line that proceeds across and down the picture from the upper right corner to the lower left, beginning with the top edge of the rock face to the right of Bridalveil, picked up by Sentinel Rock in the middle distance, and ending with the faint outline of Glacier Point in the distance. This line gives a continuity to the drawing and leads the eye into the distance; its interruption by the three peaks effectively separates foreground from background.

"Cascade of the Rainbow" effectively illustrates the major aspects of Ayres' style, aspects which are even more impressively on display in "The Yosemite Falls" (Plate 2), his finest work. Central to the success of this drawing is his choice of a vantage point from which the upper fall, the cascades, and the lower fall appear to descend in a straight line. Then, to make the falls seem even more linear, he depicts the upper portion as falling straight down, rather than as windblown to the left in the fashion that has become popular since his time, and he omits almost all hint of mist at its base. A foreshortening occurs as a result of this streamlining of the falls, similar to the effect that a telephoto lens gives: the horizontal distance between the upper fall in the rear and the lower fall in front appears greatly reduced, so that the water seems to fall from the top of the cliff to the valley floor in one grand motion rather than in three distinct motions. And this effect in turn makes the cliffs appear even higher than they actually are.

To counterbalance the straight up and down falls Ayres very effectively breaks up the canyon wall into a harmoniously interrelated series of planes with an effect that is almost cubist, and has a light shadow from a hazy Sierra summer sun fall across the rock face in the middle of the Upper Fall. To give some hint of depth to the scene he places the foreground in deep shade, making it contrast sharply with a background done in lighter tones. Thus, while he is more or less accurately rendering the geography of Yosemite Falls, his artistic sensibility is at work intersecting lines with planes and contrasting far with near and soft water with hard rock.

Historians have paid attention to Ayres largely because he was Yosemite's first artist. Rarely do they comment at all on his work, and when they do, the comments are typically uncomplimentary. I hope I have demonstrated that, on the contrary, he is a skilled and self-conscious craftsman. Although his approach is basically realistic, his tendency to simplify in order to contrast amounts to a kind of abstraction and gives a modern feeling to his drawings. His artistic contributions should be taken more seriously.

Possibly an obscure Frenchman by the name of Antoine Claveau painted the first oil of Yosemite in 1857. The *San Francisco Bulletin* of October 27, 1857 mentions that "a panorama of Yosemite Falls and Valley [is] now being painted

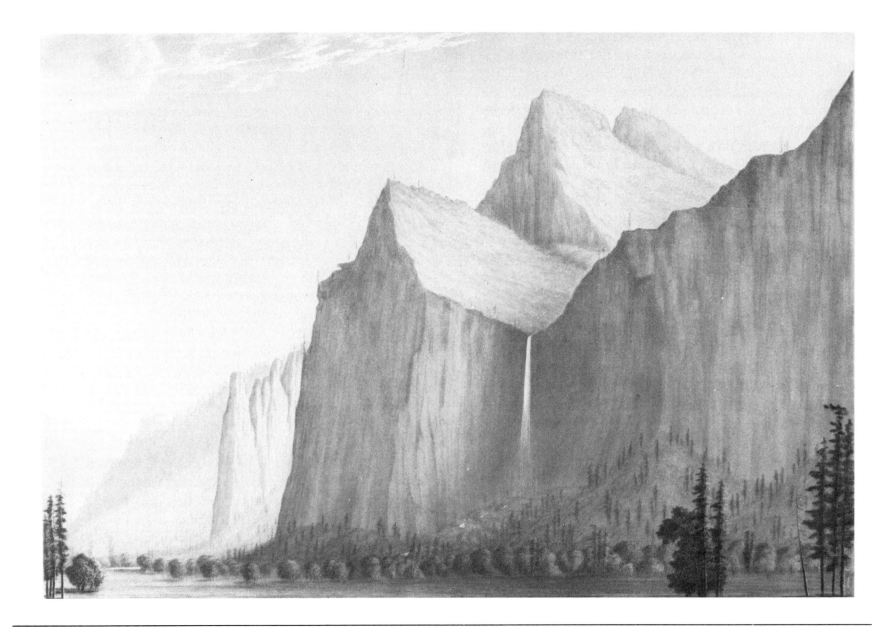

Plate 4. Thomas A. Ayres. *Cascade of the Rainbow.* 1855. Drawing. 14 × 9½ inches. National Park Service, Yosemite Collection.

there by Mons. Claveau . . . in a tent high enough to contain the canvas." The panorama was commissioned by the Mann brothers (builders in 1855-56 of the toll trail that became the basis of the Wawona Road) who were, however, not willing or able to pay for it. In October of 1857 Claveau brought suit against them for $3,500 alleged to be due him and filed for possession of the panorama in lieu of payment.[23] Undoubtedly he won his case, for an advertisement announcing a December, 1858, showing of the panorama in the San Francisco Musical Hall lists Claveau as the proprietor.[24] This same advertisement states that the panorama contained *Twelve Different Views* including the most remarkable features of the wonderful Yosemite, closing with a View of the Great Falls." Earlier that year, in September, a Thomas G. Hambly had entered two paintings by Claveau, one of "Bridal Falls" and one of "Yosemite Falls," in the Second Mechanics Fair in San Francisco.[25] Even though presumably owned by Hambly, these paintings were probably two of the panorama's twelve. Unfortunately, all of Claveau's work has been lost.

On the other hand, maybe Frederick Butman did the first oil painting of Yosemite. He came to California in 1857 and was singled out by B. P. Avery, early historian of California art, as "identified with the first decided movement in the direction of . . . native Art, for he undoubtedly gave the first strong impulse to landscape painting in California."[26] According to a note by art historian Marjorie Arkelian in the Oakland Museum's Archives of California Art, a painting by Butman with the caption, "Earliest known painting of Yosemite Valley, 1857," was on sale at Newbegins Bookshop in San Francisco in the early 1950s. Both the owner of the book store, Charlotte Newbegin, and one of her former employees, Giovanni Scopazzi, verified that Newbegins did indeed sell

such a painting. Unfortunately, no record exists of the buyer. If it was, in fact, completed in 1857, it might antedate Claveau's panoramic views by a month or so. By the late 1850s Butman had finished a number of Yosemite paintings. An article in the *Alta* of October 30, 1859, comments on two of his Yosemite paintings on sale in a local gallery, and a Yosemite landscape by him won first prize in the category of oil paintings at the California State Fair in 1859.[27]

Yosemite's first watercolorist was undoubtedly James Madison Alden, a direct descendent of John and Priscilla Alden. In the spring of 1859 he took time out from his duties as official artist of the United States-Canadian Boundary Survey to visit Yosemite. The details of this trip are nowhere recorded, but nine watercolors of Yosemite scenery still exist, six of which bear the date 1859, indicating that he finished them in the valley or shortly thereafter. Alden's technical skills are quite limited. His inability to control perspective in "Valley of Yo-Semite, California" (Color plate 2) causes the painting to break up into three loosely related parts, foreground of river and meadow, middleground of cliffs and trees, and background sky that is itself composed of two discrete areas, orange below and blue above. He fails, especially, to integrate foreground with middleground. The Merced River is very crudely done: besides being barely distinguishable from the meadow, the S-curve it makes is highly schematic. He is here painting a typical river rather than the actual Merced. The cliffs and trees, on the other hand, are quite effective. The minutely crafted, starkly silhouetted tree right at the point where the cliffs from either side of the valley, the river, and horizon meet rivets our gaze to that point. Despite the amateurish look, the painting as a whole is undeniably charming. Cathedral Rocks look not so much like real cliffs of huge size as quaint formations fit for a land of fairytale.

Cathedral Spire, in particular, looks like a butte transported from the badlands of Utah or Arizona. Whether this effect is intentional or results from Alden's inadequate draughtsmanship is hard to tell. His choice of sunset orange, although too bright in places, reinforces the idea of Yosemite as an unreal, never-never land.

In 1855 Hutchings brought to Yosemite its first illustrator, Thomas Ayres. To Hutchings also goes the credit for bringing in, four years later, its first photographer, Charles Leander Weed. Both times his purpose was to obtain copy for his magazine. But in his writings Hutchings mentions Weed by name so infrequently and publishers so often used Weed's photographs without giving proper credit that until the 1950s he was virtually a forgotten man. Since then three people, A. William and Mary V. Hood and Peter Palmquist, have successfully exhumed him from history's graveyard.[28] As a result of their patient historical spadework we can now chart the basic course of his life.

Born in New York State on July 17, 1824, by 1854 he was working as a photographer in Sacramento, and in early 1858 took charge of a satellite studio Robert H. Vance, San Francisco's leading Daguerrian, ran in the state capitol. Then, in October of 1858, Vance sent him up the American River to photograph its mining communities by the new wet-plate, or wet-collodion, process. Unlike the method invented by Louis Daguerre, which like today's polaroid yielded a positive incapable of duplication, the wet-plate process yielded a glass negative that could be used to make innumerable paper positives. So it became economically feasible for a photographer like Weed to go on an extended field trip, since he could return to his home studio and print hundreds of positives over an indefinite period of time from a limited number of negatives.

While actually on the American River, however, Weed had to pay dearly in muscle and patience for any success that might await him. Under ideal studio conditions wet-plate photography was a most exacting and laborious process. In the foothills of the Sierra Nevada in the middle of the last century, the hardships must have been next to overwhelming. In a wagon without shock absorbers across roads that, if they existed at all, were probably not much more than a gathering of potholes, he had to take not only numerous glass plates, a hefty camera, and a sturdy tripod, but an entire darkroom! Once he had found a prospect worth photographing, had set up the camera and tripod, and had composed and focused the scene on the ground glass, he could not simply insert the pre-packaged film and click the shutter. Rather he had to enter the darkroom tent already erected on the spot and begin an elaborate procedure: take a cleaned and polished glass plate and pour over it enough collodion (a solution of guncotton in alcohol and ether) to coat the entire surface; next make the coated plate light sensitive by soaking it in a bath of silver nitrate, insert it in a light-tight holder and transport it to the camera; take the lens cap off and make an exposure of from a few seconds to a few minutes; then, quickly, for the entire procedure must be completed while the collodion is still tacky, return the plate to the darkroom for developing, fixing, and washing; and, finally, inspect the result. Was the exposure too long, or too short? Did, despite great care, the collodion not coat the plate evenly? Did the collodion dry before development took place? If the answer was yes to one or more of the above, he could scrape the emulsion off the glass and start over. If not, he could dismount everything—camera, tripod, darkroom tent—pack them in the wagon, and head on down the road looking for another choice view, hoping that a sudden jolt would not

break the fragile results of all his labor.

On this particular trip Weed made it back with his glass plates intact, for in 1859 they were displayed in Vance's gallery in San Francisco. Weed himself moved there in the spring of that same year, probably to serve as Vance's field man. So it was he who got the assignment to accompany Hutchings to Yosemite in June, 1859. Hutchings gave a detailed report of the trip in his magazine.[29] The party left San Francisco by boat on June 14 and arrived the next day in Stockton. After a coach ride to Coulterville, they completed their trip to Yosemite on horseback, arriving at the recently completed Upper Hotel late in the evening of June 17.

Until Mary Hood and her photographer husband William began their research it was thought that Weed's first photograph in Yosemite was of the hotel itself. Hutchings says in a later recounting of the trip:

Soon after its formal opening Mr. C. L. Weed . . . [was] among the first guests. The accompanying illustration is from the first photograph ever taken in Yo-Semite and by C. L. Weed in June 1859.[30]

The Hoods noted, however, that in his magazine account, written no more than a month or two after the event, Hutchings says that the morning of the 18th (since they arrived at night, no picture could have been taken on the 17th) was spent at the base of Yosemite Falls, where "a photograph was taken."[31] From the shadows the Hoods deduced that Weed's photograph from the base of the falls (Plate 5) was taken in the late morning, whereas his picture of the hotel was probably taken in the early afternoon. They felt justified in concluding that the former was the first photograph ever taken in Yosemite.

Before he left Yosemite on the 22nd, Weed made at least

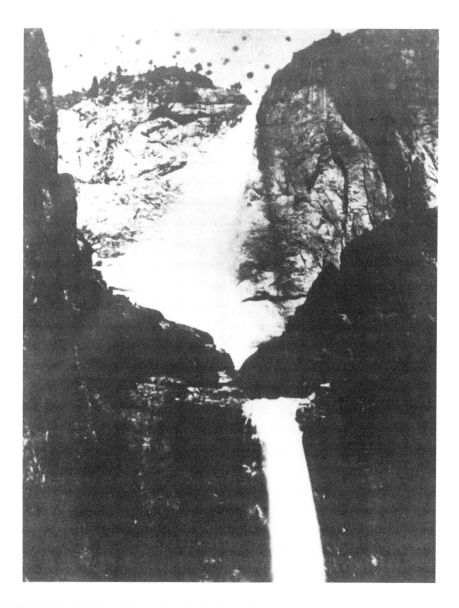

Plate 5. Charles Leander Weed. *Yosemite Falls.* 1859. [The original of this photograph has been lost. The above reproduction is taken from *Yosemite Nature Notes* 38 (1959) 83.]

twenty 11 by 14 views, and at least forty stereos, and shortly after his return to San Francisco both sets went on display at Vance's gallery. A notice in the *Daily Times* for September 15, 1859, announced:

Ho! For the Yo-semite Valley
A magnificent photographic panorama of the Great Yo Semite Valley... can now be seen, free of charge, at *Vance's Photographic Gallery....*
These wonderful views were executed for Mr. V. by C. L. Weed, Esq., whose reputation as one of the best Photographers in the State is a sufficient guarantee that they are excellent specimens of the art. In addition to these, may be seen a large number of finely cut stereoscopic views... which are not simply pictures, but fac-similies of the spots themselves....
Having the negatives of all the above, duplicates of each can be given at the shortest notice and at the lowest rates.

The stereos were arranged within a machine so that the observer by simply turning a knob on the outside

has them placed successively before him. Every important place about the valley... is vividly depicted.... The great waterfalls, glistening in the sunlight, are seen leaping out from the crags and hang in mid-air as clearly as if witnessed in nature.[32]

Clearly what excited the visitors to Vance's gallery was not only the grand scenery, but the way the photographs brought them right up to the brink of actually being there. Unlike paintings, which were mere "pictures," the photographs were "fac-similies," and the stereos three-dimensional "fac-similies."

In addition to the exposure given Weed's photographs in Vance's gallery, Hutchings used a number of them as the basis for engravings in his magazine. He also kept for himself an album of Weed's prints, and by a fortuitous set of circumstances this album has been preserved. After a fire had gutted

the Hutchings' San Francisco home in 1880, two friends of the Hutchings' children, Irving and Wallace Rosenblatt, while ransacking the debris, came across an album of water-stained pictures. A third Rosenblatt, Arthur, saved them, not because he realized who took them but because he liked them. In 1929, while on vacation in the valley, he noticed a drawing of the old Upper Hotel that was based on Weed's photograph and realized that he possessed the original. When consultation with Carl P. Russell of the National Park Service confirmed the authenticity of his prints, he donated them to the Yosemite Museum, where they lay mostly unnoticed until Mary Hood came upon them in 1956. Sometime later they were transferred to the Bancroft Library in Berkeley.[33]

In 1864 Weed was back in Yosemite, probably as a member of a photographic excursion sponsored by the publishing firm Lawrence and Houseworth. This time, following the lead of Carleton Watkins, who had in 1861 used a mammoth-plate camera in Yosemite, he took glass plate negatives 17 by 22. Such size, of course, only compounded the already enormous difficulties facing the expeditionary photographer. In 1867 Lawrence and Houseworth submitted 26 of Weed's mammoth-plate views of Yosemite, together with a number of other photographs, to the Paris International Exposition and came away with the bronze medal, the highest award offered in photography.

In 1865 Weed left San Francisco for Hawaii, where he was the first to photograph its volcanic landscape. From there he journeyed to Hong Kong, maybe to Europe, and to Red Bluff, California, before returning to San Francisco in 1871. The next year he may have accompanied Edweard Muybridge on a trip to Yosemite. After a seemingly tenuous association with a number of San Francisco photographic studios during the seventies, by 1880 he had become a photoengraver, a profes-

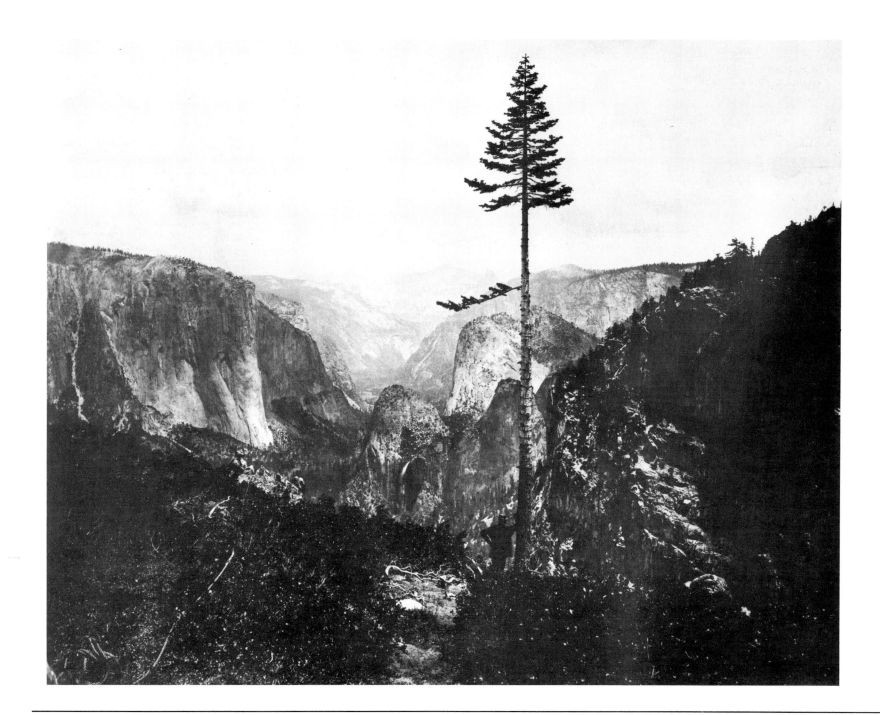

Plate 6. Charles Leander Weed. *The Valley, from the Mariposa Trail.* 1864. Mammoth-Plate. Courtesy The New York Public Library.

sion he practiced until his death in Oakland on August 31, 1903.

Artistically, Weed's photographs have little to recommend them. Judging from the prints themselves Weed had one thing and only one thing on his mind when he exposed the plates: illustrate Yosemite landmarks. Consequently, he gives little thought to composition other than to fill up the frame with the object he is showing off, be it rock or waterfall. When he includes a foreground of trees or meadow, he takes no discernible pains to relate them artistically to the main object.

Nor is Weed's use of people as props very creative, though to us at least, occasionally humorous. The 1864 mammoth-plate taken from Old Inspiration Point is a good example. (Plate 6) The use of the tree, lone and stark and linear against the deep and broad panorama behind it, is quite effective. (Though this tree looks suspiciously strange, with all lower limbs missing and all upper limbs intact. Possibly the lower limbs have been cut on purpose, perhaps by Weed or an associate so that they would not obscure the view beyond.) But the nonchalant attitude of the man leaning against the tree utterly contradicts the sublimity of the landscape he looks out upon. And the woman casually reclined on the rock to the left further disrupts the mood.

The first picture that Weed took in Yosemite is perhaps his most effective. (Plate 5) Because a camera lens does not have binocular vision (excepting stereographs, of course), it tends to flatten a three-dimensional scene, that is, it makes the objects look closer together than they are. A photographer can re-introduce depth by a judicious use of shadows. In this picture Weed has done just that. By waiting for, or arriving at, the moment when the morning sun was shining on the upper falls but not on the lower, he has successfully and dramatically separated the two falls from each other.

These mostly disparaging remarks about the quality of Weed's photographs should not subtract from our estimation of his accomplishments as a pioneer photographer. It is just that his artistic powers were not equal to his physical stamina and to what must have been truly an astounding amount of patience.

In this chapter we have gone in quest of firsts, and we have found Bunnell, Ayres, Claveau or Butman, Alden, and Weed. These Caucasians were not, however, the first artists in Yosemite. If we had taken the trip from San Francisco across the San Joaquin Valley and up through the foothills into the canyon of the Merced in 1850, we would have found only native Americans. These people were the first artists in Ahwahnee, or "Big Mouth," their name for the valley.[34] Unfortunately, a few legends is all we have of the art of the Ahwahneechee people that directly expresses their feelings about the valley. And even these legends were considerably recast by the Caucasians who passed them down to us. In most cases it has proved difficult, if not impossible, to sort back through the hybrids to original stock. Craig Bates of the Yosemite Museum has made a concerted effort to reconstruct the legends approximately as the Ahwahneechees told them, and Frank LaPena has used Bates' research in producing the most authoritative English version to date, *Legends of the Yosemite Miwok*.[35] Here are the three legends I find the most interesting.

The Legend of Half Dome

(abridged)

Long ago in Ah-wah-nee there were many bird and animal people there. One of them went to Mono Lake and married an Indian Woman named Tissa-ack. He started to bring his bride back to Ah-wah-nee to live.

Plate 7. Albert Bierstadt. *Horse in the Wilderness.* 1859-60? Oil on board. 14 × 20 inches. Private Collection.

the bottom of the upper fall. On the left is the fall itself and in the distance are the Royal Arches, North Dome, and Half Dome. Fluffy clouds overhead and a ubiquitous haze reflect over the entire scene the blue and pink light of a mid-afternoon sun. Even the water of the fall is bluish-pink. As a result of this light the cliffs and domes lose their weight and the valley looks like some enchanted mountain fairyland. Twain says with a sarcastic chuckle:

Some of Mr. Bierstadt's mountains swim in a lustrous, pearly mist, which is so enchantingly beautiful that I am sorry the Creator hadn't made it instead of him, so that it would always remain there.

Twain goes on to distinguish between a "picture" (in which reality may be rearranged for the sake of art) and a "portrait" (in which life-likeness is crucial) and proceeds to judge Bierstadt's painting as if it were intended to be a portrait of Yosemite. Not surprisingly he finds it wanting:

As a portrait I do not think it will answer. Portraits should be accurate. . . . We do not want this glorified atmosphere smuggled into a portrait of Yosemite, where it surely does not belong. . . . I believe that this atmosphere of Mr. Bierstadt's is altogether too gorgeous.

But why, we should ask, is a "glorified atmosphere" out of place in a painting of Yosemite? Why should Yosemite on Bierstadt's canvas resemble as closely as possible the way it looks to the eye? The answer is, it need not. To be sure, most of us, under the spell of the camera, share Twain's point of view. But it is a prejudiced point of view. Bierstadt worked in a tradition in which the painter made field sketches and assembled them in the studio, rearranging items in the land-scape for the sake of overall effect. Without doubt, then, he intended both "Domes of the Yosemite" and "Sunset in

Yosemite Valley" to be "pictures," not "portraits." Rather than record Yosemite's landscape as accurately as possible, he wanted to communicate what he felt about it and what he believed it was saying.

We have already seen that Bierstadt felt Yosemite was a natural paradise. But this is not the whole story. To under-stand more completely the fullness and depth of Yosemite's message as Bierstadt conceived it, we need to return to Ludlow's statement that nature is a kind of scripture, an assertion that Bierstadt surely agreed with. By this idea, a com-mon one in the nineteenth century, Ludlow meant that nature is a book, a Bible as it were, in which we can read not only practical moral lessons for everyday living but also eternal truths. Of course, Jews and Christians have always believed that the creation reflects the creator, as a work of art reflects the artist. But throughout most of Judaeo-Christian history they have also insisted that it is dangerous to understand God through nature. Because nature is fallen and people are corrupt, the possibility of misunderstanding is great. During the nineteenth century, however, a great kindling of interest in all things natural, sparked in part by Romantic poets like Wordsworth, Keats, and Emerson, led many people, Ludlow and Bierstadt among them, to feel confident that God speaks as clearly and as wonderfully in the behavior of animals and the colors of the sunset as in the words of the prophets. And so they habitually scrutinized the large and the small in nature to discover the gems of wisdom hidden there.

Thus, we gain a richer understanding of Bierstadt's paintings if we consider them "translations" of nature's "holy" word. "Translation" is Ludlow's term, and it is a good one. Often Nature's message, like the Bible's, is spoken in a foreign tongue. It needs to be translated into a language we readily understand. Bierstadt, then, is like a scholar of the Bible who

above. The presence of the deer confirms the idea that this is a safe, natural paradise. How radically the meaning of the painting would change if Bierstadt had replaced deer with grizzly bears! And he has made Yosemite even more grand than it already is by extending its cliffs and by altering its geography. From a point on the Merced more or less opposite the present Visitors Center, one can chart these alterations. Sentinel Rock is much further away than it is in the painting, and the back side of the Three Brothers blocks out any view of El Capitan. Clearly Bierstadt made a sketch of Sentinel Rock from a spot approximately even with Yosemite Falls and then moved down the valley a mile or more and made another sketch of Cathedral Rocks and El Capitan. Only after he had returned to his studio did he combine the sketches into one painting.

The thoughts of a traveling companion, Fitz Hugh Ludlow, as he first looked into the valley from Old Inspiration Point in 1863, suggest one way of understanding what Bierstadt has made Yosemite a symbol of:

We did not so much seem to be seeing from that crag of vision a new scene on the old familiar globe as *a new heaven and a new earth* into which the creative spirit had just been breathed. I hesitate now, as I did then, at the attempt to give my vision utterance. Never were words as beggared for an abridged translation of any *Scripture of Nature*. [Italics mine][2]

What Ludlow felt he could not do with words Bierstadt attempted with paint and in large measure succeeded in doing: he gave us on canvas a vision of Yosemite not merely as one more place, however spectacular, on an old worn-down earth, but as the earth made over, made like heaven, where human beings might find regeneration and a new beginning.

"Valley of the Yosemite" depends for its success on Beirstadt's balancing on canvas what he saw with his eyes and what he saw with his "eye within an eye," that is, his imagination. He had a vision of paradise, but, unlike so many visionary artists who put their utopias in a never-never land, he located his utopia in a real place, encouraging us to hold out the hope that this paradise might actually be attainable. He did not, however, always so nicely blend literal seeing with imaginative vision. Sometimes he added so much vision that what he imagined outshines what was actually in front of his eyes. Take "Sunset in Yosemite Valley," painted in 1868, for instance (Color plate 4). Our vantage point is about the same as it was in "Valley of the Yosemite": beside the Merced River looking west past Cathedral Rocks and El Capitan to the setting sun. But it is an hour or so later in the afternoon and the cloud cover has increased. In this more dramatic light shadows are deeper, sharply silhouetting the trees and cliffs, which have become molten ingots in the golden light. The heavy, almost brooding clouds together with the cliffs form a tunnel through which the blazing rays of the setting sun shine like a beacon.

In this painting as in "Valley of the Yosemite" sunlight is the key element. But whereas there it harmonizes cliffs, trees, deer, and river in gentle chords to accompany lyrics of paradise, here it sings a solo, blaring out its almost too golden notes. And Yosemite seems not so much like a real mountain valley as a place the light has transformed into a ruined temple of an ancient and glorious civilization of giants. This interpretation is not farfetched; many people of Bierstadt's time described Yosemite as the ruined architecture of a bygone race of giants.

Bierstadt was severely criticized for overdoing the effects of light and atmosphere in paintings like "Sunset in Yosemite Valley." Typical is a Mark Twain review of a painting entitled, "Domes of the Yosemite."[3] In this painting the viewer looks up the valley from a spot on the Yosemite Falls trail just below

tion to reroute the Overland Trail, he applied and was accepted as a member. He accompanied Landor as far west as the South Pass in Wyoming, bringing back with him a passionate love of the West and field sketches that were the basis of some of his most famous oil paintings.

Having made a reputation during the early 1860s on paintings of the western mountains, he inevitably wanted to return for fresh sketches. Two of these return trips were important for his artistic career, and on both of them he traveled all the way to California and Yosemite. On the first, in 1863, he spent roughly the month of August in Yosemite, and afterwards journeyed up the Sacramento River to Mt. Shasta and then on to Portland. On the second trip, in 1871-73, he was in Yosemite several times: in February of 1872 to sketch the valley in winter, again in May, and for the final time of his life in the summer of 1873. During this stay on the west coast he also visited the Tahoe and Donner Pass areas and the Sierra south of Yosemite.

Bierstadt was at the height of popularity during the late 1860s and early 1870s. He and Frederic Church were considered by both connoisseur and average gallery-goer the premier painters of mountain scenery. But after his return from California in late 1873 negative criticism became more frequent and more harsh. Only recently, in the midst of a renewed appreciation of native American painting in general, are kinder words heard again.

What distinguishes Bierstadt from all other painters of Yosemite is his use of light for dramatic effect. He especially liked the soft, tinted light of a rising or setting sun, for it allowed him to accomplish several ends crucial to the success of his paintings. Because a rising or setting sun shines up or down an east-west oriented Yosemite Valley, he could use the silhouetting effect of the horizontal light to throw into relief various features of the landscape. He could also use the color of the oblique light to unify the composition. And most importantly, because we can look directly at a sun low on the horizon, he could make the sun itself the center of the painting, around which everything else is oriented. A good example is "Valley of the Yosemite" (Color plate 3), painted the year after Bierstadt returned from his first visit to California. Because the light is directional from a sun fairly low on the horizon, the deer stand out against the water, the trees are outlined against the cliffs, and each rock on the south side of the valley is clearly visible. Yet everything is joined together into a single whole by sharing the golden tone of the light. The clouds and the water of the Merced serve also to unify the painting. They are mirrors of each other, both stretching from one side of the valley to the other and both reflecting the light throughout the scene. And the sun, just beginning to disappear behind El Capitan, is the center of the painting. We look down the valley to it. Yet, since the haze makes it more of a bright glow than a distinct disc, and since its radiance illumines the entire scene, it is more like a presence than an object, something that is felt more than distinctly seen with the eyes.

By the use of this mellow, golden, omnipresent light, together with a rearrangement of the valley furniture and a heightening of its peaks, Bierstadt has made Yosemite both real and unreal, both itself and a symbol of something else. On the one hand, it is the real Yosemite all right. Sentinel and Cathedral Rocks are on the left and El Capitan on the right. The sky is a faithful rendition of the heavens on a typical Sierra summer evening. Yet, on the other hand, the Yosemite he depicts is also strangely unreal, less like the actual place and more like a wild, wonderful Eden enclosed by great mountain walls on either side and open to the heavenly sunlight from

Early Painting

I N A SENSE neither Bunnell, nor Ayres, nor Weed, nor even the Ahwahneechees were the first artists of Yosemite. Before them came Volcano, Earthquake, Glacier, Wind, and Water. Preparing for this grand open air museum these artists took their time: a million years to raise a mountain, ten thousand to scoop out a valley, a thousand to grow a tree. And they were very good at what they did; Yosemite may well be their global masterpiece. Consequently, it ought to be the easiest place on earth for human artists to work. They merely have to transcribe Nature's already magnificent canvas. But this assignment is not so easily accomplished. It is no simple matter to capture in art the spirit of Nature's daring artistry. Almost anyone writing a postcard home from Yosemite has come face to face with this difficulty, "As you can see by the picture, I am in Yosemite. Words cannot describe how beautiful it is." The problem is the same if you photograph or paint instead of write.

Many artists strive for a realistic rendering of Yosemite just as it is. Usually they run into serious difficulty: scenery that is truly magnificent in reality may look mildly magnificent when copied too literally. Other artists, in order to recreate in their art a Yosemite as wonderful as the original, picture it as more grand than it really is. They rearrange cliffs, subtract details, add picturesque trees, or manufacture just the right weather for the occasion. But they too encounter a problem: scenery that is exaggerated may seem contrived. The artist seems to be cheating, and we respond with disbelief. Because exaggeration is so often an important ingredient in humor, we may chuckle or even laugh right out loud.

This chapter is concerned with the principal painters of the 1860s and 1870s. It deals chiefly with three central figures, beginning with Albert Bierstadt, who habitually exaggerated Yosemite's natural grandeur, and ending with William Keith, who took a more literal approach. In between is Thomas Hill, who steered a middle course between the two.

Albert Bierstadt was raised in New Bedford, Massachusetts, where his family had settled in 1832 after immigrating from Düsseldorf, Germany, when he was two years old.[1] Because of family connections in Düsseldorf, he decided to return there twenty-one years later to further his career as a painter. At that time almost all ambitious American artists who could arrange financing crossed the Atlantic to study under the acknowledged masters of the craft. He returned to New Bedford in 1857 and energetically resumed his artistic career there. But he was restless. Members of the Hudson River School of Painters had already magnificently depicted the mountains of the East. To rival them he felt the need of new vistas. Besides he felt a spiritual kinship with landscapes bigger and wilder than any the East offered him. So, when he read in the newspapers of Colonel Frederick Landor's expedi-

were returning from a Grizzly Bear hunt, reported seeing a valley 3000 feet deep and a mountain that looked "as though it had been sliced with a knife."

2 Bunnell gives the date variously as March 21 or March 25. But Robert Eccleston, a Battalion member who did not go into Yosemite and so presumably was one of those too slow of foot to distinguish himself in the footrace held by Boling, notes in his diary for March 27, "Today about noon Major Savage started for the Yosemite Camp with 57 men & an Indian Guide."

3 The most extensive investigation of the accuracy of Bunnell's account has been undertaken by A. William and Mary B. Hood. See their untitled and unpublished manuscript in the Yosemite Research Library.

4 See Robert Eccleston, *The Mariposa Indian War, 1850-1851, Diaries of Robert Eccleston: The California Gold Rush, Yosemite, and the High Sierra,* edited by C. Gregory Crampton (Salt Lake City, 1957); John Bowling, "Letter to G. W. Barbour," *San Francisco Alta California,* June 14, 1851; and Carl P. Russell's interview with Maria Lebrado, granddaughter of Tenaya, Chief of the Ahwahneechees, reported in "The Last Link with the Past," *Yosemite Nature Notes,* June, 1928.

5 In addition to *Discovery* see "How the Yosemite Valley was Discovered and Named," *Hutchings' California Magazine* 3 (May, 1859) and "The Date of the Discovery of the Yosemite, by One of the Party of Discovery," *Century Illustrated Magazine* 40 (September, 1890) 795-797.

6 *Discovery of the Yosemite* (abridged reprinting of the 1911 edition by Outbooks, Olympic Valley, CA, 1977), 42-43.

7 P. 132.

8 P. 133.

9 Pp. 53-54.

10 What it is about Yosemite that made him feel safe is not easy to say, but thousands of visitors since Bunnell have testified that it shares the capacity with other great objects, whether natural or artistic, to make people feel strangely at ease.

11 Pp. 80-81.

12 P. 52.

13 P. 57.

14 P. 48.

15 P. 78.

16 P. 81.

17 Some thirty years later, in *In the Heart of the Sierras,* published in 1886, Hutchings, for some unknown reason, gives the date as June 20.

18 *San Francisco Chronicle,* August 18, 1855. The *Chronicle* is reprinting an article that appeared earlier in the Mariposa Gazette.

19 Note that the spelling of Yosemite varied greatly in the early days. Hutchings in particular advocated an "h" instead of an "s" in the second syllable because he thought, possibly with some justification, that the Indians pronounced it that way. Others wanted a final "y" because they thought, clearly with good justification, that many English-speaking people would think the final "e" silent.

20 Hutchings later, in *In the Heart of the Sierras,* says that his party spent "five glorious days in luxurious scenic banqueting" in the valley (p. 91). Actually, as these diary entries show, they were there only four days.

21 In order to get expert advice about the materials Ayres used I asked Larry Dinnean, Curator of the Pictorial Collections at the Bancroft Library, to make a detailed study of the two drawings held by the Bancroft. He took the drawings out of their frames and cut away the matting, and the two of us examined them at length with a hand lens. The results of his analysis are summarized in the text.

22 The date on the back of "Yosemite Falls" establishes this beyond doubt. It reads, "Nov. 1855."

23 See *San Francisco Bulletin,* October 26, 1857.

24 See *San Francisco Bulletin,* December 13, 1858.

25 *Report of the Second Industrial Exhibition of the Mechanics Institute of the City of San Francisco* Held at the Pavilion of the Institute, From the 2nd to the 26th September, A. D. 1858 (San Francisco, 1859), 94.

26 "Art Beginnings on the Pacific." *Overland Monthly* 1 (1868) 33.

27 *Transactions of the California State Agricultural Society,* during the Year 1859 (Sacramento: Botts, 1860) 277.

28 See Mary V. Hood, "Charles L. Weed, Yosemite's First Photographer," *Yosemite Nature Notes* 38 (June, 1959) 76-87, and Peter E. Palmquist, "California's Peripatetic Photographer: Charles Leander Weed," *California History* 58 (Fall, 1979) 194-219.

29 See *Hutchings' California Magazine* 4 (1859-60) 148-160, 193-208, 241-252, 386-395.

30 *In the Heart of the Sierras,* 101.

31 *Hutchings' California Magazine* 4 (1859-60) 195.

32 *Daily Times,* August 19, 1859.

33 See the Weed file in the Yosemite Research Library and Carl P. Russell, *100 Years in Yosemite* (Yosemite: Yosemite Natural History Association, 1968) 57.

34 See the very helpful article on the Indian meaning for various Yosemite place names by Craig Bates in *Yosemite Nature Notes* (Yosemite Natural History Association, 1978).

35 Yosemite: Yosemite Natural History Association, 1981.

Tec-hee-nah where he was going. He said that late in the afternoon she was to leave the acorn granary and go to the foot of the great bluff east of Yosemite Falls to watch for him.

Said Oo-pooh, "When I have finished hunting I will shoot an arrow down to you. For each deer I have killed I will cut a notch in the arrow. Then you must send me one man for each deer."

Oo-pooh had good luck in hunting and killed seven deer. He came to the edge of the great granite wall to shoot the arrow. When he released it, the bow string broke and the arrow fell down the face of the bluff and lodged in a crevice. It is there to this day and is known as The Lost Arrow.

Oo-pooh waited a long time but no one came. So he hurried down before dark and found Tec-hee-nah waiting for him. He was very thirsty and told her to bring him a basket of water from the river. As it was evening he thought that Poo-coo-yah would not see her.

Across the valley Yah-nah was still watching. He called across to Poo-coo-yah, telling what had happened.

Tech-hee-nah ran to the river and dipped up a basket of water. It was full of Water Snakes. Poo-coo-yah had placed them there. Thought Tec-hee-nah, "I will go farther up-stream. Perhaps there will be no Water Snakes there."

Again Tec-hee-nah dipped her basket and again she found the Water Snakes in it. But there were not so many this time. "So," thought Tec-hee-nah, I will go still farther up-stream and there will be no Water Snakes at all."

Going close to the foot of the Yosemite Falls, she dipped her basket for the third time and this time there were no Water Snakes in it. But just as she lifted the basket from the stream Poo-coo-yah drew her into Yosemite Falls and kept her there for a long time.

Finally Tec-hee-nah came from the falls. She had with her a little child, son of Poo-coo-yah. He told her not to tell where she had been or he would destroy all of her people. But her father asked her many times and finally she told him. All of this time the Frog Watchman had seen and heard everything. He called to Poo-coo-yah and told what had happened.

The wrath of Poo-coo-yah was terrible. He raced through Ah-wah-nee and destroyed all of the acorn granaries and all of the Indians. He grasped Tec-hee-nah and again drew her into the Falls. There she stays to this day. Sometimes the wind brings the sound of her crying down to us, but she never comes out of the place where Poo-coo-yah made her prisoner long, long ago.

Neither Bunnell nor Ayres nor Weed lived in the valley. They came when the weather was fine and left before winter

arrived. Nor did they make a living there. In Yosemite they gathered a harvest of words and pictures that they sold on the San Francisco book and art market. Since they were having extraordinary experiences on extraordinary excursions into regions far from home, they picture Yosemite, understandably enough, as an extraordinary place, a church, even heaven itself. The legends of the Ahwahneeches, on the other hand, reflect the everyday life of a people for whom Yosemite is home. Domestic tensions arise from intertribal marriage with the Mono Indians. Insuring that a daughter remain chaste by becoming an overprotective father is dangerous, both for the daughter and for the tribe. Droughts and floods are ever-present threats. One of the serious purposes of the legends is to teach young Ahwahneechees how to behave in this homeland. The legends of Pi-wy-ack and Pohono, for example, teach that waterfalls are places where powerful forces reside, forces that must be recognized and respected. A serious purpose did not, however, preclude a lighthearted treatment of Yosemite The story of Half Dome originating from a basket-throwing quarrel between husband and wife is hilarious. The moral of this tale seems to be: act civilly toward one another or the gods will turn you into stone. It is hard to imagine Bunnell making up such a story.

When the responses of the Ahwahneechees to Yosemite are placed opposite those of the earliest "tourists," fundamentally different ways of treating the valley emerge: as home vs. a special, even sacred place; as ordinary vs. extraordinary; as permitting lightheartedness vs. preferring great seriousness. In coming chapters we will see how each of these ways gives rise to its own kind of art.

1 Joseph Walker's party crossing the Sierra in 1833 possibly looked down into Yosemite from the north rim, and in 1849 W. P. Abrams and U. N. Reamer, as they

The husband carried a roll of deer skins on his back and held a staff in his hand. Tis-sa-ack had a baby cradle in her arms and a pointed carrying basket on her back.

When the travelers came to where Mirror Lake is now, the new husband quarreled with Tis-sa-ack. She wanted him to return with her and live at Mono Lake. He said that there were no oaks or other trees there. Said she, "I will take acorns and seeds along and we can plant trees." But her husband would not listen to her plea.

Finally Tis-sa-ack began to cry and ran back along the trail. Then the husband became angry. He cut a green limb and ran after his run-away wife, beating her severely.

Tis-sa-ack also became very angry at her husband and threw the carrying basket at him. This basket turned to stone and became Basket Dome. Still running, Tis-sa-ack threw the baby cradle at her husband. It also turned to stone and became the Royal Arches.

Because of their anger both Tis-sa-ack and her husband were turned to stone. The husband became North Dome, and the wife became Half Dome. The Mono women bob their hair and cut it in bangs. Half Dome looks just like the head and shoulders of a Mono woman.

Since the quarrel, Tis-sa-ack has always been sorry. The old Indians say that the tears she shed formed Mirror Lake. You can still see the marks of these tears where they ran down the face of Tis-sa-ack.

I also like a variant of this legend. According to it the wife, despite the fact that she carries most of the weight, far out-distances her husband on the journey from Mono Lake to Ahwahnee. The trail is hot and dusty and on arriving at Mirror Lake she drinks it dry. Her husband also arrives thirsty, but no water is left for him to drink. His frustration precipitates the quarrel between them.

The Legend of Tu-Tok-a-Nu-La and Tis-Sa-Ack

(abridged)

The chief of the Ah-wah-nee-chees had a son. The people wanted him to become a great chief, so he was wrapped in the skin of the grizzly bear, that he might grow up fearless and strong.

When he grew to manhood he was the beloved leader of all the people. They prepared him a lofty throne on the great rock which guards The Gateway of the Valley, and he was called Tu-tok-a-nu-la, after the great cranes that lived in the meadow near the top.

One day Tu-tok-a-nu-la saw approaching his valley a strange people, led by a maiden of exceptional beauty. He called to them and the maiden answered him, saying, "It is I, Tis-sa-ack. We have come from the land of my people in the far south." Tu-tok-a-nu-la welcomed the visitors and had prepared for Tis-sa-ack a home on the summit of the great dome at the eastern end of the Valley. He visited her often and begged her to become his wife. But she denied him. And when he became importunate in his wooing, she left her home in the night and was never seen again.

When the great chief knew that she was gone, a terrible loneliness came to him, and he wandered away in search of her. He forgot to call upon the Great Spirit to send the timely rains. The streams grew smaller and finally became dry. The crops failed.

The Great Spirit became very angry with Tu-tok-a-nu-la. The earth trembled with his wrath so that the great dome that had been the home of Tis-sa-ack was destroyed and half of it fell into the Valley. The melting snows came down into the Valley in a flood and drowned hundreds of people. But the wrath of the Great Spirit was quickly spent. The floods receded, the sun shone, and once more peace and calm reigned over Ah-wah-nee.

When the Valley was once again clothed in beauty, there appeared on the broken face of the dome the beautiful face of Tis-sa-ack. At the same time there appeared on the face of the great rock supporting his throne the majestic figure of the great chief, dressed in a flowing robe and pointing a finger to where he had gone, to El-o-win, the happy land beyond the setting sun.

The Legend of the Lost Arrow

A long time ago there lived a beautiful Indian maiden. Her name was Tec-hee-nah. She was so beautiful that Oo-pooh, her father, was afraid that she would be stolen by Poo-coo-yah, the Evil Wind Spirit, who lived in Yosemite Falls.

So Oo-pooh had kept Tec-hee-nah shut up in the acorn granary ever since she was a little girl. But the Evil Wind Spirit had planned for many years to catch her and had Yah-nah, the Frog, keeping watch for him from the Cathedral Rock across the Valley.

One day when Tec-hee-nah was a beautiful girl, Oo-pooh planned to go to the top of the Yosemite Falls and hunt for deer. Before he left, he told

Plate 8. Hans Burgkmair the Elder. *The Altarpiece of St. John* (Central Panel). 1518. Alte Pinakothek. Munich.

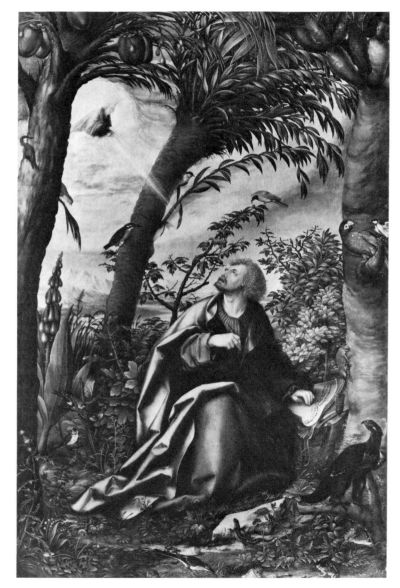

translates its Greek and Hebrew into English, except that he is reading Yosemite instead of Genesis and translating what it says not into words but into pictures, using the vocabulary of paint.

Perhaps Bierstadt's translation of Nature's message is clearest in a painting of the Wind River Mountains entitled "Horse in the Wilderness." (Plate 7) Once again light is the dominant element in the painting and the question is, what meaning does this light have. A comparison of Bierstadt's painting with "The Altarpiece of St. John" by Hans Burgkmair the Elder (Plate 8) and "Voyage of Life: Old Age" by Thomas Cole (Plate 9) provides an answer. Already in the sixteenth and seventeenth centuries European artists were putting in the upper left hand corner of some of their paintings sunlight streaming magnificently out of mountain clouds, and were

Plate 9. Thomas Cole. *Voyage of Life: Old Age.* 1840. Oil on canvas. 51¾ × 78¼ inches. Munson-Williams-Proctor Institute, Utica, New York.

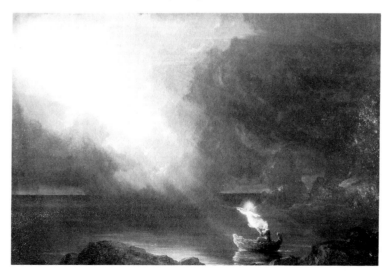

making this light symbolic of God and his favor. Sometimes they even painted a little man in the center of the light to make absolutely sure we recognized God as the source of the light. A few years before Bierstadt painted "Horse in the Wilderness," Thomas Cole, the most famous American landscape painter of the time, continued this European tradition in a sequence of paintings on the "Voyage of Life," the last of which was "Old Age." In his painting also, the sunlight symbolizes God's radiance and forms a pathway to heaven, down which come dove-like angels to escort the soul to its ultimate home.

One of the most interesting ways of studying art is to notice which conventions an artist chooses and then to analyze what changes he makes in them. By these changes he is able to communicate his own special meanings. Thus, if we can say why Bierstadt chose to use the convention of mountain sunlight and also make sense of the changes he made in this convention, then we will know what meaning the sunlight had for him. This knowledge will in turn tell us how he has translated nature's scripture. Unfortunately, no record exists stating his intentions. He traveled extensively in Europe between 1853 and 1857 and probably saw use of this convention by European masters. Back in New England he worked among painters whose mentor was Cole, so almost certainly he knew how Cole continued the European tradition. Circumstantial evidence, then, is strong that he was aware of this convention and used it consciously. Nevertheless, in the absence of recorded statements, we are left to infer his reasons from the painting itself and from the rest of his life and work.

By modeling the light in "Horse in the Wilderness" after the European masters and Cole, Bierstadt, I think, wants to assert that the light in his painting, like the light in theirs, is divine. But note that he has made the sunlight, the clouds, and the mountains completely natural; many of us have actually witnessed scenes like the one in his painting. A change from supernatural to natural is, then, the first change he makes in the convention. By it he is saying that the divine can be discovered in nature itself. Not only does God reveal himself in a supernatural way through special people like St. John, but also he makes himself known in a natural way at special moments and in special places in the wilderness.

The second change concerns the horse. In the painting by Burgkmair a human being occupies front and center position and the light from the heavens shines on him. This light is a sign of God's approval and, moreover, implies that we must go to him to receive revelation. But in Bierstadt's work revelation comes directly to us from nature and need not go through a special person. Thus, for the people he substitutes a horse. To put it in the foreground, however, and to have the light shine upon it would imply that we should look directly at the horse in order to see the revelation. Such a move would exalt the horse above the glory of the mountain scenery. So he moves it back in the shadows, and makes it and the freedom it stands for a part and only a part of the whole message the wilderness has for us.

To sum up, Bierstadt sees the divine written in nature's scripture, and his painting translates this "word" into paint so that we too can "read" the message. Given the meaning of sunlight in "Horse in the Wilderness," we can understand more fully Bierstadt's use of the sun as the center of many of his Yosemite paintings. The divine sun spreads its heavenly light over the entire landscape, and by making us look directly into it Bierstadt is helping us "see" this divine presence. Yosemite, like the mountains in "Horse in the Wilderness," is one of those special wild places where divinity is made known through nature.

During his later years Bierstadt's portrayal of Yosemite became more and more formulaic. Water and deer in an idyllic foreground, a dramatic waterfall tumbling over steep cliffs in the middle distance, and ever more tumultuous clouds over all. Finally, his liberties became outrageous. Yosemite became unrecognizable. Anything grossly exaggerated tends to evoke laughter, and some of Bierstadt's later Yosemite paintings do just that. Clearly the danger of trying to boost an already grand nature is that one may appear ludicrous.

The Yosemite painter who most successfully kept himself balanced between seeing and vision was Thomas Hill. Born in England in 1829, Hill came to New England in 1844 and to California, seeking a milder climate for reasons of failing health, probably in 1861.[4] The very next year he made his first trip to Yosemite, and he returned several times before he left in 1866 to spend a year in Paris and four years in Boston. While in Boston he finished two six-foot-by-ten-foot paintings of Yosemite, both of which were based on sketches made in the early 60s. The first, entitled "Yo-Semite Valley," completed in 1868, was immediately hailed as a masterpiece, and was eventually sold to railroad magnate Charles Crocker of San Francisco for $10,000. It is no longer extant and is presumed to have been destroyed in the 1906 earthquake. The second, "Grand Canyon of the Sierras," was finished in 1871 just before Hill returned to California in hopes that its climate would once again restore his health. Crocker's brother, Judge E. B. Crocker, purchased this one, which now hangs in the Crocker Art Museum in Sacramento.

Hill's return to San Francisco coincided with the beginning of a decade of prosperity for that city, due in no small measure to the opening of the trans-continental railroad in 1869. To furnish their mansions the wealthy bought art, and luckily for Hill, paintings of Pacific Coast scenery were in great demand. Famed for his ability to paint rapidly, he produced and sold at handsome prices canvas after canvas. During these years Yosemite became his favorite subject.

Hill's sales fell off sharply in 1879 with the onset of an economic depression in California, and gradually his popularity and health followed suit. As he once had left New England for California to restore his health, he now for the same reason forsook San Francisco for long summer vacations in Yosemite. He opened a studio in Yosemite Valley in 1883, only to have it destroyed in a windstorm the following winter. The next summer he spent in Wawona, and, after his daughter Estella Louise married John Stephen Washburn, a proprietor of the Wawona Hotel, he made the hotel his permanent summer residence, wintering in nearby Raymond. In 1886 the Washburns had a three-room studio adjacent to the hotel built for him.[5] In it, though hampered by several strokes, he continued for almost two decades to turn out scores of Yosemite scenes for the tourists, who replaced the wealthy as his principal patrons. On June 30, 1908, he died in Raymond.

Placing a third six-by-ten-foot canvas Hill painted of Yosemite, "Yosemite Valley (From below Sentinel Dome, as Seen from Artist's Point)" (Color plate 5) next to Bierstadt's "Valley of the Yosemite" (Color plate 3) makes clear several differences between the two painters. One has to do with light. In Bierstadt's painting the rocks, river, and clouds are like supporting actors in the drama of the setting sun, which as leading actor occupies center stage. On Hill's canvas, however, the sun hardly makes its presence felt. Everywhere is the Yosemite haze, which scatters the sunlight into millions of indistinct, blue rays, making shadows indefinite and causing the valley to glow as if it were the source of its own light. Instead of Bierstadt's strong, directional light Hill has a soft

light coming from all directions at once.

Hill uses this light to illumine every feature of the valley, beginning with El Capitan and Bridalveil Fall in the middle distance, proceeding next to Sentinel Rock, the Royal Arches, and Half Dome, and then on to Cloud's Rest and the Sierra crest in the far distance. Moreover, and here is a second difference between the two painters, Hill is faithful to every cliff down to the seams in its face and the position it occupies relative to the other cliffs, whereas Bierstadt, because he is most of all interested in staging the sun's dramatic evening entertainment, feels free to move the cliffs around and exaggerate their height. A photograph taken from where Bierstadt stood would reveal the liberties he took. A photograph from where Hill stood would reveal a Yosemite virtually identical to the one he painted.

This is not to say that Hill's aim is photographic realism. He, like Bierstadt, wishes to convey the impact that Yosemite has on the feelings of the viewer. A large part of that impact has to do with grandeur. The fact that Hill chooses a six-foot-by-ten-foot canvas shows his intention. Both painters dramatize. Perhaps the major difference between them is this: it is the valley itself, in all its height, width, and depth, and not the sun, that is Hill's main concern. So he has staged the drama of Yosemite Valley using its own haze as lighting, whereas Bierstadt has put on a drama of the sun with Yosemite cliffs as props.

It is probably also significant, as a third difference between Bierstadt and Hill, that the latter chooses to place in the foreground of his painting tourists rather than animals. Although Bierstadt's deer are a natural part of Yosemite, they actually function more as symbols of innocence. In none of Hill's paintings of Yosemite is there even the slightest hint of religious symbolism. Over and over again he depicts it as a real

place, a particularly beautiful real place, to be sure, but nevertheless a place on this same old earth that we have known all along.

A fourth difference between the two painters deserves mention. Bierstadt's paintings are characterized by "tight" drawing and brushwork and carefully filled in, or "worked up," details. For example, individual leaves are often separately drawn and are so accurate anatomically that species of trees are distinguishable. And people and animals are so fully drawn that a magnifying glass reveals eyes, noses, and mouths of individual faces. Such work, of course, must be done painstakingly with small brushes and meticulous brush strokes. And a painting executed by these methods has such a fine resolution that, even at fairly close range, the brush work of the painter disappears and the scene painted seems almost real.

At the beginning of his career Hill painted in this same way. But in Paris in 1866-67 he began to make broader strokes with bigger brushes and to give the impression of objects without "working them up." He once gave this advice to his son Thomas Virgil Troyon Hill, also a painter:

Don't paint paws on your figures, a dab of color is enough.... Accidental effects can only be gotten with a big brush, I depend entirely on accident—you have no idea how much is produced that way.... It is not necessary to work the cattle up they are only for effect—dabs of color [will do].[6]

In "Yosemite Valley" he uses both styles, a "tight" or realistic style for the foreground and a "broad" or impressionistic style for the background. A close-up of the cliffs in the middle distance (Plate 10) reveals that he has applied dabs of color next to each other, not to delineate the structure of the rock, but to give the impression of the effects of the haze. He is

Plate 10. Thomas Hill. *Yosemite Valley* (close up). From a 35 mm photograph taken by David Robertson.

extremely good at this sort of thing, his rendition of the haze being remarkably "true to life." Here we seem to arrive at a paradox: impressionistic methods result in a realistic picture. But the paradox is only apparent. The haze really does blur distant objects in Yosemite, so that Hill's "dabs of color" technique is well suited to catch this effect.

In other words, Hill's styles in "Yosemite Valley" are two but his aim is one: realism. In the 1880s and 1890s, however, his very aim becomes impressionistic: to give a more fleeting, less solid impression of the valley at any given moment. Clearly his aim has changed because now entire paintings (with the curious exception of the people, who continue to be "worked up" rather meticulously) are done with broad strokes of a big brush. "Scene of Lower Yosemite Valley from below Sentinel dome" (Color plate 6) is an excellent example of Hill's

later, more impressionistic work. In this painting Cathedral Rock (the large cliff on the left) is made not out of granite but out of about a dozen well placed, broad brush strokes. Once, in a note made in his Bank of California passbook while attending the World's Columbian Exposition in Chicago in 1893, Hill severely castigated the French Impressionists:

Of all the nations represented I like the German paintings best—the Germans are conscientious workers that try to paint nature as we see it. Other schools like the French, merely give you a suggestion, an impression of the Thing which the observer must complete according to his own taste. This they call poetic Art. I call it *Rott* [sic].[7]

Nevertheless, scores of paintings Hill himself did in the last decades of the nineteenth century show beyond doubt that he was heading in a similar direction.

In 1888 William Keith, the third member of the trio of early great Yosemite painters, gave a lecture on painting at the University of California in Berkeley. In it he compares the career of an artist with the life of an individual:

I often think that an artist's experience consists of three states, just as in life there are the three states of childhood, youth and manhood. The first state—the young painter is full of ideas and vague feelings, but he cannot express himself, in the second state, he gets down to hard work and in the pursuit of knowledge he accumulates all kinds of facts, and gradually the knowledge and the facts crowd out the vague and mysterious impulses and feelings, and here is where many stop. The next state is when there is a return to the state of feeling but with the increase of knowledge which gives him the power of expression.[8]

Without doubt he has his own career in mind, for he continues:

For sometime back I have been laboring hard to get into the third state where I can express myself, subordinating the lesser to the greater.

He probably considered the decade in San Francisco, 1859-69, as his artistic childhood. He began it as an engraver, a profession he learned in New York, where his family had settled in 1851 after emigrating from Scotland. But by the mid-sixties he had begun to feel that engraving was a corset around his imagination and turned to painting. During the late '60s he toured northern California and the Pacific coast, including a visit to Yosemite in 1868, making sketches for a series of landscape paintings he exhibited in San Francisco in 1869. Although to twentieth century viewers these paintings often possess a naive charm, it is understandable why Keith felt that they were "full of ideas and vague feelings" imperfectly expressed. At the conclusion of the exhibition the paintings were sold at public auction, and Keith and his wife used the proceeds to travel to Düsseldorf.

This trip marks the beginning of the second stage of his career, the period, lasting for a little over a decade, when he not only "accumulate[d] all kinds of facts" but also sharpened his skills as a painter. The "facts" he is talking about are the facts of nature, and he learned many of them on high Sierra trips with John Muir after he returned to California in 1872. The two first met that year when Muir took Keith to Tuolumne Meadows and up the Lyell Canyon in search of the glories of the California Alps.[9] Muir was a naturalist: he had taught himself to note precisely and accurately the facts of nature. Not surprisingly, therefore, he liked paintings that were scrupulously faithful to nature. The painters at Düsseldorf had already headed Keith in the direction of meticulous realism, and his friendship with Muir made him want to continue down this path.

Most of Keith's Yosemite canvases were painted during this period. "Sentinel Rock, Yosemite" (Color plate 7), executed on or immediately after returning to his studio from his 1872 trip with Muir, is typical of the way he paints the valley. Often, as in this picture, the foreground is a small, intimate opening along the Merced River, where people are engaged in rather casual activities. A group of trees, all accurately rendered, defines the edge of the enclosure and by blocking off access to the course of the river upstream keeps the attention of the viewer on the activities in the foreground. Above the shadowed enclosure rises one of the valley's sunlit cliffs, here Sentinel Rock. The eye jumps dramatically above the trees to this cliff, whose height is further emphasized by the vertical frame.

"Mt. Lyell, California Sierra" (Color plate 8) is typical of the way Keith paints the high Sierra. Once again the foreground is an opening on a river, this time the Tuolumne, where an Indian village is situated. In the middle distance the sides of the canyon descend to a V, focusing our attention on Mt. Lyell, rising majestically in the far distance. In painting after painting of the high Sierra Keith follows, with minor variations, this same compositional formula. That he is recording the way high Sierra valleys and peaks actually look makes it no less formulaic.

In all of his pictures of the 1870s Keith was painting in the tradition of grand realism. Subject matter, faithfully and meticulously depicted, took precedence over the more painterly elements of form and color. He was rendering what his eyes saw rather than what his inner eye envisioned. By the 1880s he had so painted himself into a realistic box that his imagination had little room to express itself. As he gives his lecture at Berkeley he is standing on the threshold of his third period, looking forward to it and looking back not too happily on his second. He believes he has paid so much attention to facts that they have crowded out of his paintings the "mysterious impulses" he feels. "Nature is so rich and so

compelling" that it has "tyrannize[d]" him. Once he thought "that the only way to paint is to paint directly from nature;" now he believes:

It is not all you see before you that is the valuable thing, but it is what is behind, the personality of the artist. Just in the same way, a sketch with its varyings and uncertainties makes it more interesting than when carried further in detail.

Not only did Keith feel that tyrant nature was infringing on his artistic right to express himself; he also came to see more and more clearly that what he had been trying to do—copy nature—was impossible:

Art has its limitation and in imitating nature the artist is at the greatest disadvantage because he is trying to do the impossible.

As an example Keith brings up the subject of Yosemite:

There are many pictures painted of Yosemite (I have perpetrated several myself—am sorry—I won't do it again) but did you ever see one that gave you the true impression? There you have in summertime a constantly blue sky, then you have a large mass of purplish gray rock cliffs and a mass of dark green—if you paint in the morning and face the sun—In the evening you paint with your back to the sun—what have you?—the same mass of sky, cliffs, and foliage, but out of all proportion to make a harmonious whole. You say that in nature it looks beautiful and why not when painted?

There is a sameness about Yosemite—blue sky, dark green foliage, gray rocks—which becomes monotonous if viewed in painting after painting. Moreover, Yosemite's proportions are so prodigious that the realistic painter is hard put to scale them down to even a large canvas without producing gross distortions. As Keith puts it: "What I wish to make clear is that there are certain things in nature not to be painted so as to make an agreeable whole."

Albert Bierstadt responded to Yosemite by trying to outdo nature, and his paintings, though sometimes successful, are too frequently grandiose instead of grand. William Keith responded to Yosemite by trying to duplicate it, and his paintings, though sometimes successful, too frequently resemble reduced copies of the original. Some of the information in the original has been lost and much of its power. Keith's own personality and vision might have made up the difference, but he has supplied too little. Consequently, his paintings of Yosemite often are not interesting enough in and of themselves.

In order to get more of his personality into his paintings Keith, in his third period, his artistic "manhood," turned to smaller, more subtle, and more intimate landscapes:

When I began to paint, I could not get mountains high enough or sunsets gorgeous enough for my brush [and colors]. After a considerable number of years' experience I was contented with very slight material, a clump of trees, a hillside and sky. I find these hard enough and varied enough to express any feeling I may have about them.

Best of all he liked the oaks and pastures, the streams and hills of the coastal mountains around San Francisco Bay. His brushwork became more and more free; form and color became more important than subject matter. With this more impressionistic, more abstract style he was able to express the mysteriously romantic, often melancholy feelings he had about nature (Plate 11). Many of his friends who had liked his realistic paintings, including Muir, were unhappy over this new direction, but Keith defended himself: "Some good friends may think that I am going too far, but I know that I am on the

Plate 11. William Keith. *Secluded Grove.* 1898. 12¼ × 16¼ inches. Oil on canvas. Collection of Saint Mary's College, Moraga, California.

CHAPTER THREE

Early Literature

IN MANY RESPECTS James Hutchings and John Muir, Yosemite's most important early writers, were much alike.[1] To begin with both came from the British Isles. Hutchings was born in Towcester, England, on February 10, 1820, Muir in Dunbar, Scotland, on April 21, 1838. Both left for the United States in the late 1840s: Hutchings without his family in 1848, sailing to New York and, after an intermediate stop in New Orleans, continuing overland to California as part of the gold rush in 1849. Muir's entire family took the trip. One evening in February, 1849, his father, Daniel, suddenly announced to his children, "Bairns, you needna learn your lessons the nicht, for we're gan to America the morn!"[2] Across the Atlantic, up the Hudson, through the Erie Canal, around the Great Lakes they went from Glasgow to Milwaukee by boat, finally settling inland near Kingston in Marquette County, Wisconsin.

Both Hutchings and Muir were adept with their hands, Muir spectacularly so. Hutchings learned carpentry from his father and intended to practice that trade in the States. In his diary he tells of making benches and of helping the ship's carpenter, and later, on the overland journey, he was hired as a wheelwright by an army pack train. After he settled in Yosemite Valley in 1864 as proprietor of the "Upper Hotel" (soon to be known as Hutchings' Hotel) he added onto the back of the hotel a combination kitchen-sitting room and says that he constructed the fire place, complete with cranes and Dutch ovens "with my own hands."[3] A little later, with the help of James Lamon (pronounced "lemon"), Yosemite's earliest settler, he built a log cabin for his family on the sunny north side of the valley. Remnants of the orchard he planted nearby can still be seen below Yosemite Falls.

Muir's manual dexterity and inventiveness are legendary. As a teenager he rigged up an alarm clock, an "early-rising machine" he called it, with parts whittled out of hickory wood, that would tell time, strike the hours, and by means of levers and cogwheels wake him by standing his bed upright.[4] An exhibition of some of his wooden mechanical wonders at the State Agricultural Fair in the fall of 1860 brought him instant fame and turned his attention away from his father's farm and eventually to the University. There, under the tutelage of professors like Dr. Ezra Slocum Carr, who later taught at the University of California, Berkeley, he received a brief but sound education in the fundamentals of science. Carr's wife, Jeanne, became Muir's lifelong friend and literary benefactor. Muir's ingenuity also secured for him a job and rapid advancement with a firm manufacturing carriage parts in Indianapolis, and he seemed headed for a prosperous career as inventor and businessman. While he was adjusting a new belt, however, the file he was using accidently flew up and pierced his right eye. An assistant standing close by heard him say, "My

4 For biographical information on Hill I have consulted mainly Marjorie Arkelian, *Thomas Hill: The Grand View* (Oakland: The Oakland Museum, 1980).

5 This studio still stands. It has recently been refurbished, including a fresh coat of the awful pink that Hill liked, and is open to the public on a limited basis during the summer.

6 Thomas Virgil Troyon Hill, "Remarks in Father's letters to me" (memorandum book). Quoted in Arkelian, *Thomas Hill,* 36.

7 Quoted in Arkelian, 36.

8 All quotations from Keith's speech are taken from Eugen Neuhaus, *William Keith: The Man and the Artist* (Berkeley: University of California Press, 1938) 49ff. For another version of the speech see Brother Cornelius, F.S.C., M.A., *Keith, Old Master of California* (New York: G. P. Putnam's Sons, 1942) 202ff.

9 See Chapter 3 for Muir's account of this trip.

10 *Alta California,* June 5, 1870.

11 *Alta California,* August 28, 1870.

12 *Granite Crags,* 91.

13 Pp. 282-283.

14 These comments on Gordon-Cumming's ethnography were supplied by Craig D. Bates, Assistant Curator of the Yosemite Museum.

specialist. Consequently, when he came to Yosemite in 1874, what interested him most was the behavior of the tourists. He brought them front and center and spread them out against a backdrop of Yosemite high country. This painting and its companions, one showing the same group on the way to and the other depicting its return from Glacier Point, are major accomplishments in the history of Yosemite art. Already in this early period tourists were an important factor in the park, and Hahn was the first to do more than use them as stock figures to indicate scale.

Constance Gordon-Cumming had in her, by her own admission, a "locomotion demon." Scottish by birth, she spent much of her life roaming the earth in search of its wonders. She wrote a constant stream of letters back to her friends and relatives and later arranged them into a series of travel narratives. Her book about Yosemite is entitled *Granite Crags* and was first issued in 1886. She arrived in the valley in April, 1878, intending to stay only a few days; people in San Francisco had assured her that three days would be ample to "do" Yosemite. She quickly realized how wrong they were. "I have wandered far enough over the wide world to know a unique glory when I am blessed by the sight of one, and the first glimpse of this extraordinary combination of granite crags and stupendous waterfalls showed me plainly enough that it would take me weeks to make acquaintance with them."[12] So she stayed for three months.

During the three months she completed about fifty drawings and watercolors. Responding to local demand she agreed to stage an exhibition before she left. "Having issued a general invitation to every man, woman, and child in the neighborhood, I borrowed a lot of sheets from my landlady, who allowed me to nail them all round the outside of the wooden house. To these I fastened each sketch with small pins, so that the verandah became a famous picture-gallery."[13] Perhaps one of the pictures in her exhibit was "Indian Life at Mirror Lake" (Color plate 11). In it Yosemite is portrayed as an American version of Eden, a western wild place where unfallen Ahwahneechees live an idyllic life. Her painting and Hahn's are poles apart: in his Yosemite is ideal for visiting, in hers it is an ideal place to live. While his tourists survey it from above, her Miwoks carry out everyday chores down below. Her representation of their life is by and large ethnographically correct. The bark-dwelling is accurately depicted, although the cradlebasket is unlike any reported for native American groups in California. The burden basket on the ground near the group was more commonly cone-shaped and the smoke rising from the floor of the home was an unusual occurrence.[14] The painting also faithfully reproduces the topography of Tenaya Canyon. We are on the northwest side of the lake looking east. Mt. Watkins and Point Ahwiyah are in the middle distance and beyond them the great mass of granite below Clouds Rest is visible. The low horizon line accents the height of the mountains, especially Half Dome, which soars off the canvas in a grand thrust upward. Over this realistically depicted scene a hazy morning sun casts softening, warm rays and a low-lying bluish mist, augmented by smoke from the fire, hovers over the far side of the lake. The new moon adds a final touch to the romance of "Indian Life" in idyllic Yosemite.

1 For the biographical details of Bierstadt's life, I am indebted to Gordon Hendricks, *Albert Bierstadt: Painter of the American West* (New York: Harry N. Abrams in association with the Amon Carter Museum of Western Art, no date).

2 Fitz Hugh Ludlow, *The Heart of the Continent* (New York: Hurd and Houghton, 1870) 426.

3 *San Francisco Alta,* August 4, 1867.

right road, as long as I have a widening and deepening love for everything in Nature."

With regard to Keith a question arises that is important for the understanding of all Yosemite art: was it necessary that he change subject matter when he changed his purpose? Surely a theoretical answer would be no. Hypothetically a painter can express his or her personality through any subject matter. But the experience of over a hundred years of Yosemite art indicates that it was much easier for Keith to switch subject matter than to fight the powerful, domineering force of Yosemite. It tends to impose itself on artists; only with the greatest of difficulty do artists impose themselves on it.

In addition to Bierstadt, Hill, and Keith, almost every landscape painter resident in northern California during the 1860s and 1870s exhibited paintings of Yosemite. Among them were Fortunato Arriola, Edwin Deakin, Herman Herzog, Ransom Gillet Holdredge, William Smith Jewett, William Hahn, John Ross Key, William Marple, Gilbert Munger, Carl von Perbandt, Enoch Wood Perry, Julian Rix, the brothers James Davis and George Henry Smillie, Jules Tavernier, Juan Buckingham Wandesforde, Virgil Williams, and Raymond Yelland. In addition, visiting artists, like Thomas Moran, famous for his canvases of Yellowstone and the Grand Canyon, and Constance Gordon-Cumming from England, usually included Yosemite in their itinerary. All worked in the tradition of realism, with varying amounts of talent and success. The three discussed below are not necessarily the best or the most famous, but each arrived at a vision of Yosemite that is arresting as well as personal.

Throughout the 1860s and 1870s in the San Francisco papers critics commented upon the works of California painters. During 1870 two reviews of works by Gilbert Munger, formerly an engraver in Washington, D.C., who came west after the Civil War, are particularly perceptive. One critic says of a Munger painting that it is "the most striking embodiment of quiet."[10] The other, after praising Munger's ability to capture the spirit of the California landscape and the "feeling of nature's handiwork," states, "Munger has come nearer into [the] mysteries [of nature] than any other."[11] These reviewers have noticed what is the most intriguing aspect of Munger's paintings: the quality of quiet and subtle mystery. To return often to a work of art and each time be drawn willingly into its world is surely a sign of quality. I have been innumerable times to the Oakland Museum, where "Yosemite Valley Scene" (Color plate 9) hangs alongside more than a dozen other paintings of Yosemite. I habitually go to it first and spend more time in front of it than before any other painting of the valley, including ones by Bierstadt, Hill, and Keith. Yosemite's massive cliffs are present but in the background, barely visible through the black oaks, the interplay of whose shapes is the main subject. Each tree has an individuality of its own and also fits harmoniously with its companions, making a network of black trunks and limbs silhouetted against the delicate green foliage. Prominent is the play of V-shapes among the trees, beginning in the left foreground and continuing in the grove across the meadow. A marvelously transparent haze pervades the entire painting. Munger's light is reminiscent of Bierstadt's, but softer and less dramatic.

Coming from the typical Yosemite painting to Wilhelm Hahn's "Looking down on Yosemite Valley from Glacier Point" (Color plate 10) is like switching ends of a pair of binoculars. Usually people, if they are present at all, are far away and small, dwarfed by a monumental landscape. Hahn, a native German who met William Keith in Düsseldorf in 1869 and accompanied him to California in 1872, was a genre

right eye gone! Closed forever on all God's beauty!"[5] Shortly after the accident he experienced total blindness, since the injury to the right eye traumatized the left. Unable to see grass and flowers and trees made him realize how little he wished to spend his life inside a factory. He noted that "God has to nearly kill us sometimes, to teach us lessons."[6] Fortunately, sight eventually returned to both eyes.

Both Hutchings and Muir were writers. Hutchings, immediately after his arrival in California, went to Hangtown (modern Placerville) to try his hand in the "diggings." He was successful enough to deposit a sizable sum with a private bank in San Francisco, but the failure of the bank plus the overall difficulty of the work in the mines made him want to return to his first love, traveling. (A deep and insatiable "wanderlust" was another trait he shared with Muir.) The popularity of a parody of the 10 commandments he wrote in 1853, called "the Miner's 10 commandments," made him realize that he could make a living writing and publishing. He conceived the idea of issuing an illustrated magazine on California life and scenery, and began two years of traveling around the state collecting material, all the while selling engraved stationery to make ends meet. Although he himself apparently drew some of the sketches and took some of the photographs used by the engravers, his more usual practice was to hire a trained artist or photographer to accompany him. In the summer of 1855 he hired Thomas Ayres for this purpose, and the two made their historic journey to Yosemite in July. The first issue of his magazine came out in July of 1856, with the lead article on Yosemite. Hutchings had not only found his calling but his principal subject.

Although Muir was a faithful keeper of diaries and writer of letters, he was not an author by preference. He was pulled into it by the rope of causes he believed in. One cause was glaciers. Josiah D. Whitney, Yale graduate, California State Geologist and eventually Harvard professor, claimed in his *Yosemite Guide-book*, published in 1869:

The bottom of the Valley sank down to an unknown depth, owing to its support being withdrawn from underneath during [a] convulsive movement [of the Sierra Nevada]. . . . A more absurd theory was never advanced than that by which it was sought to ascribe to glaciers the sawing out of those vertical walls and the rounding of the domes. . . . There is no reason to suppose, or at least no proof, that glaciers have ever occupied the Valley, or any portion of it . . . so that this theory, based on entire ignorance of the whole subject, may be dropped without wasting any more time of it.[7]

Whitney's remarks were directed at Clarence King, whom we will meet later in this chapter, and who as Whitney's employee on the State Geological Survey first suggested that glaciers were significant factors in giving the valley its shape.[8] After Whitney's blast, King, although he had observed unmistakable signs of glaciers, obeyed his master's voice and dropped the matter. King's retreat left the field of battle open for Muir to enter playing David to Whitney's Goliath.

Muir also believed in the cause of trees and meadows. He saw that unless something were done sheep and cattle would reduce the Sierra Nevada's grasslands to stubble and timbermen would decimate its forests. So, beginning in the middle 1870s and continuing for the rest of his life, he wrote article after article supplying information on wilderness areas and advocating a policy of protection. *The Mountains of California*, issued first in 1894, is a compilation of many of these articles.

Both Hutchings and Muir were intrepid mountaineers with physical constitutions that could endure excruciating punishment. Muir's exploits are by now the stuff of legends. Of a trip he took in the Yosemite backcountry in 1895, at the age of 57, he writes to his wife:

I had a hard time and a good time.... I started with provisions for two weeks, but after breaking my way for a few miles through the rocks and brush, I found that it was too heavy and bulky and so had to throw half of it away. Somehow I couldn't eat much, only a handful of crackers and a bite of chocolate, no matter how hard I scrambled, so I threw away half of what was left when I was about the middle of the canyon.... The weather was hot during the day and I soon was very tired, and carried that extra thick suit of underclothing to draw on at night because I had no blanket, but I abandoned it also and got along better, though of course cold at night....[9]

For recklessness and stamina Hutchings ran Muir a close second. His trip into the valley from Wawona in the winter of 1862, undertaken so that he could find out if it were inhabitable during the winter months, was a notable achievement, not only because he had to push through barrier after barrier of snow, but also because he had to overcome the barrier of fear that his friends had erected in their efforts to dissuade him.

Furthermore, the religious backgrounds and orientations of the two men were strikingly similar. Both came from traditions that were Puritan in doctrine and discipline and encouraged iconoclastic dissent from accepted beliefs and practices. Moreover, both ended up devotees of their own idiosyncratic forms of nature mysticism, in which nature rather than scripture, priests, or the church, was the principal intermediary between God and Humankind. Hutchings may actually have belonged to the Anglican church before he left England, but his beliefs and attitudes as revealed in his diaries were Protestant to the core. On board ship he noted that "no song of Zion" was sung; so he decided to "raise a public service."[10] A sizable congregation attended the initial effort, with Hutchings announcing the hymns and reading from scripture. The following week he "took [his] old Sabbath-school bible and with the capstan as a pulpit addressed the people"[11] but two weeks later abandoned the whole project

when he heard "that the two who had taken the lead in singing had been using bad language." He was afraid to continue the services because these two reprobates might "come uninvited, and disgrace the cause."[12] Once in New York he put church after church to the test of how well the gospel was preached, and continued that practice throughout his travels in California. His standards were strict; he found most of the sermons wanting and gradually became "weary of common place preaching and church going."[13] To churches made with hands he preferred "God's own temple,"[14] nature. While near Shasta on a Sunday late in 1855, thinking of his religious past in England, he wrote, "the peaceful solitude of a mountain side, in this land, is *my church* [italics his].[15]

John Muir's father, Daniel, was a hardcore Protestant: protest your unhappiness with one religious group by leaving it and joining another. Fired by the idea of the equality of all men before God, he left his Presbyterian Church, with its doctrine of election, and tried one sect after another in search of a more democratic religion. Perhaps one reason he had difficulty finding it was the autocratic dogmatism he himself practiced. John, while far more lovable and loving than his stern father, caught the spirit of dissent from him and exercised it in precisely the way one would expect: he rebelled against his father's religion. He rejected orthodox Christian belief in favor of a variant of Emerson's Transcendentalism, according to which God, Man, and Nature are a part of each other and together share a cosmic harmony of purpose and destiny. Muir was not a traditional theist (one who believes that God and Nature are distinct entities). Nor was he a Pantheist (one who believes that God and Nature are identical). Theologians would probably classify him as a Panentheist, that is, one who asserts that God dwells in Nature but is not limited by it. Whatever labels are attached to him,

essentially he took his father's Christian religion and substituted nature for the place and role of Jesus Christ: it is nature that partakes of divinity, it is through nature that human beings have access to God, it is by nature that they are redeemed from sin, which for Muir was roughly equivalent to city living.

Of course, Muir and Hutchings were also alike in that Yosemite was the hub from which the spokes of their lives radiated. Hutchings came first in 1855 with Ayres, then with Weed in 1859, then in the winter of 1862 to see if the valley was inhabitable during the coldest months. Having found that it was, he brought his family in 1864, and, with his mother-in-law as cook and housekeeper, ran the Upper Hotel until 1875, when he was expelled from his illegal land holdings by the State Commissioners. He returned triumphantly in 1880, after a new Commission elected him Guardian of the valley. His tenure lasted only four years, however, and after that he lived mostly in San Francisco. In 1901, while entering the valley on the old Big Oak Flat Road, he was thrown onto some rocks and killed when a horse pulling his buggy bolted. The man who made so many famous entrances to Yosemite died, appropriately enough, on its threshold.

Muir's first entrance was not until 1868. After the errant file cast the die of his life, he headed for the gulf states with the intention of traveling eventually to South America. Bouts with malaria, however, changed his mind about that, and news of Yosemite helped turn him toward California. His appetite whetted by the initial visit in 1868, he returned the next year, first as sheepherder in Tuolumne Meadows and then as sawyer to the enterprising Mr. Hutchings. This position he kept for about two years, until dissension with Hutchings and his desire to wander over the mountains in search of glaciers made any regular job seem like fetters on his feet. Until 1874 he lived mostly in Yosemite, with occasional visits to the civilized but sense-dulling world outside. After that year, just the reverse was the case: he lived outside, from 1880 on in Martinez with wife and family, but returned periodically to the sanctum sanctorum of the Sierra. He lobbied in the early 1890's to have "all the Yosemite fountains" included in a national park; then in the middle nineties he began a campaign to have the State grant of Yosemite Valley and the Mariposa Grove receded to the national government so that it too could be included in the National Park, a battle he eventually won. After the turn of the century came a battle he eventually lost—the struggle for Hetch Hetchy. When San Franciscans realized that their city was destroyed in 1906 more by lack of water with which to fight fires than by earthquake, they began to dream of the Hetch Hetchy Valley, that other Yosemite, full of water. In December of 1913 President Wilson signed the bill to make their dreams come true. Muir's death came a year later, on December 24, 1914.

With so many traits in common, why did Muir and Hutchings dislike each other so? Maybe there is human truth in the electromagnetic law that opposite poles attract and identical poles repel. Maybe Hutchings was jealous of this new kid on the block. In 1869 Hutchings was 49, Muir 31, so a rivalry between the younger and the older generations may have been involved. Hutchings' wife was 27, closer in age and inclination to Muir than to her husband. Muir and she often hiked and botanized together, and rumors spread of an affair between them. Probably most threatening of all to Hutchings was Muir's popularity as a guide. Until the late 1860s Hutchings was Mr. Yosemite, the one sought after by visitors. His knowledge of things natural was about as extensive as Muir's though he never engaged in an active attempt to solve scientific problems. He was eloquent and enthusiastic. But

Muir's friend and promoter, Mrs. Carr, knew the important scientists and people of letters both in San Francisco and east of the Rockies, and she directed the likes of Professor Joseph Le Conte of the University of California and Ralph Waldo Emerson to Muir. As long as he worked for Hutchings everyone seeking him made inquiry at Hutchings' Hotel. It is rather easy to sympathize with Hutchings in this situation.

Their attitudes toward the land were also very different. From the moment Hutchings entered the valley as a hotel proprietor, he staked land claims that were in direct conflict with the grant by which the national government gave Yosemite to the state of California. In other words, he saw Yosemite not only as the temple of God but as his private property, with scenery that he could mine for more gold than he could ever dig out of the Sierra foothills. Muir saw Yosemite as the temple of God, period. One could no more own it than one could own a church. In it all people had access to the Universal and the Eternal. To own it or to exploit it, whether for land that sheep might graze or for water a thirsty city might drink, was sacrilege. Once again, it is easy to sympathize with Hutchings, for in America in the 1860s Muir was the one out of step.

Thus, given these differences and given what was at stake between them—will Yosemite be a private reserve or a national preserve—it is not surprising that these two men, despite all their similarities, had less than mutual admiration for each other. It is also not surprising that their writings are very dissimilar. Both wrote voluminously, a fact that poses a strategic problem: how to give a just presentation of their work in only a few pages. Going with each one on a climb of the same mountain will help us compare them and also enable us to get an impression of their respective styles.

In the late fall of 1872 Muir returned to Yosemite Valley from long summer ramblings in the Sierra, intending to stay for the winter. But waiting for him, with a letter of introduction from Mrs. Carr, were William Keith and another artist. They wanted to be taken to some alpine scenery worthy of canvas, and Muir knew just the place. He had been up the Lyell fork of the Tuolumne River, with its marvelously picturesque views of the Lyell group of peaks and glaciers. He took them there, and instead of biding his time while they sketched, he decided, despite the approach of winter, to attempt a climb of the theretofore unscaled Mt. Ritter. The narrative of his daring ascent was first published in *Scribner's Monthly* in 1880 under the title, "In the Heart of the California Alps," and was later revised and included in *The Mountains of California* under the title, "A Near View of the High Sierra."

Early in the morning, leaving the artists to their work, Muir crossed over the crest of the Sierra to its eastern flank and made his way south, toward Ritter, exulting in all the streams and flowers and birds along the way, "every sight and sound novel and inspiring, leading one far out of oneself, yet feeding and building a strict individuality."[16] With evening came the alpenglow:

to me the most impressive of all the terrestrial manifestations of God. At the touch of this divine light, mountains seemed to kindle to a rapt, religious consciousness, and stood hushed like devout worshipers waiting to be blessed.[17]

After a bitterly cold night (and remember that Muir took to the high mountains clothes that most people would find insufficient for a summer day in San Francisco) and a breakfast of dry bread and tea, he set out "free and hopeful." As he crossed the "land of desolation" above timber line, he

met Cassiope, growing in fringes among the battered rocks. Her blossoms had faded long ago, but they were still clinging with happy memories to the

Color Plate 2. James Madison Alden. *Valley of Yo-Semite, California.* 1859. Watercolor. 11¾ × 17¾ inches. Courtesy California Historical Society, San Francisco/Los Angeles.

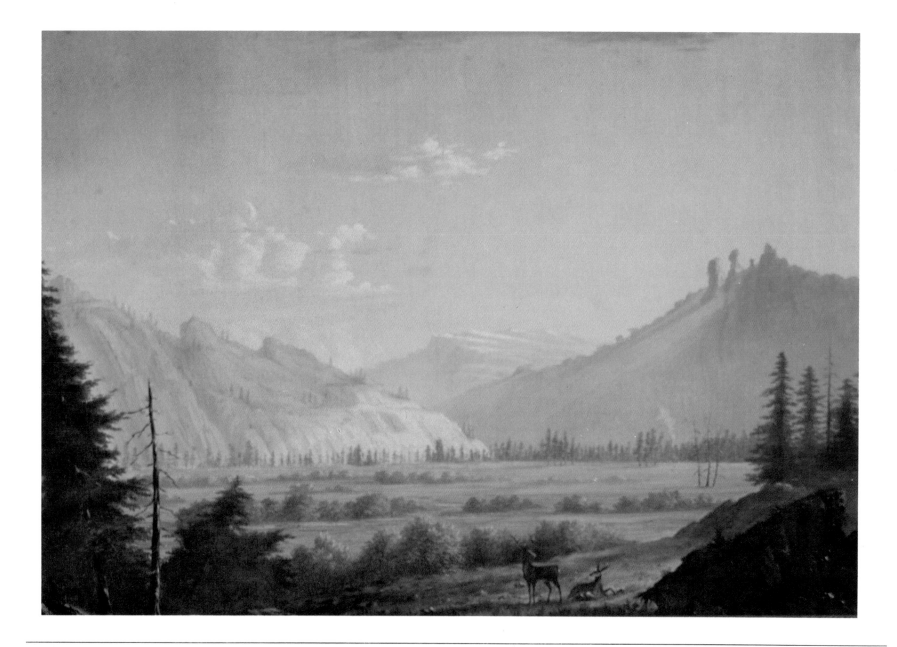

Color Plate 1. Thomas A. Ayres. Untitled (Tuolumne Meadows). 1858. Oil on Canvas. 13¾ × 20 inches. National Park Service, Yosemite Collection.

up precipices, and along ridges, until they reached the foot of Tyndall. Up it they went, with considerable difficulty, until they attained a point about 500 feet from the summit. Here it seemed that "Nature had intended to secure the summit from all assailants" and had "planned her defences" with care, "for the smooth granite wall which rose above the snow-slope continued, apparently, quite round the peak."[35] But King was a formidable adversary. He noticed that "quite near us the snow bridged across the crevice, and rose in a long point to the summit of the wall,—a great icicle-column frozen in a niche of the bluff."[36] They ascended the giant icicle cutting steps until it became

so thin that we did not dare to cut the footsteps deep enough to make them absolutely safe. There was a constant dread lest our ladder should break off. . . . At last, in order to prevent myself from falling over backwards, I was obliged to thrust my hand into the crack between the ice and the wall, and the spire became so narrow that I could do this on both sides; so that the climb was made as upon a tree, cutting mere toe-holes and embracing the whole column of ice in my arms.[37]

After reaching the top of the wall and crawling out onto the smooth slope of granite that led to the top, King turned around to watch Cotter:

He came steadily up, with no sense of nervousness, until he got to the narrow part of the ice, and here he stopped and looked up with a forlorn face to me; but as he climbed up over the edge the broad smile came back to his face, and he asked me if it had occurred to me that we had, by and by, to go down again.

All that remained was almost a stroll to the crest, which they reached

at exactly twelve o'clock. I rang my hammer upon the topmost rock; we

grasped hands, and I reverently named the grand peak *Mount Tyndall*. [italics his]

Once on top King surveys for us the general topography below him. Just as the chapter on the Newtys of Pike is King at his storytelling best, here he is at his descriptive best. Never has the high Sierra been more compellingly described. He is standing on the crest; to the north and south "snow-peaks" stretch on for miles, "the farthest horizon still crowded with their white points."[38] To the west lies a chain, now called the Great Western Divide, which runs parallel to the crest and is dominated by Mt. Kaweah and Mount Brewer. Across the gulf that separates the two chains "juts the thin, but lofty and craggy ridge"[39] that he and Cotter have just crossed, this ridge dividing the waters of the Kings River to the north from those of the Kern River to the south. In this direction King sees:

a thousand sculptures of stone, hard, sharp, shattered by cold into infiniteness of fractures and rift, springing up, mutely severe, into the dark, austere blue of heaven; scarred and marked, except where snow or ice, spiked down by ragged granite bolts, shields with its pale armor these rough mountain shoulders; storm-tinted at summit, and dark where, swooping down from ragged cliff, the rocks plunge over canon-walls into blue, silent gulfs.[40]

In the other direction, eastward, "the whole range [falls] in sharp, hurrying abruptness to the desert, where lie

plains clouded with the ashen hues of death; stark, wind-swept floors of white, and hill-ranges, rigidly formal, monotonously low, all lying under an unfeeling brilliance of light, which, for all its strange, unclouded clearness, has yet a vague half-darkness, a suggestion of black and shade more truly pathetic than fading twilight. No greenness soothes, no shadow cools the glare.

"The two halves of this view express the highest, the most acute, aspects of desolation."[41] The desert seas to the east

He might rely on it, I was going to say.

He added, "Thet—thet—thet man what gits Susan *has half the hogs!*" [italics his][28]

Although the entire account is written from the lofty vantage point of King's superior, not to say haughty, position as a man of culture, his acute powers of observation and his ability to portray character in a few choice words of conversation, as well as his success in leading the reader to the denouement without giving away his hand, make this the outstanding chapter in the book. Having failed to climb the false Mt. Whitney, he returns to the central valley and is saved from bandits by the stamina and speed of his pony, Kaweah. Next, he journeys to and around the rim of Yosemite valley in order to survey its boundaries and later fails to climb Mt. Clark because of a November snow storm.

The remainder of the book consists of a series of disconnected chapters on his return to the region of the Merced River and Yosemite in 1866; adventures in and around Mt. Shasta; his ascent of Mt. Langley, all the while under the impression that it is Mt. Whitney; and finally, some reflections on the character of the people in the Sierra, concluding with King's belief that, out of the common folk of the California mountains, despite low beginnings in the squalid and crime-ridden mining camps, "Time shall separate a noble race."[29] Included in one of the chapters is his encounter with a presumably fictitious artist by the name of Hank G. Smith, who becomes King's mouthpiece for a critique of Bierstadt:

It's all Bierstadt and Bierstadt and Bierstadt nowadays! What has he done but twist and skew and distort and discolor and belittle and be-pretty this whole doggonned country? Why, his mountains are too high and too slim; they'd blow over in one of our fall winds.[30]

King did not climb Mt. Ritter (though he tried once) so it is not possible to compare him with Hutchings and Muir by also following him up that great peak. His ascent of Mt. Tyndall, however, though it is far to the south of Yosemite, makes a perfectly acceptable substitute. Whereas for Hutchings the act of climbing was a practical problem presented to one who wished to reach the top, and Muir saw it, especially when the "other self" took over and he climbed naturally and fearlessly, as an almost Zen-like expression of harmony between Human and Nature, King viewed it primarily as adventure. To him climbing was like a military campaign. Nature erects its mountains and defends them with precipices, crevices, and snow fields. He and Cotter, like great warriors, are as ingenious at devising offensive strategies as nature is defensive ones. They are "assailants"[31] of her summits, "animated by a faith that the mountain [cannot] defy [them]."[32] Their most important goal is the top, and all the better if they are the first there.

During the adventure King is looking for "exhilarating thrill[s] to the nerves,"[33] thrills that are possible only when great danger is present. Danger tests his self-reliance; passing the test is a source of pride. He says:

When hanging between heaven and earth, it was a deep satisfaction to look down at the wild gulf of desolation beneath, and up to unknown dangers ahead, and feel my nerves cool and unshaken.[34]

His cool self-satisfaction and faith in his own prowess contrast sharply with Muir's loss of confidence in a similar situation and Muir's having, in order to regain control, to resort to transcendent spiritual powers.

Starting from Mt. Brewer, named for the captain of their expedition, King and Cotter made their way across canyons,

School and Whitney's right hand man in the California Geological Survey. King recognized Brewer, introduced himself, and was promptly persuaded to join the Survey as Brewer's assistant.

The next summer Brewer along with King, Gardiner, and other survey members explored the headwaters of the Kern, the Kings, and the San Joaquin rivers, and in the fall King and Gardiner surveyed the boundaries of the newly created Yosemite Grant. King was also in Yosemite very briefly in 1866. Shortly after that he was put in charge of a survey of the 40th parallel from the California border to Colorado, a task he was occupied with until 1877. The next year he was appointed the first director of the newly established United States Geological Survey. He resigned from that post in 1881 in order to use his vast knowledge of geology and mining in an effort to join the ranks of America's wealthy men. All of his schemes failed, however, and he died broken in health and spirit in 1901. Without question one of the most talented and fascinating figures in the history of American science and letters, King was plagued by having a young manhood so illustrious that middle age was a depressing anticlimax.

Mountaineering is a strange book. Its chapters were originally written, as were the chapters in Muir's *Mountains of California*, as articles for monthly magazines, and were only later collected into a single volume. It has, therefore, an episodic quality: instead of possessing a unified plot it consists of a series of loosely related incidents. It is written as if it is fact, yet surely over half consists of fictional elaborations of actual events. King is famous as a climber of mountains, and, to be sure, the most exciting chapters narrate his ascent of Mt. Tyndall. Yet his writing is most powerful, not when he chronicles events, but when he describes scenery and, more especially, when he delineates the character of the people he

meets in the Sierra. So *Mountaineering* is a peculiar combination of travel narrative and adventure story that reads most of all like a loosely constructed novel.

After an initial chapter which narrates the geological history of the Sierra, describes its present physical appearance, and tells the story of King's trek across the Colorado desert in 1863, chapters two through eight deal with the 1864 campaign of the Whitney survey. Because these chapters tell of events closely related in time and space, they are the most unified and constitute almost a book within a book. The survey party ascends through the foothills and conifer forests to the high Sierra in the area of the present Kings Canyon and Sequoia National Parks. King and Dick Cotter, the survey's packer, leave the rest of the group, journey cross-country through some of the most rugged terrain in the Sierra, climb Mt. Tyndall (near Mt. Whitney) and return. From the central valley King goes back to the mountains to attempt a climb of the peak he thinks is Mt. Whitney. Along the way he meets the Newty family of hog farmers from Pike County, Missouri. To hail from Pike County in those days was the equivalent of having come to California from Oklahoma in the 1930s, and the term "Piker" was used in the same derogatory way as "Okie." The whole of chapter five is devoted to his brief and hilarious sojourn with the Newtys: the mother's effort to size him up as a man by asking if he has killed his coon; the romantic overtures to him by the strapping daughter, Susan; his efforts to determine if the ignorant and materialistic Susan can appreciate the glories of nature; the father's parting words:

"You'll take care of yourself, now, won't you?" he asked. I tried to convince him that I would.

A slight pause.

"You'll take care of yourself, won't you?"

together with a courage and a practical knowledge of mountain climbing that was roughly equal to Muir's, rather than with an uncanny agility inspired by otherworldly agents. Clearly for Hutchings mountain climbing was more a practical than a spiritual affair:

Sept 16th Thursday

This morning at day break started to climb Mt. Ritter. This camp is 7829 ft. We descended abt 150 to river. Then climbed up benches. Threaded our way among clumps of trees. Worked on among bushes over boulder, and boulder strewn moraines of recent date. Then to the top of the talus beneath the serrated peaks that form the southwestern wall of Mt. R. Here we were 11,230 above sea. Now our only way of reaching the top was:

First we looked up and concluded the feat impossible—then we peeped above a shattered peak whose very rocks were loose and ready to fall—then climbed among loose blocks or on the broken edge of a seam in the rock, holding tightly on by feet as well as hands. But how to get over or around the next peak or across the deep chasm between peaks with an abyss on either side? That this was done time after time until we came to the main peak. This was at an angle of sixty eight or seventy degrees. How to find points to clutch, or for foothold was a puzzle indeed.

Patiently, however one dangerous spot was passed; and by turning to the right or left another; until within about 30 feet of the summit. Here was a sharp angular rock that bade defiance to any farther progress—an abyss of some thousands of feet being on three sides. At length I espied a crack, into which I could thrust my fingers. Then a slight projection where I could bear—not stick—my foot. I pulled up—then by shuffling along with my knees and my legs dangling I succeed [sic] in reaching the summit.

The most interesting aspect of Hutchings' comments once he has reached the summit is that they are not very interesting. As did Muir, he looks this way and that and describes the sights, but, since his mind does not probe beneath the surface for understanding, he has no insight to give:

But who can describe the glorious panorama of mountains, and pine clothed ridges and vast deserts stretching away into Nevada, with all their light and shadows. Here and there a green meadow—no longer grassy however—the sheep having denuded it utterly—or a grassy hollow.

On the north side of the south peak (the one we had climbed) lay a good sized glacier—perhaps 400 feet across, and a third of a mile long—extending away down the basin between the two peaks. This formed the principal source of the north fork of the San Joaquin river.

Beyond to the north stood the north Peak of Ritter [Banner Peak] towering at least six or seven hundred feet above where we stood on the summit of the south peak 12,070 ft above the sea.

His notes about the descent and return to camp are as exciting as entries in a ship's log:

How to get safely down was as difficult to determine as to get up it. It was a nervetester with thousand [sic] of feet abysses to avoid. But it was at length safely accomplished.

The climb from camp (Camp Ritter) took eight hours and twenty minutes to the top. The whole trip just twelve hours, altho only 5000 ft fm river.

The Minnaretts loomed up very finely and showed peaks utterly inaccessible. How well they are named.

Thermo 46

In terms of influence Muir and Hutchings are the Sierra Nevada's most important writers to date. But the best single book ever written about the Sierra is undoubtedly Clarence King's *Mountaineering in the Sierra Nevada.*[25] King was born in Newport, Rhode Island, on January 6, 1842, and graduated from Sheffield Scientific School at Yale in 1862.[26] The following year he set out with fellow geologist James Gardiner on a cross-continent trek to California, and later that year, in what Sierra historian Francis Farquhar describes as "one of those remarkable chance meetings that determine not alone men's careers, but events of considerable importance,"[27] found himself on the same Sacramento River steamer with William Brewer, also a graduate of the Sheffield Scientific

tion is parallel to that of religion. When faced with cruelty, pain, and suffering in the world, Christians ask, are love and redemption possible? The presence of the God-Man in history enables them to answer yes. On the desolate, high mountain ridges Muir asks if warmth and redemption are possible. The presence of the God-Flower,[21] Cassiope, enables him to answer yes. Similarly, on the top of Ritter, looking over apparent chaos, he asks, can sense be made of this disorder? Through the science of geology he can answer yes. For geology enables him to look, not just at the scene present to his eyes, but back in history in order to understand how the present came to be, and to look forward into the future and know that future landscapes will also be intelligible to the initiate:

> While we thus contemplate Nature's methods of landscape creation, and, reading the records she has carved on the rocks, reconstruct, however imperfectly, the landscapes of the past, we also learn that as these we now behold have succeeded those of the pre-glacial age, so they in turn are withering and vanishing to be succeeded by others yet unborn.[22]

A crucial tenet of Muir's religious outlook was that the universe is a whole, with everything (past, present, and future; far and near) interrelated. He once said, "When we try to pick out anything by itself we find it hitched to everything else in the universe."[23] It is, therefore, easy to see why geology excited him so much. It enabled him to make sense of Yosemite and gain adherents in a scientific debate with the great Whitney. But more than that it proved to him that his central philosophical doctrine—the unity of all things—was not just a pipe dream. Present mountains look the way they do because of intelligible forces acting in the past and will change their looks according to the action of those same forces. And so,

redeemed by Cassiope, delivered by his "other self" from sure disaster, informed by glaciers, and warmed by a timely fire the night following his ascent, Muir the next day rejoined his painter acquaintances, who had in the meantime become needlessly anxious, having neither his faith nor his understanding.

Three years later Hutchings set out from Yosemite Valley with his wife and a party of men to climb Mt. Ritter and Mt. Whitney. It is not entirely fair to Hutchings to compare the handwritten and unrevised diary he kept on this trip with an account Muir polished for publication.[24] Yet, in matters of substance, Hutchings' published articles and books differ hardly at all from his diary entries. Editing probably would have amounted to little more than buffing the surface here and there.

The entry for the very first day of the trip, September 3, is typical:

> Left Yosemite via the McCauley or Glacier Point Trail. Passed all the main scenic standpoints on the way such as the Sentinel, El Capitan etc etc Union Point is 2,330 ft above valley Glacier Point 3,200. We ascended about 100 ft higher on way to Glacier. Skirted Sentinel Dome and camped in a beautiful grove of Silver Firs and Pinus Contorta—Elevation above Yosemite, 3,925 ft. above sea 7,925 ft. Distance (about) 7 miles.

Hutchings gives the impression right from the beginning of the diary that he is taking notes for a guidebook. His interest is geographical, not geological: he exhibits no concern to understand how the Yosemite landscape came to be; rather he wants only to map how it is. Consequently, his experience in the wilderness seems far more superficial than Muir's.

The actual ascent of Ritter on September 16 was accompanied by some of the same dangers that Muir faced, but he met them with this-worldly patience and persistence,

evergreen sprays, and still so beautiful as to thrill every fiber of one's being. Winter and summer, you may hear her voice, the low, sweet melody of her purple bells. *No evangel among all the mountain plants speaks Nature's love more plainly than Cassiope. Where she dwells, the redemption of the coldest solitude is complete.* [italics mine][18]

No passage illustrates any better the essential nature of Muir's religion: the structure and language are Christian, but the role of savior is played by one of nature's species.

At the foot of a "narrow avalanche gully" directly below the summit, a tense drama began:

I could not distinctly hope to reach the summit from this side, yet I moved on across the glacier as if driven by fate. Contending with myself, the season is too far spent, I said, and even should I be successful, I might be storm-bound on the mountain; and in the cloud-darkness, with the cliffs and crevasses covered with snow, how would I escape? No. I must wait until next summer.... But we little know until tried how much of the uncontrollable there is in us, urging across glaciers and torrents, and dangerous heights, let the judgment forbid as it may.

I succeeded in gaining the foot of the cliff on the eastern extremity of the glacier, and discovered the mouth of a narrow avalanche gully, through which I began to climb.... I thus made my way into a wilderness of crumbling spires and battlements, built together in bewildering combination, and glazed in many places with a thin coating of ice, which I had to hammer off with a stone. The situation was becoming gradually more perilous; but, having passed several dangerous spots, I dared not think of descending.... At length ... I found myself at the foot of a sheer drop in the bed of the avalanche channel ... which seemed absolutely to bar all further progress.

After trying unsuccessfully to avoid this precipice by going to either side of it, he concluded that he must go up it or go back. It should surprise no one that he chose to go up:

After gaining a point about half-way to the top, I was brought to a dead stop, with arms outspread, clinging close to the face of the rock, unable to move hand or foot either up or down. My doom appeared fixed. I *must* fall. There

would be a moment of bewilderment, and then a lifeless rumble down the one general precipice to the glacier below. [italics his]

The account of his "rescue" is one of the most famous passages in all of Muir:

When this final danger flashed in upon me, I became nerve-shaken for the first time since setting foot on the mountain, and my mind seemed to fill with a stifling smoke. But this terrible eclipse lasted only a moment, when life blazed forth again with preternatural clearness. I seemed suddenly to become possessed of a new sense. The other self—the ghost of by-gone experiences, Instinct, or Guardian Angel—call it what you will—came forward and assumed control. Then my trembling muscles became firm again, every rift and flaw in the rock was seen as through a microscope, and my limbs moved with a positiveness and precision with which I seemed to have nothing at all to do. Had I been borne aloft upon wings, my deliverance could not have been more complete.[19]

Having reached the summit, and after bathing in the warm sunlight momentarily, Muir describes for his readers the view in each direction. He notes that "an inexperienced observer" is often "oppressed" by the view "from an all-embracing standpoint because the jumble of mountain peaks, glaciers, rivers, and meadows seems so "incomprehensible." But once such a scene is studied in the light of glacial action, the "far-reaching harmonies become manifest":

Then, penetrate the wilderness where you may, the main telling features to which all the topography is subordinate are quickly perceived, and the most ungovernable Alp-clusters stand revealed, regularly fashioned, and grouped like works of art—eloquent monuments of the ancient ice-rivers that brought them into relief ... Nature's poems, carved on tables of stone.[20]

What science, specifically the science of geology, enables Muir to do is clear: make sense out of apparent nonsense. Its func-

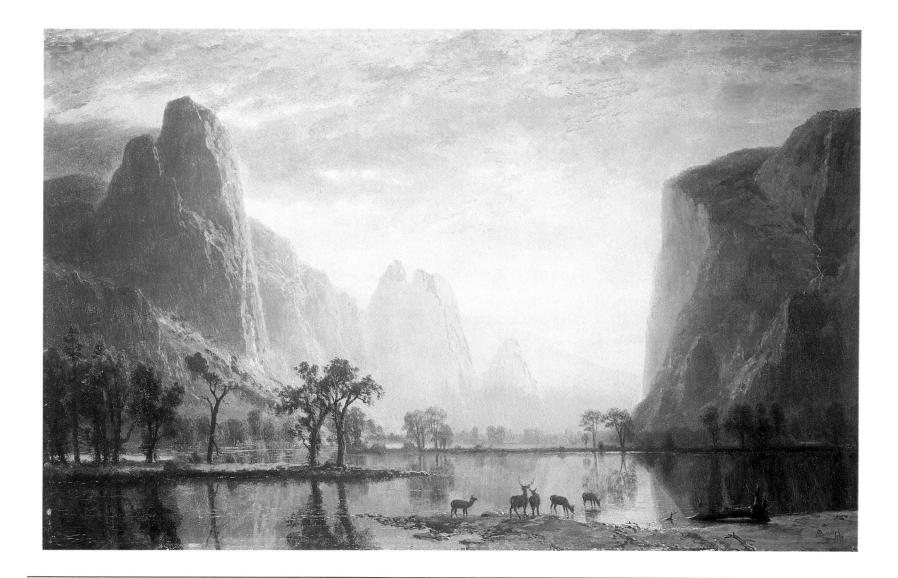

Color Plate 3. Albert Bierstadt. *Valley of the Yosemite.* 1864. Oil on canvas. 29.7 × 48.9 cm. M. and M. Karolik Collection. Courtesy Museum of Fine Arts, Boston.

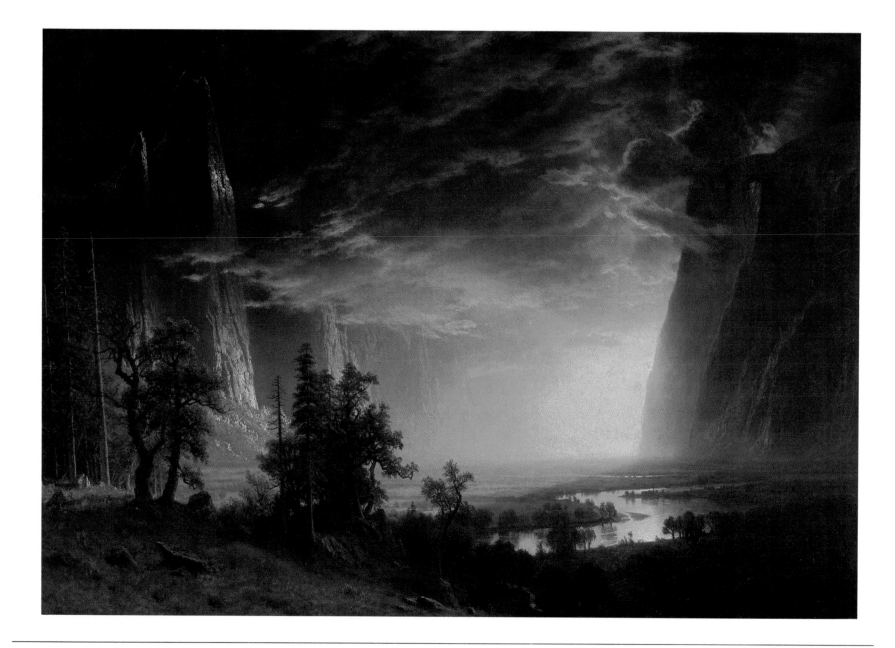

Color Plate 4. Albert Bierstadt. *Sunset in Yosemite Valley.* 1868. Oil on canvas. 35½ × 51½ inches. Haggin Collection, The Haggin Museum, Stockton, California.

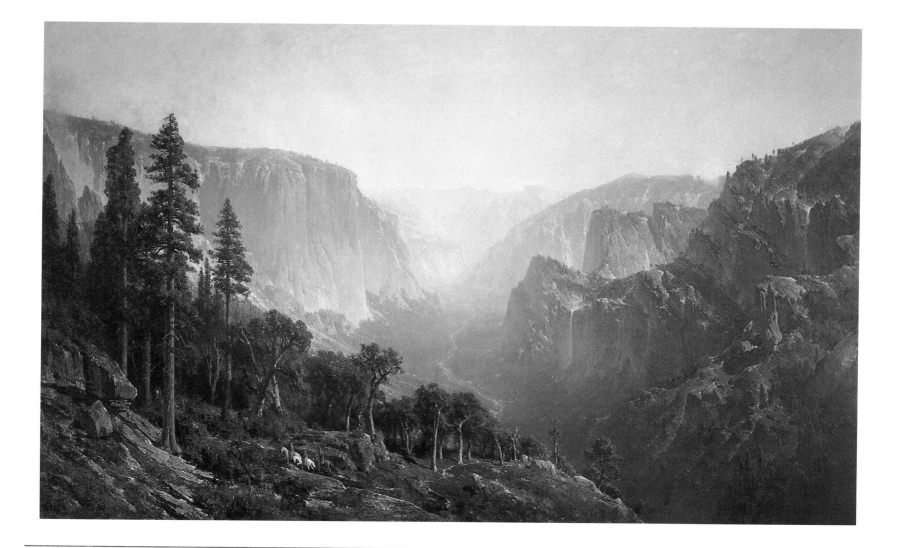

Color Plate 5. Thomas Hill. *Yosemite Valley (From below Sentinel Dome, as Seen from Artist's Point)*. 1876. Oil on canvas. 72 × 120 inches. Kahn Collection, Oakland Museum.

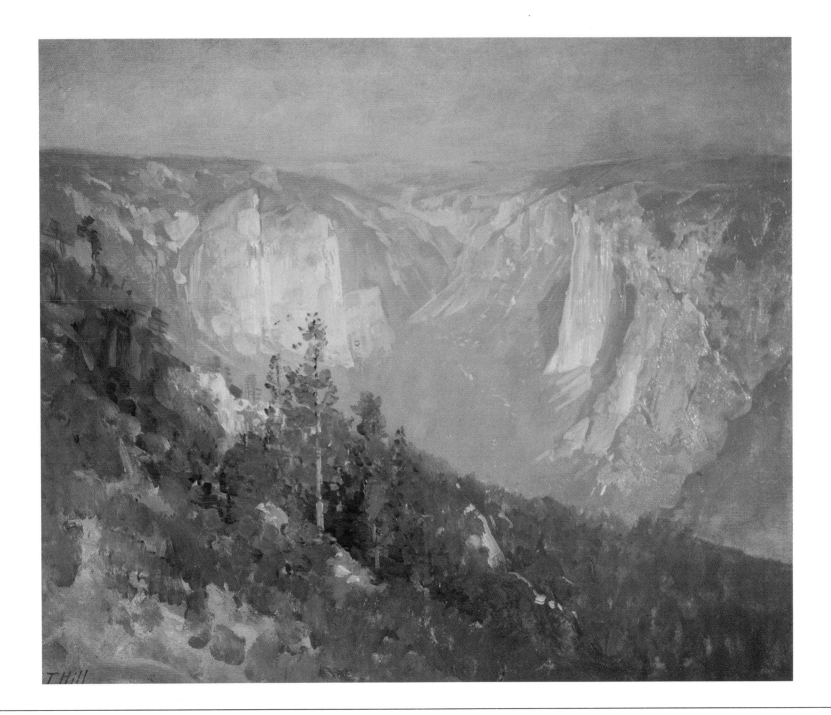

Color Plate 6. Thomas Hill. *Scene of Lower Yosemite Valley from below Sentinel Dome.* No date. Oil. 19½ × 23½ inches. National Park Service, Yosemite Collection.

Color Plate 7. William Keith. *Sentinel Rock, Yosemite.* 1872. Oil on canvas. 18³⁄₁₆ × 14⅛ inches. Courtesy The Bancroft Library.

Color Plate 8. William Keith. *Mt. Lyell, California Sierra.* 1874. 16 × 25 inches. Oil on canvas. Collection of Saint Mary's College, Moraga, California.

have "dried up and blown away," leaving "white, salt-strewn bottoms" which "lie there in the eloquence of death." On the mountain walls to the west "in marks and polishings has been written the epitaph of glaciers." Now "vacant canons lie open to the sun . . . shrouded with snow . . . still as graves, except when flights of rocks rush down some chasm's throat, startling the mountains with harsh, dry rattle. . . ." No relief from the desolation can be had by looking up, for the sky too "is grave with nocturnal darkness":

That fair contrast we love in lower lands between bright heavens and dark cool earth here reverses itself with terrible energy. You look up into an infinite vault, unveiled by clouds, empty and dark, from which no brightness seems to ray, an expanse with no graded perspective . . . only the vast yawning of hollow space.

In this dark sky

with an aspect of endless remoteness burns the small white sun, [whose] light seems to pass invisibly through the sky . . . flooding rock details with painfully bright reflections, and lighting up the burnt sand and stone of the desert with a strange blinding glare.

"I have never seen Nature when she seemed so little 'Mother Nature,' " he says by way summing up.[42]

Doubtless for many people gazing too intently and too long at "titanic confusion"[43] would be depressing. Muir should probably be numbered among them. He loved to climb the high peaks and peer out over the jumble of rocky forms and the empty expanse of desert, but he habitually took measures to lessen the emotional impact that chaos and desolation might have upon him. He reduced chaos to order by understanding its history; he sought in desolation a sign of God's love, as in the flower Cassiope. But best of all he liked, before the desolation without became depression within, to return to lower elevations and more gracious climes, where the love of God was more evidently manifest in green and growing things. In fact, his favorite spot was

the tranquil uplands where exhilarating air and a free far outlook are combined with the loveliest of the flora. In that zone below the ice and snow and above the darkling woods . . . perfect quietude is there, and freedom from every curable care.[44]

For King, on the other hand, the more completely the pall of death hung all about him, the more he found the scene appealing. In a sense, he used adjectives like sombre, deathlike, gloomy, cold, grave, vacant, and pathetic as compliments. Rather than hush the music of dead silence that played about Mt. Tyndall, he wished to listen and to let its chords register as on a wind harp sympathetic vibrations within his soul until the notes within and the notes without resonated in complete harmony:

I thoroughly enjoyed the silence, which, gratefully contrasting with the surrounding tumult of form, conveyed to me a new sentiment. I have lain and listened through the heavy calm of a tropical voyage, hour after hour, longing for a sound; and in desert nights the dead stillness has many a time awakened me from sleep. For moments, too, in my forest life, the groves made absolutely no breath of movement; but there is around these summits the soundlessness of a vacuum. The sea stillness is that of sleep. The desert of death, this silence is like the waveless calm of space.[45]

King's response to Yosemite was in keeping with his predilection for desolation. Notes he recorded on a small purple pad while working for the State Geological Survey illustrate the mood he preferred:

I have just been to the Yo Semite Lower Fall, and now it storms I hear the musketry of the fall dark gray wild clouds hang over the whole valley the

granite as sombre awful gray clouds (helmet) curl ov[er] the brow of the half dome mist darkness hang over the cathedral rocks they are deep terrible purple white clouds break away over cathedral[46]

And in chapter 7 of *Mountaineering,* entitled "Around Yosemite Walls," he speaks of the valley's "geological terribleness,"[47] of a "granite plateau suddenly rent asunder," and of "the shattered fronts of walls [that] stand out sharp and terrible, sweeping down in broken crag and cliff to a valley whereon the shadow of autumnal death has left its solemnity." King's response is more like the Mariposa Battalion's rank and file than it is like Muir's. His frequent use of images from Dante's Inferno suggest that he viewed the valley and the Sierra as a kind of awe-full Hell, fascinatingly terrible, delectably gloomy. To balance his Yosemite books, however, it ought also to be said that he is capable of very Muir-like reactions. At one point in *Mountaineering* he summarizes the two ideas that Yosemite gives the "earnest observor."[48] First, as might be expected, is an impression of the "titanic power . . . which has rent this solid table-land of granite in twain." But second is "the magical faculty displayed by vegetation in *redeeming* the aspect of wreck and masking a vast geological tragedy behind draperies of fresh and living green." [italics mine]

Two other early Yosemite writers deserve mention, Therese Yelverton and Thomas Starr King. Yelverton spent the summer of 1870 in the valley and became infatuated with Muir and the Hutchings household, James, his wife Elvira, and his daughters Florence and Gertrude, nicknamed Cosie. While still in the park she decided to write a novel loosely based on the lives of her new friends and even followed Muir around taking mental notes. Her book, *Zanita: A Tale of the Yosemite,*[49] was panned by critics from the moment of its publication and has been read mainly by Muir enthusiasts eager to watch their hero in action. Zanita (Florence Hutchings) is an entrancingly beautiful, headstrong heroine whose character "bears the impress of the wild, untrammeled"[50] mountains of Yosemite. Her dying mother (Elvira Hutchings), certain that her husband (Hutchings) cannot control the girl, asks Mrs. Brown (Therese Yelverton) to take her to Oakland where she can be properly raised. Once there Zanita remains as uncontrollable as ever and brings acute discomfort to stuffy and vainglorious city dwellers.

Thus far the novel is mostly a social satire using the age-old device of placing the genuine in the midst of the fake. Urbanites come to Yosemite and while there frequently offend the park residents by their "unnatural" behavior. Zanita with her "uncivil" actions is the agent of Yosemite's revenge. But she also has a dark side to her character. She is a darling, mischievous sprite when amused but a jealous demon of vengeance when seriously threatened. She is incapable of true love. "Zanita never cared for any one more than would gratify her immediate purpose," Mrs. Brown notes, and Kenmuir (Muir) explains that she is "gratified by attention, and strives to enthrall every one in her train."[51] All the acculturating powers of foster mother and a Mother Superior cannot humanize her. "She remains," says Mrs. Brown, "the uncurbed child of nature in spite of all we could do to make her conventional."[52] Thus when she meets Egremont (based on Yelverton's own husband, son of Viscount Avonmore, who married and then left her) she covets the status marrying him would give her. Mrs. Brown, anxious that flirtation not lead to matrimony, flees with Zanita to Yosemite only to find Egremont already there. He falls in love with Zanita's younger sister, Rosalind (Gertrude Hutchings), and when he asks for her hand in marriage, Zanita acts swiftly and decisively. A

Plate 15. Carleton Watkins. *Bridal Veil Falls.* 1861. Glass stereograph. National Park Service, Yosemite Collection.

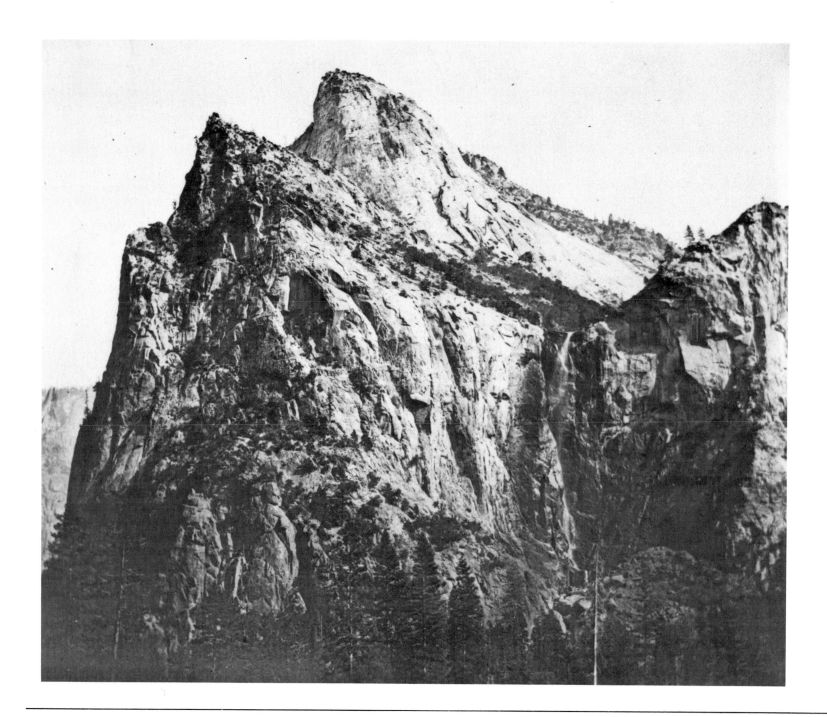

Plate 14. Carleton Watkins. *Bridal Veil Falls.* 1861. Glass stereograph. National Park Service, Yosemite Collection.

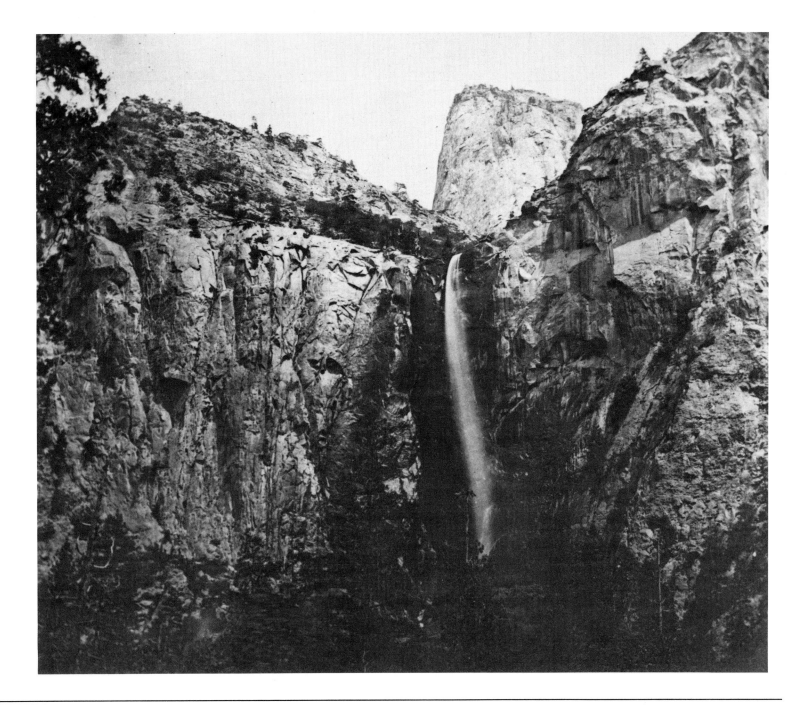

Plate 13. Carleton Watkins. *Bridal Veil Falls.* 1861. Glass stereograph. National Park Service, Yosemite Collection.

Plate 12. Carleton Watkins. *Lady Franklin and Party.* 1861. Glass stereograph. National Park Service, Yosemite Collection.

Undoubtedly he had heard of Yosemite's size and had decided to respond in kind—a monumental nature deserves a monumental picture. Since enlarging was not practiced in those days, a mammoth picture required a mammoth negative and a mammoth negative required a mammoth camera. So he had one built to his specifications. He was, thus, the first to respond to the pressure that an immense Yosemite puts on an artist by matching big with big.

By the very nature of the wet-plate process, wherever the stereo camera went, glass plates, chemicals, and darkroom had to follow. Still it was relatively light and portable compared with the unwieldly mammoth-plate camera. Watkins used it much like a 20th century photographer might use a 35mm camera, taking snapshots of his tour group, for example, Plate 12. In most of these pictures he was careful to juxtapose foreground sharply against background. Looked at by the unaided eye the images appear flat and unexciting; in a stereoscope, however, by means of the magic of binocular vision, foregound and background separate, giving viewers the impression that they are witnessing the actual scene. This sense of actually being there is increased by the fact that in a stereoscope the scene occupies the entire field of vision; the picture, as it were, has no borders.

In all probability Watkins also used his stereoscopic camera the way a modern photographer might use a combination of Polaroid and view camera. Since each negative had to be developed on the spot, he could get a good idea not only of the quality of an image but also of the effectiveness of its composition before proceeding further. Thus, on a number of occasions he took several views of a single subject with the stereo and on the basis of the results seems to have decided where to set up the cumbersome mammoth-plate camera. His pictures of Bridalveil Fall, first analyzed by Nanette Sexton, present a textbook-clear example of this practice.[5] With the stereo camera he apparently first made a number of exposures, including a close-up, a middle-distance shot, and one that shows the falls above some foreground trees (Plates 13, 14 and 15). Having decided that the composition of the middle distance shot would work best in the larger format, he then set up the larger camera and exposed his one mammoth-plate view of Bridalveil (Plate 16).

In the last few years Watkins' 1861 stereos have received a great deal of praise from historians and critics, partly because a large number of them have only recently been discovered[6] and partly because among them are the type of pictures preferred by modern tastes, pictures of small, anonymous places in which abstract design is more important than subject matter. Without doubt, however, Watkins considered that his mammoth-plate views were his truly serious and important work. To be sure, his stereos are intimate and delightful. But such adjectives are not often applied to Yosemite; rather people speak of it as grand, majestic, sublime. With his mammoth-plate camera Watkins intended to render a grand subject with photographs equally grand.

Watkins published 30 mammoth-plate photographs from his 1861 trip. Copies of all exist today and are easily distinguishable from mammoth-plates he took in the ensuing years. The lens he used in 1861, while it permitted a wider angle of vision than previous lenses available to landscape photographers (a considerable advantage in Yosemite where steep, narrow walls frequently prohibit backing away from objects to get more of them in the picture), nevertheless significantly distorted the image at the margins. In printing he rounded off the upper corners, probably to mask this distortion. In so doing he inadvertently gave us a sure clue to his 1861 work. The deficiences of this lens and the availability

parents' bias that a photograph gives a truer picture than does pencil or pigment.

Carleton E. Watkins was the earliest of Yosemite's triumvirate of great photographers.[2] A New Yorker by birth, he had by 1853 arrived in Sacramento, where he worked as a carpenter, and where in all likelihood he met Robert Vance, San Francisco's leading portrait photographer. Later, despite the fact that presumably Watkins knew next to nothing about picture-taking, Vance asked him to run his San Jose studio on an emergency basis until a replacement could be found for the regular operator who had suddenly quit. Undoubtedly Watkins liked the work, for he remained a photographer from this moment until he became too blind and too feeble to carry on.

None other than James Hutchings may have had something to do with his interest in Yosemite. Pauline Grenbeaux discovered that several of Watkins' photographs of the mining regions around Mariposa may have been used as the basis of the engravings illustrating an article in the July, 1859, issue of *Hutchings' California Magazine*.[3] Whether Hutchings was along on this particular trip (which would have taken place at least a few months before the article appeared and maybe as early as 1858) or whether Watkins even had personal dealings with Hutchings is not known. But merely taking pictures for the use of Hutchings' engravers would be sufficient to bring him within the sphere of influence of this energetic man with an almost maniacal interest in Yosemite. Hutchings' trip to Yosemite with Weed took place a month before the Mariposa article appeared, and the article reporting on that trip was printed in October, complete with illustrations made from Weed's photographs. In the meantime the photographs themselves had gone on display at Vance's gallery. Clearly the neophyte photographer moved among people who must have frequently discussed Yosemite's scenic wonders.

Watkins' Yosemite career had three rather distinct phases: the first, from his initial trip to the valley in 1861 to 1867, when he opened his Yosemite Gallery in San Francisco; the second, from 1867 to 1876, when I. W. Taber, apparently foreclosing on a loan, took possession of the Yosemite Gallery and all of Watkins' negatives; and the third, after 1876, when, discouraged but not daunted, he set about the prodigious task of restocking his Yosemite cupboard with freshly made negatives.

His most creative work was done in the first phase, 1861-1867, and more specifically on two trips during that time: the initial one in 1861 and another in 1866. On the former, except for an occasional foray 500 to 1000 feet up the side of a cliff, he photographed exclusively from the valley floor, beginning just west of Bridalveil Fall and ending at the foot of Nevada Fall. By looking at these pictures we can judge how successful he was in solving the main problems the valley presents to the photographer. Although he returned there many times, by and large he merely repeated himself, retaking the same views, often from the exact same vantage point, only with better equipment. Usually the later prints are technically superior but artistically less imaginative. In 1866 for the first time he went into the high country, traveling along the south rim from Inspiration Point to Glacier Point. By looking at the pictures he took on this trip we can see how he attempted to solve the problems of photographing Yosemite from above.

On the 1861 trip Watkins took with him a stereoscopic camera[4] and a mammoth-plate camera, so-called because it took genuinely mammoth negatives, approximately 17″ by 21″. Circumstantial evidence suggests that the idea of using a mammoth-plate camera in Yosemite was Watkins' own.

to its main features. They were not tempted to fret with the lace and tassels of color at the expense of the fabric and design of the main garment. Consequently, the problems they set themselves were the critical problems any visual art of Yosemite must solve: how to make the huge look huge and the deep deep, how to prevent projecting, shapely hulks of granite from appearing flat, how to find a vantage point that will demonstrate the great length and delicate finesse of Yosemite water falling. Upon reflection color turns out to be frosting and not cake.

Another reason photography has been so successful in Yosemite may also appear, at first glance, to be a strange one: Yosemite photographers, for the most part, have not thought of themselves as artists, that is, as people consciously setting out to make works of art! This generalization applies more to the earlier picture-takers than to the later ones, and a large exception is Ansel Adams, whom I will discuss at length in Chapter Six. Usually, being self-conscious about one's work and being steeped in the artistic traditions of the past are prerequisites for making good art. So the seemingly paradoxical assertion that not being artists helped the early photographers produce great art needs an explanation.

The problem for the early painters and writers was not that they came from the eastern United States or Europe (as almost all did, but so did the photographers) nor was it that they were self-conscious artists. Rather the problem was that they looked either to Europe or to New England not only for instruction in technique and for inspiration, but also and most critically, for their notions of what mountains ought to look like. Thus, they gave the peaks and granite domes of the Sierra either the look and atmosphere of the Alps or the cast and hue of the lower and more lush mountains on either side of the Hudson River. Hill, Keith, and Muir came the closest to

having 20/20 Sierra vision; Bierstadt, Hutchings, and above all, the poets looked past the nearby Sierra and focused on mountains far to the east.

Since Yosemite's first photographers did not think of themselves primarily as artists, it did not occur to them to travel over the seas to Europe to look through the lenses of the masters. At that time, hardly more than 30 years after its birth, there were no masters of photography. Rather they were professional businesspeople, sometimes hired by geologists to illustrate geological formations, other times engaged in commercial ventures, trying to make a profit out of the public's curiosity about a much applauded place. Hence, their approach to the Sierra was straightforward, even blunt, an approach that was well suited to the realism inherent in photography and that resulted in honest, accurate pictures of the Sierra.

This point leads naturally into a third reason why photography was so successful. By and large Americans in the last half of the nineteenth century were practical-minded; they wanted the facts, the truth. So when reports of the glories of western scenery came from painters, who had long been in the habit of inventing landscapes, or from poets, who nearly always spoke in highfalutin ways, or from travel writers, who could not resist telling tall tales, they were understandably skeptical. But they were inclined to believe the photographers. Because photography dealt with light and chemicals, it seemed more scientific than paint or words; because light did not go through the eyes of the photographer on its way to the film, there seemed less room for distortion; the camera had to tell the truth. Is it any wonder, then, that the "sun pictures" of Yosemite's earliest photographers met with such public acclaim and financial success? Even today, though we have seen how photographers can distort what the eye sees, we still share our grand-

Early Photography

YOSEMITE is a dramatically three-dimensional valley: over 3000 feet deep, about 7 miles long, and about ½ mile to ¾ mile wide. At evening the colors in its ceiling run the spectrum of the rainbow, from a shocking pink to a cool light blue; on its floor a light spring green changes to an olive summer green to a golden autumn brown. How could black and white photography,[1] which must not only subtract one dimension but also reduce the rainbow to shades of grey, possibly do justice to such a dramatic place? Painters have a hard enough time, but at least they have color. And they also can eliminate unwanted detail, move mountains around, condense clouds with the stroke of the brush and blow them into just the right spot. Photographers, on the other hand, must include debris if it is too big to move, must prospect for good perspectives, and must be on the spot when the light is right. The handicap they carry is heavy; how could they ever win an artistic race in Yosemite?

Yet, and here is the central paradox of the story told in this book, from the 1860s to the present black and white photography has more convincingly and imaginatively than any other medium transformed Yosemite into art. It has won not only the race for the public's purse, but also the race for the critic's acclaim. Yosemite's three great photographers, Carleton Watkins, Edweard Muybridge, and Ansel Adams are also its three most creative artists, and right behind them march a host of stars of lesser magnitude. And these same three are also the only Yosemite artists who have, from an international point of view, made genuinely innovative artistic advances. Bierstadt, Hill, and Keith are all secondary figures in the history of painting; they borrowed their techniques from the European avant-garde and applied them to Yosemite. And the ground-breaking achievements of John Muir lie in the fields of natural history and politics.

Of all the arts why has photography been so successful? First, and strange as it may seem, the fact that photographers could initially render Yosemite in black and white only, and not in color, was a help and not a hindrance. Color is not one of Yosemite's outstanding attributes. Monolithic size, shape of granite cliffs, fall of water, gigantic trees—these are the strongest points in its character. Granite is grey, falling water white, and trees dark, precisely the tones in which black and white photography pictures them. Except in the autumn when the black oaks turn yellow and orange, and in the spring with certain wild flowers, color is critical only in the sky overhead. And a picture of the sky at sunset tends to be just that—a picture primarily of the sky, in which the lines and shapes of Yosemite are not shown for their own sake but to provide a dramatic earthly setting for an even more dramatic heavenly event. Because photographers for a long while could not develop Yosemite in color, they were forced to pay attention

31 P. 74.

32 P. 62.

33 P. 67.

34 P. 63.

35 P. 74.

36 P. 74.

37 This and the following two quotations are from page 75.

38 P. 77.

39 P. 76.

40 This and the following quotation are from page 77.

41 This and the following quotations are from page 78.

42 P. 79.

43 P. 74.

44 Quoted in Teale, *The Wilderness World of John Muir* (Boston: Houghton Mifflin, 1954) 314.

45 *Mountaineering,* 80.

46 This pad is now in the Henry E. Huntington Library, San Marino, California.

47 This and the following quotations are from *Mountaineering*, 133-34.

48 This and the following quotations are from page 184.

49 New York: Hurd and Houghton, 1872.

50 P. 200.

51 Pp. 179 and 232 respectively.

52 P. 200.

53 P. 282.

54 No relation to Clarence King.

55 Boston: Crosby, Nichols, and Company, 1860.

56 *The White Hills*, quoted in *A Vacation Among the Sierras*, xiii.

57 Edited, with an introduction and notes, by John A. Hussey (San Francisco, The Book Club of California, 1962).

58 This and the preceding quotations are from *A Vacation Among the Sierras*, 29-35.

spire with a column whose life is older than the doctrine of the Trinity, to appreciate its vastness.

During the afternoon of his stay among the giants of the Mariposa Grove, he sequesters himself from his companions at the foot of the largest tree. As he watches the golden sunlight "mounting the amber trunk," he wonders about its age. The playful wit with which he retells his thoughts is King as his best:

How long since the quickening sunbeam fell upon the first spear of green in which the prophecy of the superb obelisk was enfolded? Why cannot the dumb column now be confidential? There comes a breath of wind . . . —why will not the old patriarch take advantage of that ripple through his leaves and whisper to me his age? Are you as old as Noah? Do you span the centuries as far as Moses? Can you remember the time of Solomon? Were you planted before the seed of Rome took root in Italy? At any rate, tell me whether or not your birth belongs to the Christian centuries; whether we must write "B.C." or "A.D." against your infancy. I promised the stalwart greybeard that I would tell nobody, or at most only the *Transcript,* if he would just drop into my ear the hour of his nativity.[58]

1 Linnie Marsh Wolfe's *Son of the Wilderness: the Life of John Muir* (New York: Alfred A. Knopf, 1945; reprinted by the University of Wisconsin Press, 1978) is the best source for the biographical details of Muir's life. Shirley Sargent's *John Muir in Yosemite* (Yosemite: Flying Spur Press, 1971) is an excellent guide to Muir's Yosemite activities. She has also just recently edited the diaries Hutchings kept on his voyage to America and on his journey overland to California: *Seeking the Elephant, 1849* (Glendale, CA: Arthur H. Clark, 1980). The revised edition of the same author's book on Galen Clark, *Galen Clark: Yosemite Guardian* (Yosemite: Flying Spur Press, 1981) also contains valuable information on Hutchings, as does the chapter, "Hutchings' Harem," in her *Pioneers in Petticoats: Yosemite's Early Women 1856-1900* (Yosemite: Flying Spur Press, 1966).

2 Wolfe, 23.

3 Sargent, *Pioneers*, 34.

4 Wolfe, 53.

5 Wolfe, 104.

6 Wolfe, 105.

7 Josiah D. Whitney, *Yosemite Guide-Book* (Cambridge, MA: University Press, 1869), 83-84.

8 See Clarence King, "Field Notes and Observations on the Yosemite Valley and Surrounding Country, Oct and Nov 1864." Manuscript in the Henry E. Huntington Library, San Marino, California.

9 Sargent, *Pioneers*, 30.

10 May 28, 1848 (Page 45 in *Seeking the Elephant*).

11 June 4, 1848 (Page 49 in *Seeking*).

12 June 18, 1848 (Page 57 in *Seeking*).

13 1855 Diary, June 3.

14 1855 Diary, June 3.

15 1855 Diary, December 23.

16 "In the Heart of the California Alps" (reprinted by Outbooks, Olympic Valley, California, no date) 14.

17 P. 14.

18 P. 16.

19 Pp. 19-21.

20 Pp. 22-23.

21 The reader should realize that the term God-Flower is as literal for Muir as the term God-Man is for Christians.

22 P. 23.

23 *My First Summer in the Sierra* (Boston: Houghton Mifflin Company, 1911) 157.

24 James Mason Hutchings, *1875 Diary*. Owned by Shirley Sargent. Quoted with permission.

25 Boston: James R. Osgood and Company, 1872. Reprinted by the University of Nebraska Press, 1970.

26 I have used Thurman Wilkins, *Clarence King* (New York: Macmillan, 1958) for biographical information on King.

27 *History of the Sierra Nevada* (Berkeley: University of California Press, 1965) 133.

28 *Mountaineering,* 110.

29 P. 292.

30 P. 210.

pervades them is a boyish exuberance over the scenic wonders of the valley. He is extraordinarily resourceful in helping his Bostonian readers to imagine, in terms they are familiar with, the stupendous size of its mountains, trees, and waterfalls. Most readers are understandably wary of the exaggerated accounts of travelers to fantastic places. King knows this and resorts to a number of stock devices (like confessing, "I, too, doubted before I saw with my own eyes") to gain credibility with his audience. But it is mainly his unabashed enthusiasm and the novelty and specificity of his comparisons that persuade his readers to drop their scepticism and read him with open mind. He is like a kid making an incredible discovery out west and writing wild-eyed and breathless back home to the east to report his findings to staid adults.

As he prepares to leave Galen Clark's cabin at Wawona for the Mariposa Grove of Big Trees, he acknowledges his doubts about their existence:

Was it possible that, before sunset, I was to stand by a living tree more than ninety feet in circuit, and over three hundred feet high? Think what these figures mean, my hasty reader, when transformed into solid bark and fibre. Take a ball of cord, measure off a hundred feet from it, cut it and tie the ends, and then by the aid of four or five companions stretch it into a circle, and imagine that space filled with the column of a vigorous cedar. Now conceive this tree rooted on the Common near the Park street entrance. What do you say to the idea of looking up its smooth trunk to a point higher than the topmost leaf of any elm on the Tremont street mall, and of seeing there a bough thicker than the largest of those elms shooting out from it? What do you say to the possibility, if it lay hollowed on the ground, of driving a barouche and four through it, without their being able to touch the highest point of its curved ceiling "with a ten foot pole?" . . . If such a Colossus should spring near the frog pond, the old elm would look, by the side of it, like General Tom Thumb at the knee of Hercules.

Oh, well, he concludes, even if the trees are fictitious, he will enjoy the ride to the grove, since "flowers are plenteous along all the steadily rising trail."

He does not hide his disappointment as he approaches the first of the Sequoias. It does not look all that big. Perhaps, he thinks, this is a small one, probably only forty feet in circumference. So he takes out a measuring line, fastens one end to the bark with a knife, and walks around the trunk:

The line was seventy-five feet long. I came to the end of the line before completing the circuit. I had dismounted before a structure eighty-four feet in circumference and nearly three hundred feet high, and I should not have guessed that it would measure more than fifteen feet through.

He immediately realizes why he has been fooled. This tree is among a hundred others equally huge:

This crowd of majestic forms explains the disappointment in first entering the grove. The general scale is too immense. Half a dozen of the largest trees spaced half a mile apart, and properly set off by trees of six and eight feet in girth would shake the most volatile mind with awe.

On his way out of the valley by the northern route, he stops by the Merced Grove where the first Sequoia he sees is surrounded by "some ordinary firs":

How majestic it swelled and towered! My companion and I both exclaimed, this is the largest tree we have yet seen; this will measure more than a hundred feet. . . . It seemed profane to put a measuring tape upon such a piece of organized sublimity. But we wanted to know how much more than a hundred feet could be claimed for it, and I made the trial. It was just fifty-six feet in circuit,—but a little more than half the size of the monarchs in Mariposa. There were a hundred trees in the Mariposa grove larger than this, and all of them together did not make half the impression on me that this one stamped into the brain at the first sight. We need to see the "Mother of the Forest" towering near Trinity Church in New York, and overtopping its

search party finds Egremont's body at the foot of Glacier Point, horribly shredded by a cascade down 3000 feet of sharp granite. The next day they discover Zanita lying face up in Mirror Lake. Her father believes that Egremont pushed her off Half Dome and later committed suicide, but the reader knows what Rosalind and Kenmuir intuit, that precisely the reverse is what actually happened.

Zanita is not nearly as bad a novel as the critics would have us believe. Both Zanita and Mrs. Brown are compelling, complex characters; the supporting cast, especially Kenmuir and Egremont, are entertaining, though more one-sided. Yelverton is exceptionally good at describing the humorous assortment of minor figures in Yosemite: Bill the guide, Methley the recluse, and the backwoods family of Radd, his loudmouthed wife Nell, and their Lassie-like dog Rollo. The plot is sufficiently involved to keep us interested, and the denouement is artfully and suspensefully handled. Above all, the novel raises some profound questions about the relationship of nature and culture. According to the myth of the noble savage, people raised in nature have none of the vices of civilization. According to the myth of the depraved savage, people raised in nature have none of the redeeming graces of civilization. Zanita is both noble and depraved. While depravity wins out in the end, there is a strange loveliness about her body floating tranquilly on the waters of Mirror Lake. Gazing sorrowfully at it Mrs. Brown remarks, "Look how beautiful she is; this is not death as we regard it; it is only a change as the oak leaves change, and the ferns are golden, and water dried into silver sand. The child of the mountains! See how she sleeps in her cradle of glory."[53] Zanita, daughter of Yosemite, has returned to her mother. Yelverton thus avoids much of the simplistic thinking indulged in by Yosemite's most outspoken advocates. The best of all possible worlds, of course, would be marriage between the civilized man sensitive to nature and the natural but loving woman of the wilderness. Appropriately, the novel concludes with Mrs. Brown meeting Kenmuir and Rosalind on their honeymoon.

Thomas Starr King[54] arrived in San Francisco from Boston in April, 1860, to become pastor of the First Unitarian Church. From boyhood he had visited the White Hills in New Hampshire, and beginning in 1853 had written a series of letters to the *Boston Transcript* reporting on his vacations there. As he left for California these letters were being published in book form under the title, *The White Hills: Their Legends, Landscape, and Poetry.*[55] He brought with him to the west coast, therefore, a reputation as passionate lover of nature as well as impassioned pulpiteer. For him nature reporting and preaching went hand in glove. Since he saw a "passage of Scripture written on every cliff,"[56] his forays into the mountains were to him what sequestered reading of the Bible was to more orthodox Christian ministers.

Hardly had King unpacked his trunks than he was planning a trip to the sculptured cliffs of Yosemite. He departed San Francisco on July 11, 1860, spent the 14th among the Sequoias of the Mariposa Grove, and got his first view of the valley from Old Inspiration Point the following day. After only two full days in the valley he hurried back to report to his parishioners the spiritual lessons written there. He also decided to take up his old habit of writing travel letters to the *Boston Transcript.* In all, eight widely read letters were published, beginning in December of 1860 and ending in February, 1861. In 1962 they were gathered into a book, with the title *A Vacation Among the Sierras: Yosemite in 1860.*[57]

Curiously enough, although he preached several sermons on Yosemite immediately after his return, theological commentary is entirely absent from the *Transcript* letters. What

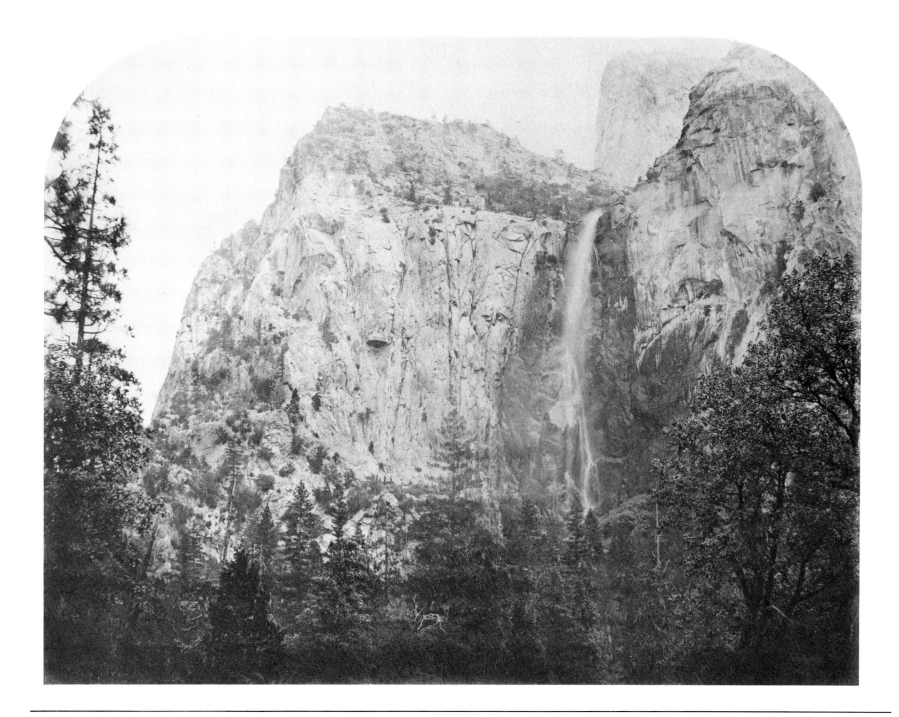

Plate 16. Carleton Watkins. *Bridal Veil Falls.* 1861. Mammoth-plate. Henry E. Huntington Library and Art Gallery, San Marino, California.

of a series of better ones in the next few years probably explain why in subsequent visits he spent so much time redoing old work.

Watkins' 1861 valley floor photographs are best understood in the light of the problems the valley presents to any picture-taker. The main problems are: 1) how to show off the grandeur, enormous size, and sculptured character of its features taken individually; 2) how to show the interrelation of two or more of these landmarks; and 3) how to present a panoramic impression of the valley as a whole. These problems are difficult to solve because big things do not automatically look big in a photograph and because cameras, except for stereoscopic ones, are one-eyed and so tend to flatten any scene they photograph. Anyone who has tried to overcome these difficulties can appreciate how diverse and subtle are the clues we use in everyday life to judge both size and depth.

Watkins again and again took a frontal approach to individual landmarks. He set up his tripod directly in front of the object, aimed the camera straight ahead, and shot. Aesthetically speaking, he did not always hit the bull in the eye. Take "Yosemite Falls (front view) 2630 ft" (Plate 17) as an example. Placing the falls dead in the center of the picture kills any sense of movement. The falls look as if they are not falling. They also look flat. Little sense is given of how far in front of the upper fall the lower one is, or of how sculptured the cascades and the cliffs to either side are. Maybe flatness is an inevitable result of a frontal approach, and therefore an unfair criticism to make. But the drama of falling water and the sculptured quality of the surrounding landscape can be captured, as Ayres' "The Yosemite Falls" (Plate 2) amply demonstrates. He used light and shadow to bring out the texture of the cliffs and to counterpoint the vertical drop of the falls, and he used a varied, broken line of trees and people that seem well in front of the falls to emphasize depth. Watkins' foreground, by contrast, consists of even lines of meadow and trees that seem flush with the canyon walls, and no shadows are present to mold the cliffs into varied shapes. Moreover, a striking result of Ayres' frontal approach is sense of height. In Watkins' photograph one can rationally deduce that the falls are high by referring to the trees or by looking down at the title for some precise figures, but the picture itself does not communicate a feeling of great height.

Watkins' frontal approach was more successful when he moved in toward the subject until, as in "Cathedral Rock" (Plate 18), it filled up the entire frame. In some ways Cathedral is the most impressive rock in the valley. It does not jut out the way its neighbor, El Capitan, does; nor does it have the fascinating sliced-loaf morphology of Half Dome. But for pure sculptured thickness it is in a class by itself. Where El Capitan is upright and seems to "stand" and "tower" over the observer, Cathedral seems to "sit" with its broad, slightly rounded base directly on the ground and its huge body tapering in, up, and away. Any successful photograph has to do justice primarily to this squat bulkiness, and Watkins and his mammoth-plate camera were equal to the task.

Fill up the frame of any negative with an object and it will seem big; fill up the frame of a mammoth negative with an object that in height goes from top to bottom and in breadth goes from side to side and it will appear all the bigger. Moreover, Watkins was able to get close enough for the wide-angle lens to make the center of the rock seem closer to us than the sides, adding the suggestion of great thickness to those of great height and great breadth. That this three-dimensional effect is not automatic can be verified by looking at almost any of the thousands of photographs that have been

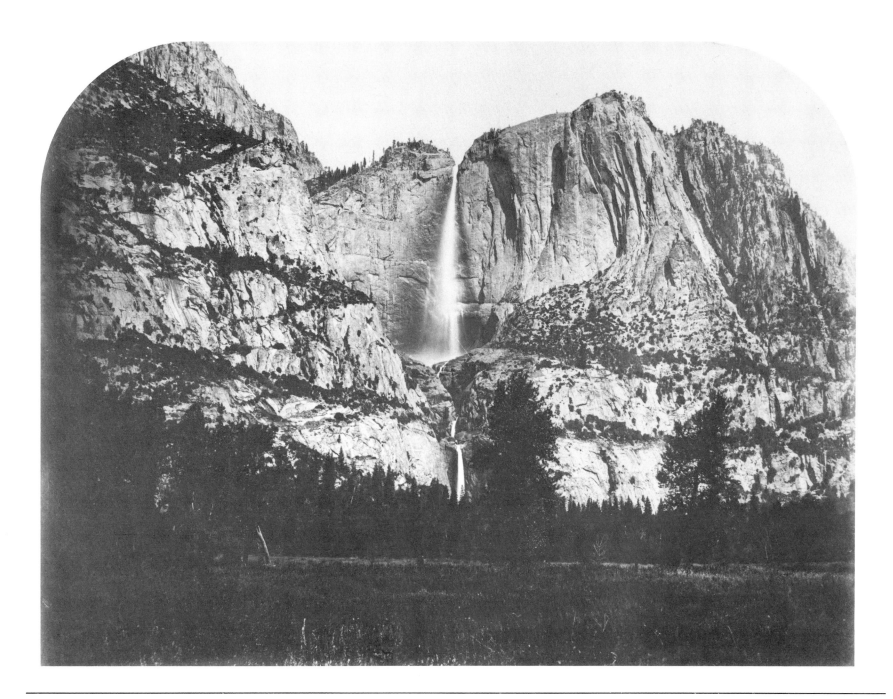

Plate 17. Carleton Watkins. *Yosemite Falls (front view) 2630 ft.* 1861. Mammoth-plate. Henry E. Huntington Library and Art Gallery, San Marino, California.

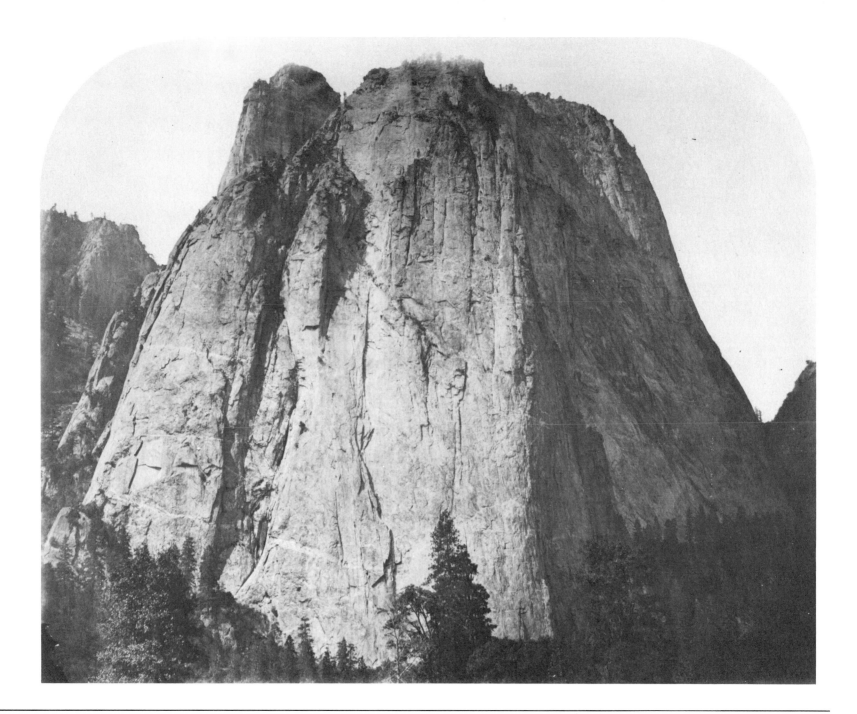

Plate 18. Carleton Watkins. *Cathedral Rock.* 1861. Mammoth-plate. Henry E. Huntington Library and Art Gallery, San Marino, California.

taken of Cathedral Rock. A limitation of the film he was using may also contribute to the success of his picture. The emulsion he poured over the glass plate was sensitive to blue light only. This means that it was far more sensitive to the blue sky than it was to the green vegetation. The length of exposure required to register details in the foliage of the trees, therefore, caused the sky and the top of Cathedral Rock to be overexposed. But far from being a defect, the brightness and loss of detail caused by overexposure augments a sense of the rock's majestical height.

In his most successful pictures using the frontal approach, Watkins backed away from the main subject, put it in the center and shot it straight on, but at the same time included diverse and non-symmetrical material in the foreground and on the sides. "Nevada Falls" (Plate 19) is an excellent example. The reappearance of the river gives depth: first it goes over the distant falls, then disappears, then suddenly reappears in the foreground. The device is almost stereoscopic, in that the sharp juxtaposition of far and near forces us to imagine the distance the river has traveled after it falls and before it reappears. It comes sliding (water in a time-exposure does not splash) over the rocks, becomes momentarily a placid pool, and then cascades under us. The downed foreground tree that has fallen to the left and the still living tree that leans to the left offset the central position of falls and stream. Finally, the helter-skelter arrangement of the rocks in the foreground contrast effectively with the upright trees that frame the falls. Watkins liked to sight Yosemite's landmarks through trees, using them as a frame a dozen or so times with the stereo camera. The results, however, are almost always picturesque in the mildly pejorative sense of cleverly pretty. He used the device only twice with mammoth-plate views, and both times, here and in "Yosemite Falls (upper view)," the results are

natural and powerful.

Watkins spent most of his time with his mammoth-plate camera depicting one by one the outstanding features of the valley. His approach was essentially frontal and he was most successful when he moved in close to a massive object or when he included in the picture sundry details asymmetrically arranged. He spent less time photographing valley features in combination and in taking panoramic shots up and down the valley. His approach to combinations was, with one exception, the same as his approach to single landmarks: find a vantage point where two or more landmarks are adjacent to each other, place them in the center of the picture, and expose the plate. The lone exception is noteworthy, however, not only because the two items of importance, Mount Broderick (Liberty Cap) and Nevada Fall, are on opposite sides of the picture, but because the sky is used as an integral part of the composition. The film's special sensitivity to blue light plus the long exposures necessary to capture the details of trees and meadows made it impossible for him to render clouds. The sky was, therefore, always a blank region of white. Usually he avoided empty skies by filling them with the silhouettes of trees or by placing the horizon line high in the photograph. In "Mount Broderick and Nevada Fall" (Plate 20), however, he used the shape of a blank sky to balance the shapely mass of Mount Broderick's curving granite.

Watkins' attempt at panoramic views are his least successful pictures. Because such shots required that he move out into the middle of the valley where his wide angle lens made the surrounding cliffs seem small and remote, they depend for their effectiveness on his ability to coordinate a distant background with foreground items like groves of trees, the Merced River, and the bushes and debris along its shores. In other words, patterns become more important as an

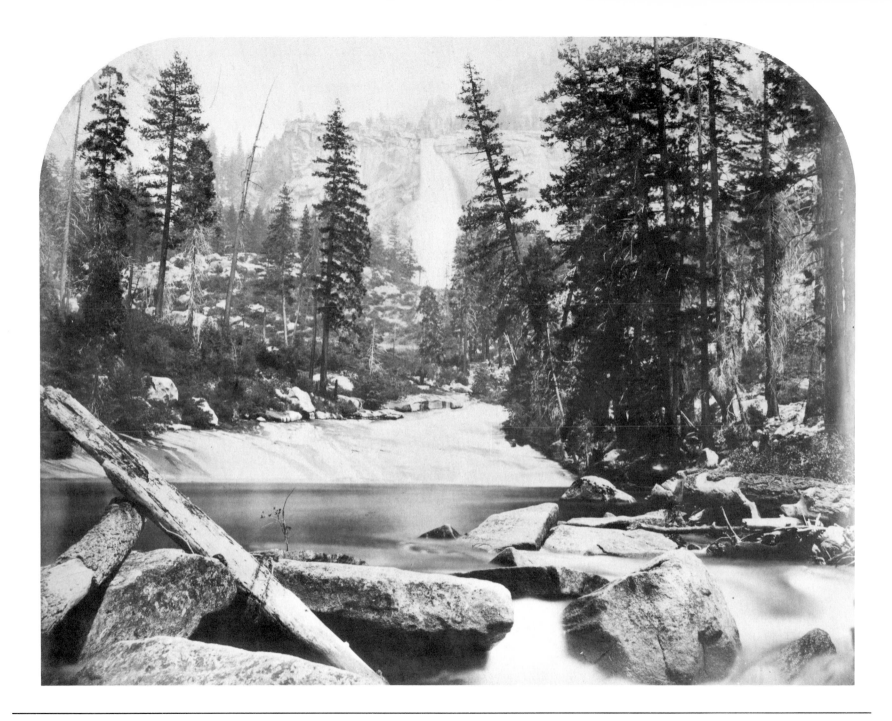

Plate 19. Carleton Watkins. *Nevada Falls.* 1861. Mammoth-plate. Henry E. Huntington Library and Art Gallery, San Marino, California.

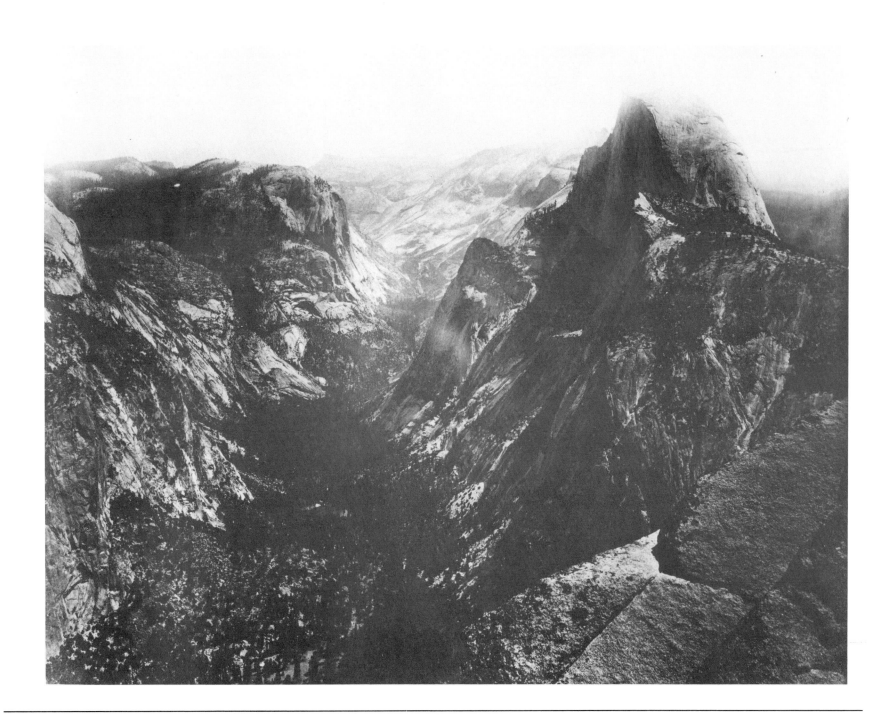

Plate 22. Carleton Watkins. *The Half Dome from Glacier Point.* 1866. Mammoth-plate. The American Geographical Society Collection of the University of Wisconsin-Milwaukee Library.

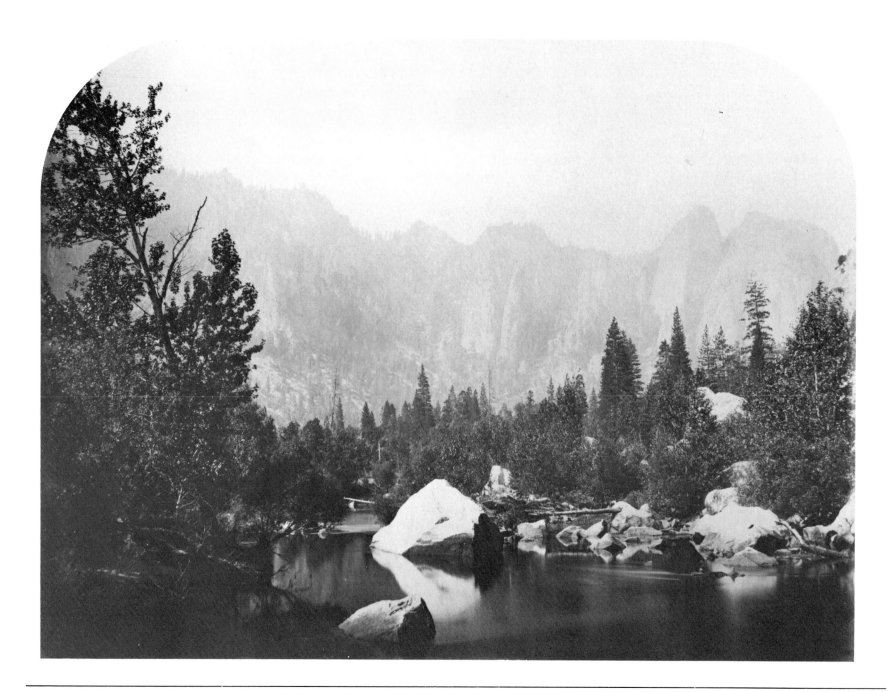

Plate 21. Carleton Watkins. *View on the Merced.* 1861. Mammoth-plate. Henry E. Huntington Library and Art Gallery, San Marino, California.

obvious center of interest recedes into the distance. And photographing patterns, despite some notable successes with the stereo camera, was not Watkins' forte. "View on the Merced, Yosemite" (Plate 21) is perhaps his best effort. Since, from where he stood, Cathedral Rock and Spires were not very imposing, he has used a line of trees in the middle distance as a harmonic counterpoint to the horizon line formed by the south rim. And then he has focused our attention on a large rock in the river, which, because of the long exposure, acts like a diffuse mirror to the rock and to the boulders along its shore.

In 1866 Watkins went for the first time along the south rim, where the photographic problems he faced were different in kind from the ones he had already encountered in the valley. Down below he had photographed objects; up on the rim he was, in essence, photographing space. How to give the viewer the sense of deep and distant space: that is the basic assignment the rim sets for any photographer. It is not an assignment easily accomplished. From Glacier Point, Tenaya Canyon opens up below as a spectacular rock-bound valley, Half Dome on one side, North Dome, Washington Column, and Watkins' namesake, Mount Watkins, on the other, with Clouds Rest and the High Sierra in the far distance. Why not tilt the camera down, put the canyon itself in the center, running its course upward to a high horizon defined by the distant peaks? Presumably Watkins thought this method would work, for he tried it (Plate 22). Unfortunately, this photograph is virtually all background. Except for the edge of some foreground rocks quite poorly integrated into the overall composition, no clues exist in the photograph to indicate how far away the landscape is, how big the mountains are, or how deep and long the canyon is. Consequently, it is an imperfect witness to the grandeur of the scene.

Photographs of large and glorious landscapes that are all background are almost always visual failures. But the solution is not as simple as including just any nearby piece of a rock or limb of a tree. Foreground details must be integrated into the overall design and enhance the grandeur of the landscape that opens up out beyond it. Three times in 1866 Watkins found brilliant solutions to this problem. The three photographs are, in my opinion, his masterpieces. How good "The Yosemite Valley from the 'Best General View'" (Plate 23) is can be demonstrated by comparing it with Weed's 1864 mammoth-plate view from the identical spot (Plate 6). First of all, Watkins eliminated the people. Maybe a person or two could have been successfully integrated into this photograph, but it is hard to imagine how. The grandeur depicted is the grandeur of nature, not of humankind. Next, he lowered his camera just slightly, just enough to cut off the top of the tree, making us look past the tree into the distance. In so doing he also raised the horizon line ever so slightly, opening up the valley just a little more than is the case in Weed's picture. All of these changes are almost miniscule, and it is hard to believe that they could make such a difference. To Weed should go the credit of seeing how effective a long, slim tree would be against the broad chasm behind it, but Watkins' refinements are what turn a good photograph into a great one.

On top of Sentinel Dome Watkins found another solution to the problem of demonstrating Yosemite's vastness. By incorporating the dome on which he was standing into the picture, he created a classical, three-tiered composition (Plate 24). The white, smooth, rounded dome in the foreground leads to and contrasts with the middleground conifers, which are darker than they look to the naked eye because of the insensitivity of the film to the longer wave lengths of light. The conifers, in turn, cut a jagged pattern across the jumble of domes and forest in the background. The distant domes echo

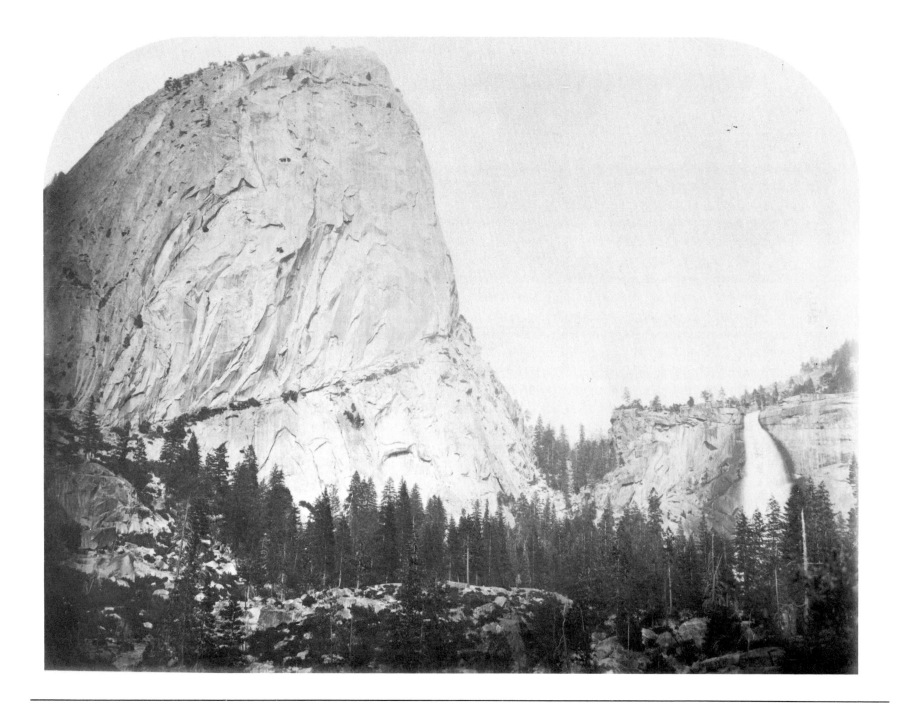

Plate 20. Carleton Watkins. *Mt. Broderick and Nevada Fall*. 1861. Mammoth-plate. Henry E. Huntington Library and Art Gallery, San Marino, California.

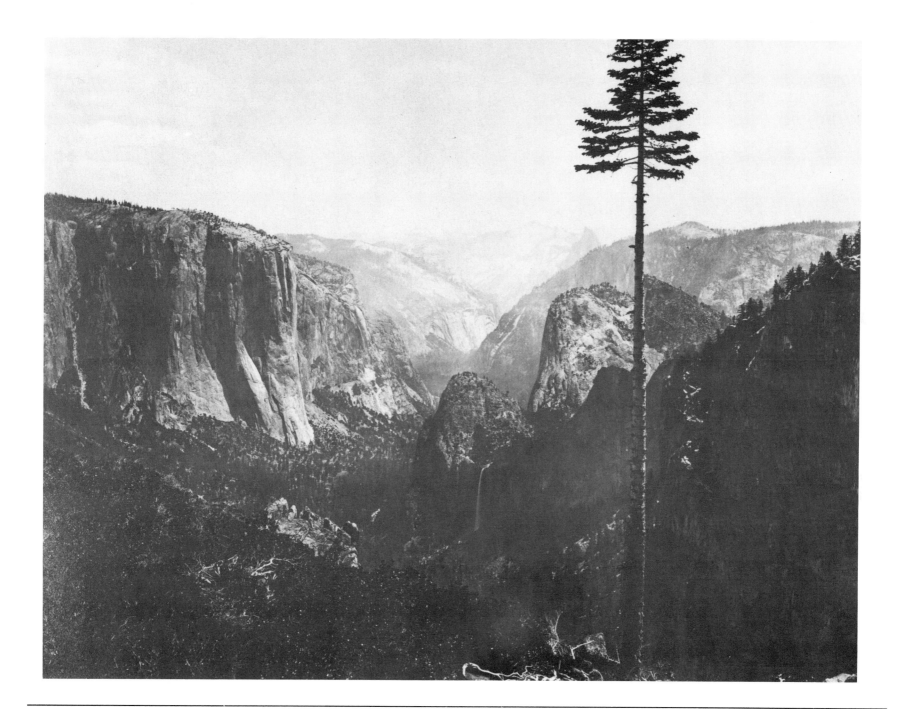

Plate 23. Carleton Watkins. *The Yosemite Valley from the "Best General View."* 1866. Mammoth-plate. The American Geographical Society Collection of the University of Wisconsin-Milwaukee Library.

71

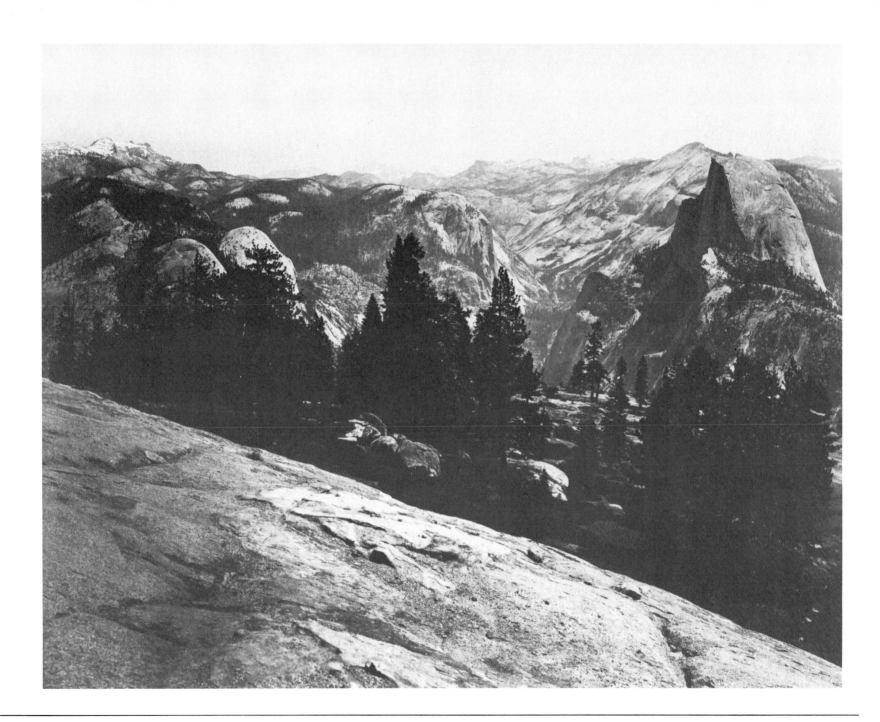

Plate 24. Carleton Watkins. *The Domes from Sentinel Dome.* 1866. Mammoth-plate. Courtesy the Boston Public Library, Print Department.

in shape and texture the single dome close at hand. The unevenness and irregularity of both middleground and background contrast sharply with the smooth foreground. The eye can bounce back and forth between the three layers for a long time without tiring of the harmonies and dissonances Watkins has created.

This photograph depends almost entirely for its artistic success on Watkins' use of Sentinel Dome as the foreground. Even the proportion of the total picture it occupies and its slant are important. Show only a little of it or make it run horizontally across the bottom, parallel to the horizon at the top, and a static, uninteresting picture will result. It comes as something of a shock, therefore, to find out that in a number of photographs he took from Sentinel Dome, the dome is either not visible at all or is barely visible and horizontally situated. All of his Sentinel Dome pictures he took on the same day. He brought at least two cameras with him, one that took negatives approximately 8″ by 12″ in addition to his mammoth-plate camera, set them side by side, and rotated them round the horizon, exposing plates as he went. One or two are great, and the rest only moderately effective. These data tend to confirm that Watkins was not actively and self-consciously building artistic values into his pictures. Surely unconsciously he was sensitive to elements of design, or no masterpieces at all would have resulted. But as he framed his pictures beneath the black cloth, he thought mainly of providing his customers back in San Francisco with adequate likenesses of Yosemite's domed landscape.

I have saved for last Watkins' most effective rendition in two black and white dimensions of Yosemite's deep and vast space (Plate 25). He set up his camera at a point near where the old Indian trail from Mariposa intersected the south rim. In this photograph, reminiscent of stereos, he included no fore *ground* at all. Consequently, it is as if the ground has been taken out from under our feet and we are suspended in space looking down breathtakingly into the mighty chasm below. We look past two nearby trees, a stock device, but used here most effectively: the trees lean each to its side, opening up the middle. In the middle a massive cliff comes in from the right; we cannot see the bottom of it, our inability to do so confirming the great depth of the valley below. Beyond it another cliff, El Capitan, comes in from the left, starkly illumined by the brilliant afternoon sunlight. Our eye picks up its shadow and follows it up the valley and on up Tenaya Canyon past Half Dome and Clouds Rest to the high Sierra. We are looking at an incomparable photograph of an incomparable valley.

With his mammoth-plate camera Watkins took a monumental approach to the task of photographing a monumental place. Many of his pictures are visually and emotionally powerful, satisfying our desire for realism and also moving us emotionally. One of the more curious aspects of his work is that he almost never included people. This is surprising, since people usually provide a good clue to scale. The effect of their absence is to make Yosemite a place austere and sublime, a place too colossal for human beings to fit into comfortably, too wonderful for their all-too-frequently petty schemes. A person in one of his pictures would trivialize the landscape. It is tempting to go even further and say that Yosemite in his photographs is holy ground. But there is nothing explicitly religious in them, no religious sign, symbol, or icon. His approach seems entirely secular. Yet the best of his work evokes from us religious feelings, if we mean by "religious" recognition of and homage to things far transcending ourselves in power and beauty.

Twenty-eight letters, most addressed to Frances Sneed, in 1880 manager of his retail store in San Francisco and in 1890

his wife, reveal Watkins as a patient, determined man, plodding doggedly on in the face of advancing age, ill health, and miserable working conditions.[7] From Anaconda, Montana, where he was photographing copper mines, he wrote:

And today it is cloudy and raining. You can imagine in what humor I am in [sic]. Nearly a month gone and nothing done.... If it was good weather I should have a tough job ahead of me and as it is it makes me pretty nearly sick. And there is provocation enough without the weather. I am in constant pain with my hip and have to limp in walking. Sometimes it seems as if I could not stand it but I have to.

A handsome financial harvest from his labors would have made the hardship worthwhile. But, realistically, he could expect no such reward. In an 1880 letter he told Frances:

When a customer comes in your place get all you can in the way of price but don't let one go [because] of price. Sell all you [can] for all you can get. That is the rule of all other dealers in my goods and I have stood out for good prices to my own detriment long enough. This year give em h—— with their own shot.

Despite all his determination by 1890 he was just about worn out. His tone has become plaintive, his attitude resigned:

Enjoy yourself as well as you can. There is no need fretting if nothing [else?] comes. The end will. That's some comfort.

Yet the letters also reveal his sense of humor and playfulness:

Helena and myself went up [to] the Presbyterian Church last night to hear the lecture on stars and the man said that the Pleadies [sic] were 9 hundred and 99 million 0000000000000000000000000 —————————

—————miles away. The first time you gave a think and then you kept up thinking all your life and you were just as far off when you got through as when you commenced. And I just said to Helena—what the use of trying to get to Heaven if its on the other side of those stars. And Helena said Who ever heard of such a *think*. [italics his]

Watkins' enduring personality comes through clearly enough in these letters, although it would be unfair to extrapolate uncritically from them to the Watkins of the 1860s, when his star was rising. Perseverence and an unbounded capacity for hard work were the traits that made him successful. While he had a good sense of humor, his wit was not scintillating; while he had a few good ideas, his mind was neither keenly analytical nor penetrating; his education and his ability to write were unremarkable; his religious posture, his attitude toward his family, his opinions about life in general were not noteworthy. In short, in most respects he was a typical, solid American citizen of his time; his life, while hard and at times tragic (twice he lost his studio, once to a man and once to an earthquake), was more or less straightforward, certainly not the stuff which romantic novels are made of.

On the other hand, it is doubtful that one of Hollywood's wildest plots could do justice to the life of the other great early Yosemite photographer, Eadweard Muybridge (pronounced ed' ward my' bridge).[8] Born just plain Edward Muggeridge in 1830 in Kingston-on-Thames, England, he came to America probably in 1852 and had arrived in San Francisco by 1856, where he was a bookseller. In an advertisement for an agent in a San Francisco newspaper on April 28, 1856, Muggeridge has become Muggridge. Less than a month later in another advertisement it has become Muygridge. During a visit to England in the early 1860s he changed his profession to photography and, by the time he returned to San Francisco, his name was Eadweard Muybridge.

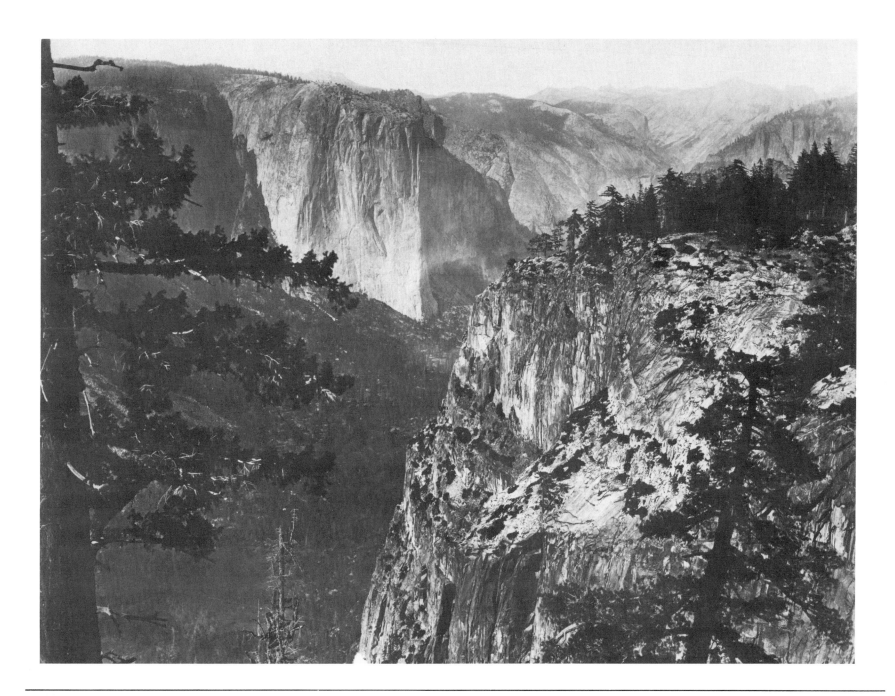

Plate 25. Carleton Watkins. *First View of the Yosemite Valley, from the Mariposa Trail.* 1866. Mammoth-plate. Courtesy the Boston Public Library, Print Department.

What was he trying to accomplish by these successive changes of name? Probably most fundamentally a change of identity. His humble birth and his most unromantic sounding name did not fit with the figure he wanted to cut out for himself in San Francisco: celebrity, eccentric photographer, companion of the wealthy. In 1871, having become famous for his photographs of Yosemite, Alaska, and other places along the west coast, he married Flora Shallcross Stone, almost 20 years his junior and a recent divorcee. After two years of apparently happily married life, Flora became friends with a young rake about town, Harry Larkyns. Muybridge's long absences from home on photographic assignments not only served to increase his wife's interest in Larkyns but also gave the pair freedom to conduct their illicit affair. When she gave birth to a son in April of 1874, Muybridge thought the son was his own. About six months later he was apparently set straight by the midwife, who gave him letters exchanged between his wife and Larkyns and showed him a picture of the child, on the back of which Mrs. Muybridge had inscribed, "Little Harry." The next day Muybridge hunted Larkyns down at a ranch in Napa County and killed him.

The trial was sensational. The juicy details of the secret love affair were disclosed to the court. The reputation for eccentricity Muybridge had cultivated stood him in good stead: defense witnesses spoke of his erratic behavior, including being photographed sitting with his feet dangling off of one of Yosemite's high cliffs. His attorneys, instead of entering a plea of insanity, cited his mental stress and suggested that what he did was normal: any man would do the same under like circumstances. The jury, after a day's deliberation, returned a verdict of not-guilty.

During the 1870s Muybridge, using an elaborate series of cameras and electrically-released shutters, successfully cap-tured Leland Stanford's trotter Occident in motion, proving that all four of a horses' feet are off the ground at one point in the gallop. That feat catapulted the photographer into international fame. He spent much of the remainder of his life, first at Palo Alto and later in Philadelphia, taking pictures of animals and humans in motion and experimenting with "motion" pictures. Although the title is hotly disputed, his biographer, Gordon Hendricks, calls him "the father of the motion picture." He died in 1904 at his birthplace, Kingston-on-Thames, in England.

Muybridge's first trip to Yosemite was in 1860, in the days before he was a photographer. Apparently the place made quite an impression upon him, for almost immediately upon returning to San Francisco from England, he launched his photographic career with an expedition to the valley that lasted five months. He was there from June to November, 1867, taking pictures with a 6x8 camera and a stereo. Back in San Francisco he published 260 views, 100 6x8s and 160 that were either stereos or "for the album," that is, prints made from one-half of a stereo. All of these photographs are signed in Greek, "Helios" (the Greek word for sun) and he called his traveling darkroom "Helios' Flying Studio." To some extent the use of this pseudonym was another of Muybridge's theatrical ploys to call attention to himself. But it was also a sound business move, serving effectively to distinguish him from already established competitors like Weed and Watkins. The signature "Helios" is a sure sign that a Muybridge print of Yosemite was taken in 1867.

Some of his 1867 stereos are as unusual as was his life. He took advantage of the stereo's portability and ease of use to make experiments that reflected his own interests and personality. For example, he was fond of posing as an aficionado of classical civilization (hence "Helios" as a

Plate 26. Eadweard Muybridge. *Charon at the Ferry.* 1867. Stereograph. Courtesy The Bancroft Library.

Plate 27. Eadweard Muybridge. *Spirit of Tutochanula.* 1867. Stereograph. Courtesy The Bancroft Library.

Color Plate 9. Gilbert Munger. *Yosemite Valley Scene.* 1876. Oil on canvas. 20 × 28 inches. City Acquisition Fund Purchase, Oakland Museum.

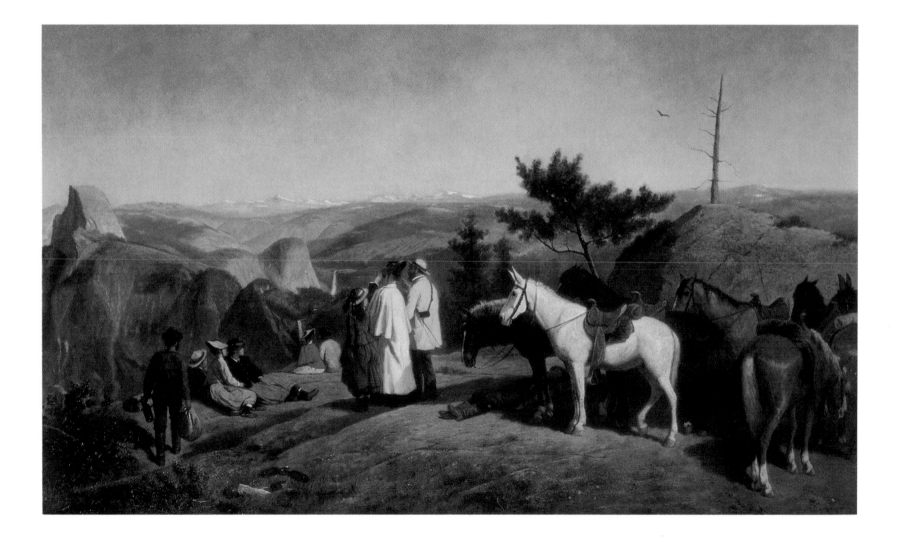

Color Plate 10. Wilhelm Hahn. *Looking Down on Yosemite Valley from Glacier Point.* 1874. Oil on canvas. 27¼ × 46 inches. Courtesy California Historical Society, San Francisco/Los Angeles.

Color Plate 11. Constance Gordon-Cumming. *Indian Life at Mirror Lake.* 1878. Watercolor. 29½ × 19¼ inches. National Park Service, Yosemite Collection.

Color Plate 12. Christian Jorgensen. *Half Dome from Washburn Point Area.* No date. Watercolor. 17 × 13 inches. National Park Service, Yosemite Collection.

Color Plate 13. Harry Cassie Best. *Yosemite Valley.* No date. Oil on canvas. 31 × 45 inches. Courtesy Virginia Adams and Michael and Jeanne Adams.

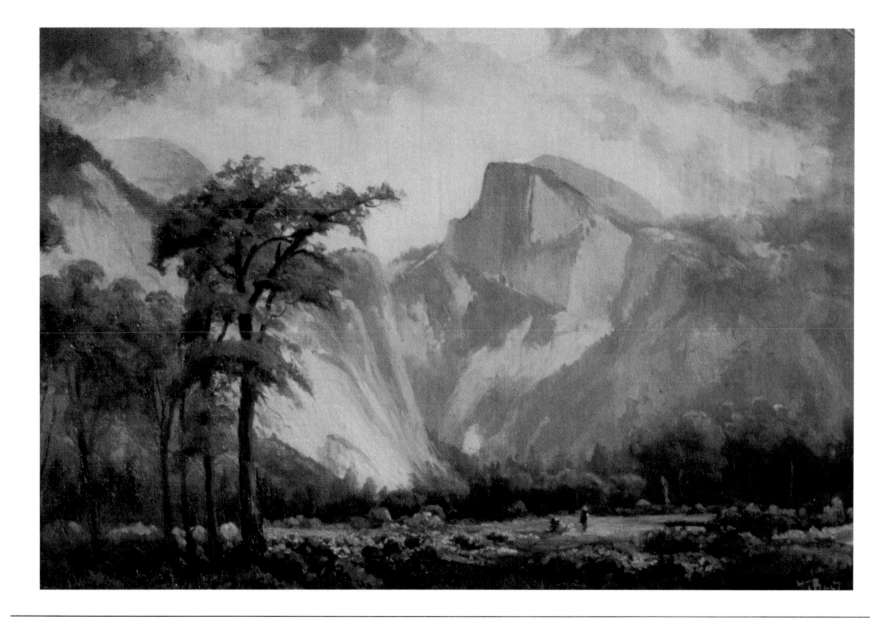

Color Plate 14. Harry Cassie Best. *Half Dome.* No date. Oil on canvas. 12 × 18 inches. Courtesy Virginia Adams and Michael and Jeanne Adams.

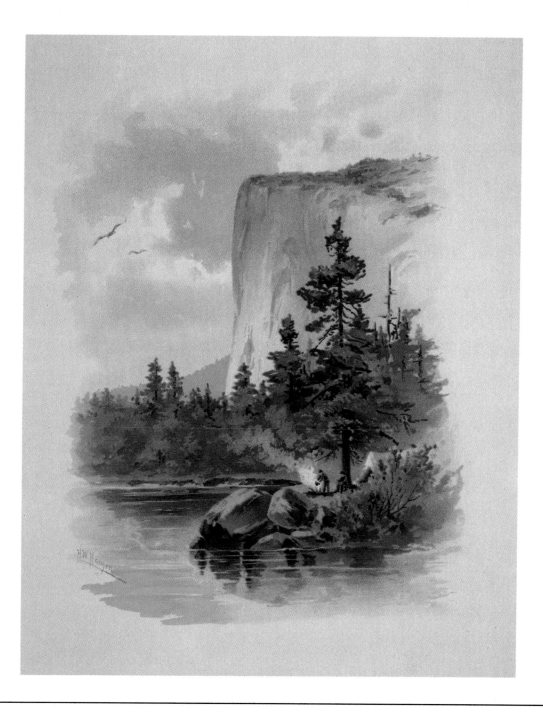

Color Plate 15. W. H. Hansen. *El Capitan.* 1890. Watercolor. Reproduced in *Yosemite Illustrated.* San Francisco: H. S. Crocker Co., 1890.

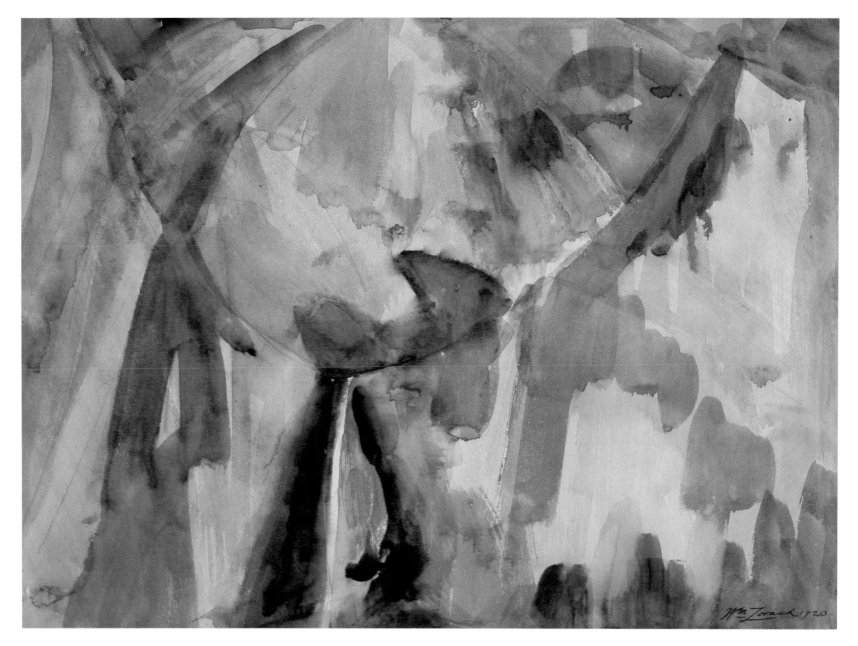

Color Plate 16. William Zorach. *Bridal Veil Falls in Yosemite Valley.* 1920. Watercolor. 13 × 18 inches. Courtesy Fresno Arts Center, Gift of Tessim Zorach and Dahlov Ipcar (Children of William Zorach).

pseudonym). So in Yosemite he posed a man on a Merced River boat dock, took his picture and captioned the resulting stereo, "Charon at the Ferry" (Plate 26). He also took a fancy to the Ahwahneechees and their culture. He used Miwok place names in the titles to the 1867 pictures, and in one of the weirdest photographs ever taken in Yosemite, he caught the "Spirit of Tutochanula" (the Ahwahneechee name of El Capitan and of the chief who lived on its summit), complete with horns, walking beside the river (Plate 27).

But far more interesting than these gimmicks is Muybridge's preoccupation with debris. Not only in picture after picture of famous landmarks did he include debris in the foreground, but he also photographed it for its own sake. Of course, debris is present in many of Watkins' prints. But there it is randomly scattered around the edges of the picture; it is not important and so is not integrated into the overall composition. With Muybridge it is different. The points of view he chose often call as much attention to the debris as to the main attraction. "Third Fall of Yosemite, Low Water" (Plate 28) is a good example.

On one level Muybridge's predilection for debris can be explained by the nature of stereoscopic photography: a prominent foreground increases the sense of depth in the scene. But this is not a sufficient explanation, since his preoccupation with it shows up also in his larger formal pictures. On another level his obsession may be a result of his search for the unusual and the picturesque; there is an undeniable charm in old logs, dead trees, and the like. But his debris is usually not picturesque. Instead of being artistically arranged it is tangled and confused, even ugly. Clearly, then, his use of debris goes beyond both the expedient and the photogenic and becomes a hallmark of his vision of Yosemite. His photographs seem to say that not everything in the valley is characterized by order and classic beauty. Lying all about is randomness, disarray, confusion. Next to the sublimely monumental, seemingly permanent cliffs is the frail and transient: old snags, fallen trees, and dead limbs scattered helter-skelter by the force of moving water.

The 6x8 views also expressed Muybridge's personality, but in a more formal way. One of Nevada Fall with a rainbow and one of Yosemite Falls surrounded by an early morning fog showed his flair for technical innovation. In depicting the ephemeral effects of sun and weather as well as the permanence of granite, these photographs represented genuine progress beyond what Weed and Watkins accomplished. More important, many of the 6x8s were taken from unusual, often dramatic perspectives. Whereas Watkins kept to the beaten path, Muybridge prospected energetically for just the right vantage points. His photograph of Illilouette Fall (Plate 29) is a good example of the lengths to which he would go. Muybridge climbed up past the fall (carrying camera, glass plates, chemicals and darkroom tent) and nestled himself as far back into the U of the canyon as possible. The picture was taken looking back down the gorge. On the right the fall seems to be coming straight at you; then it turns and flows away from you down the left side of the picture. In the distance rise the shoulder and head of Half Dome.

Also characteristic of Muybridge's 6x8 work is his use of light. In much of Watkins' Yosemite photography no shadows are present to indicate the presence of the sun. For this reason objects seem to exist in eternity not in time, to be permanent instead of transient. And even when shadows are present they contribute little to the design or impact of the composition. Muybridge, on the other hand, often chose to take his pictures when sunlight played obliquely over the surface of cliffs, revealing their contours. He even integrated

Plate 28. Eadweard Muybridge. *Third Fall of Yosemite, Low Water.* 1867. Stereograph. Courtesy The Bancroft Library.

Plate 29. Eadweard Muybridge. *Toloulooack Fall.* 1867. 6 × 8 inches.
Courtesy The Bancroft Library.

shadows into the basic design of his pictures. An excellent example is "To-coy-ae (Shade to Indian Baby Basket)" (Plate 30).[9] It, like "Tolouloack Fall" (Plate 29), was taken from Illilouette Gorge. The design made by the various cliffs is interesting in itself: the side of Panorama Cliff in the right foreground, taking up about a third of the space and slanting from the top border to the bottom; the side of Glacier Point in the left foreground; and the shoulder and head of Half Dome in the distance. Watkins undoubtedly would have photographed the scene in flat light in order to show this design. Not Muybridge. He has exposed the plate when the sun has cast the shadows of the cliffs behind him out into the middle of the scene. The shadows begin in the upper right on the side of Panorama Cliff and then jump dramatically into the center of the picture, both giving a sense of depth and making a line that offers a counterpoint to the lines of the cliffs.

Overall, Muybridge's work with the 6x8 camera exhibits a subtle care with overall composition. Watkins chose his vantage points according to the access they gave to his main subject and let everything else in the picture pretty well take care of itself. He exerted little time or energy in integrating trees, water, meadow, or debris into the overall composition. So his approach was fundamentally a straightforward one. Muybridge, on the contrary, frequently viewed famous landmarks obliquely or from a distance, so that arrangement is of greater importance in his work. "Scene on the Merced River" (Plate 31) is a good example. The famous subjects in this photograph, Half Dome and North Dome, occupy only a small portion of the total space. They are in danger of becoming little more than backdrop to a foreground that dominates our attention. Muybridge has averted this danger by very effective compositional devices. The trees on either side frame the domes and keep our attention from wandering off. Behind the trees on the right Glacier Rock slopes gradually down in the direction of the domes, leading our eyes toward them and, at the same time, providing a dark mass that contrasts with their lighter tones. Complementing its downward inclination is the line of the Merced River, curving upstream from below the trees on the right and into the center of the picture. Above the point where the line of the river almost intersects the line of Glacier Point rise the two domes. In the river are sundry rocks of various size and some downed timber, this casual debris contrasting with the stateliness of the mountains in the background.

Muybridge returned to Yosemite in 1872, this time with a mammoth-plate camera. He probably felt he needed mammoth-plate views to keep up with Watkins, his chief competitor. Stylistically, the resulting views continue and perfect the elements already present in his 1867 6x8s. He became a master at finding just the right, often unusual perspective that subtly integrates all aspects of the composition into a harmonious, visually compelling whole. If the *Alta California* for April 7, 1872, is correct, he became even downright fanatical in searching for times and places that suited his fancy:

He has waited several days in a neighborhood to get the proper conditions of atmosphere for some of his views; he has cut down trees by the score that interfered with the cameras from the best point of sight; he had himself lowered by ropes down precipices to establish his instruments in places where the full beauty of the object to be photographed could be transferred to the negative; he has gone to points where his packers refused to follow him, and he has carried the apparatus himself rather than to forego the picture on which he has set his mind.

In his mammoth-plate views from the south rim he faced the same problems Watkins faced: how to give in two

Plate 30. Eadweard Muybridge. *To-coy-ae (Shade to Indian Baby Basket).* 1867. 6 × 8 inches. Courtesy The Bancroft Library.

Plate 31. Eadweard Muybridge. *Scene on the Merced River.* 1867. 6 × 8 inches. Courtesy The Bancroft Library.

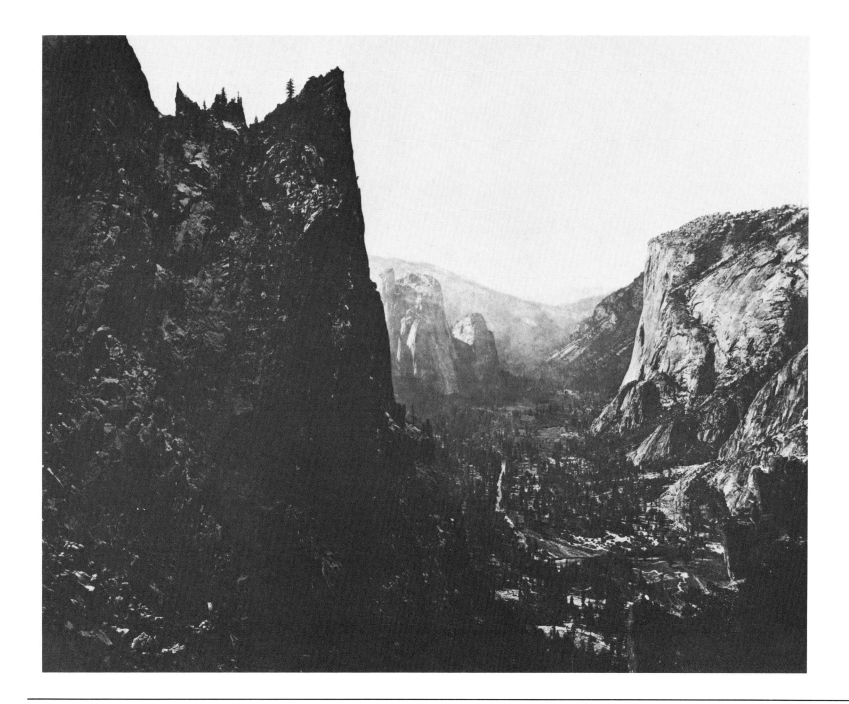

Plate 32. Eadweard Muybridge. *Valley of the Yosemite from Union Point.* 1872. Mammoth-plate. Courtesy The Bancroft Library.

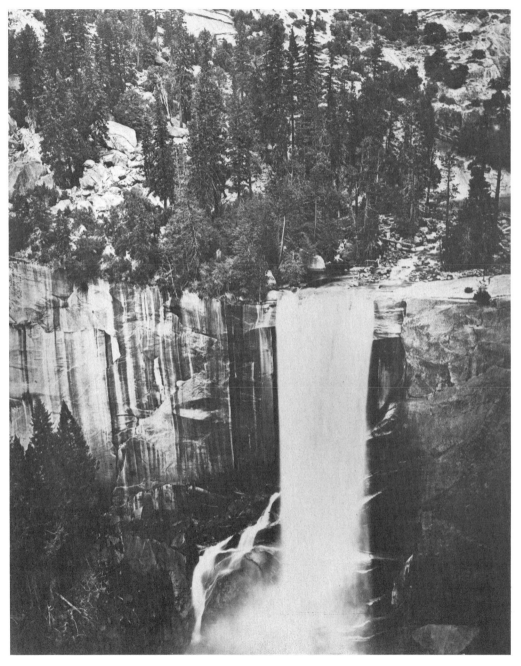

Plate 33. Eadweard Muybridge. *Pi-wy-ack (Shower of Stars), Vernal Fall, 400 feet.* 1872. National Park Service, Yosemite Collection.

dimensions a sense of depth and distance. In 1867 he had slavishly imitated some of Watkins' solutions (for example, his photograph of Tenaya Canyon from Glacier Point and his view of Yosemite Falls from Sentinel Dome are virtually duplicates of Watkins'). But in 1872 he found a solution that grew naturally out of his own earlier work: he eliminated middleground altogether and sharply contrasted foreground and background by shooting when the former was in deep shade and the latter in full sun. What results is a striking pattern of light and dark that is interesting in its own right and also dramatically demonstrates the great depth of the valley (Plate 32).

Another unusual mammoth-plate is "Pi-wi-ack (Shower of Stars), Vernal Fall, 400 feet" (Plate 33). To begin with the vantage point is unusual. Most of the early photographs of Vernal Fall were taken from below the fall. For this exposure, however, he was above the fall near the present horse trail to Little Yosemite Valley. But more unusual than the perspective is the composition: he has placed the rim of the fall right across the middle of the photograph. Ordinarily a definite line in the middle of a picture divides it into two separate and equally static halves, eliminating any sense of movement. Also, one would ordinarily want to give a fuller sense of the total design of the fall by placing the rim higher in the composition. Ansel Adams, in a personal interview, criticized Muybridge on just this point.

Yet, his photograph succeeds brilliantly precisely because he did not do what would normally be expected of him. I have never seen a photograph of falling water that communicates so fully the effect of water falling. Placing the top of the fall in the middle of the picture is partly responsible. It allows him to show us how steep the canyon walls above the fall are, and, by cutting off the stream below, makes us focus on the water in

the act of falling. A peculiarity of a camera's rectilinear frame further heightens the effect. When a camera is pointed upward, parallel lines appear to converge, making buildings, for example, look as if they are falling over backwards. Pointing a camera down produces the same result in the opposite direction. The water stains on the side of the cliff appear to converge ever so slightly, making it look as if the cliff face is falling down and away from the viewer. Consequently, the drop appears greater than vertical, an illusion that augments the viewer's sense of vertigo.

Of all the famous landmarks in Yosemite perhaps none is so inconspicuous as Sentinel Rock (whose Indian name was Loya). Its unimposing mass and its unimpressive shape virtually force a photographer to depict it in relation to its total environment. Since Muybridge was at his best in dealing with relationships, it is hardly surprising that his mammoth-plate view of it is among his very best (Plate 34). From the top right the south rim slopes gently downward, interrupted by the skyline of Sentinel Rock. Just below the Rock are several doubly symmetrical cedars (symmetrically shaped, their image in the river makes a larger symmetry). Also reflected in the water is the rim to the left of Sentinel Rock but not the Rock itself. Muybridge thus avoided what would perhaps be too formal and imposing a symmetry. As it is, the irregular pattern of trees to either side of the cedars and the random debris in the river play off against the more formal pattern of reflected trees to make a complex, though understated photograph.

On the heels of Weed, Watkins, and Muybridge came dozens of other photographers during the 1860s and 1870s. Most were after stereoscopic views. The basic idea of stereography was first proposed by the English physicist Charles Wheatstone in 1838. No practical method of mass produc-

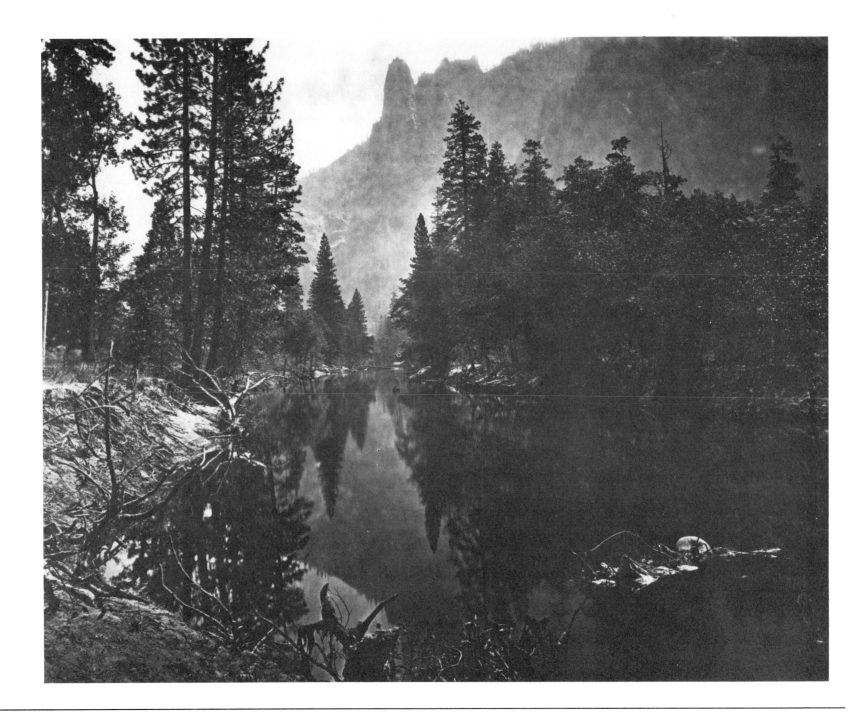

Plate 34. Eadweard Muybridge. *Loya (The Sentinel)*. 1872. Mammoth-plate. National Park Service, Yosemite Collection.

tion was available, however, until the early 1850s, when it became possible to make quickly and inexpensively glass transparencies and paper prints of high quality. Stereographs give an illusion of presence as well as an illusion of depth. Because the scene fills up the entire field of vision, it is as if one were not looking at a photograph (which is flat and has boundaries clearly separating it from the surrounding world) but were instantaneously transported to the place itself.

Photographers were quick to realize how great the potential market for stereoscopic cards was. They went far and near collecting views, and eventually publishers marketed encyclopaedic sets that covered almost every place on earth. Of course, Yosemite was a must in any publisher's catalogue. So to Yosemite came photographer after photographer with stereoscopic equipment. Charles Bierstadt, the brother of Albert, C. L. Pond, J. J. Reilly, T. C. Roche, and J. P. Soule were a few of the more prominent. Sometimes they marketed their views under their own names, sometimes they sold them

Plate 35. Walker and Fargerstein. *Campers, May 20, 1877.* 1877. Stereograph. Collection of Shirley Sargent.

to companies like Houseworth in San Francisco and Anthony in New York that specialized in publishing photographic prints.

On the whole the stereography of Yosemite is not very distinguished, nor is the work of any one photographer easily distinguishable from that of his competitors. Without the name on the stereo card it is difficult to sort out Roche's work from Soule's or Pond's from Reilly's. All take certain set views from virtually identical points of view, such as posing tourists in front of Yosemite Falls (Plate 35). All use identical composi-

tional formulas and employ the same techniques to heighten the three-dimensional effect. Posing old snags or dead limbs in the foreground was one tediously overdone device (Plate 36). This photograph was unquestionably made from two negatives, one of the land and another of the sky. Reilly was able to achieve in the darkroom what his blue-sensitive film would not permit in the field. By the 1880s stereography had become as routine and uncreative as most postcard photography is today.

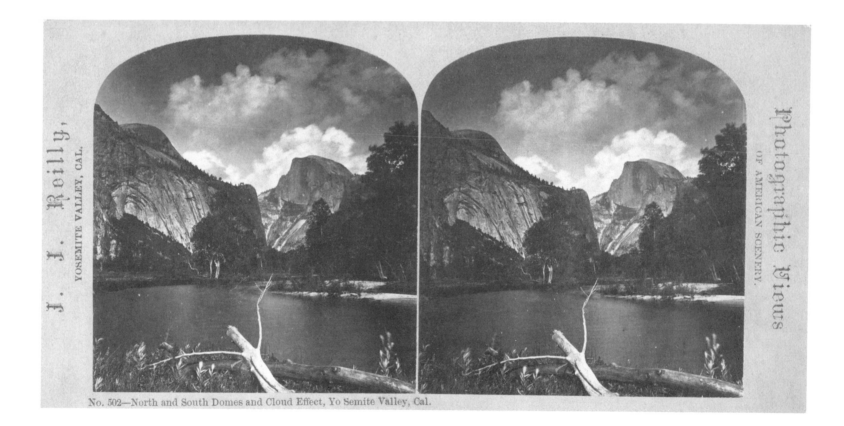

No. 502—North and South Domes and Cloud Effect, Yo Semite Valley, Cal.

Plate 36. J. J. Reilly. *North and South Domes and Cloud Effect.* No date. Stereograph. Collection of Shirley Sargent.

1 Throughout this book the unmodified noun "photography" refers to the black and white variety only. Color photography will be discussed in Chapter Seven.

2 For biographical information on Watkins the writings of Peter Palmquist have been the most helpful to me. Time and again he has brought living information out of dry bones in dusty archives. Pauline Grenbeaux and Nanette Sexton have also done important work. The special issue of *California History* (Volume 57, 1978), guest edited by Pauline Grenbeaux, and Weston J. Naef, et al., *Era of Exploration* (Buffalo and New York: Albright-Knox Art Gallery and the Metropolitan Museum of Art, 1975) are the best general sources of information on him. The most important single document for reconstructing his life was written by Charles B. Turrill, a California photographer who befriended Watkins in his old age ("An Early California Photographer: C. E. Watkins," *New Notes of California Libraries* 13 [1918] 29-37).

3 "Before Yosemite Art Gallery: Watkins' Early Career," *California History* 57 (1978) 230.

4 A stereoscopic camera is one with two lenses that operate simultaneously and are set approximately 2.5 inches apart, the distance between the eyes. The pictures it takes, called stereographs, look three-dimensional when viewed in a device called a stereoscope.

5 "Watkins' Style and Technique in the Early Photographs," *California History* 57 (1978) 246ff.

6 The Baird Collection, so-called because they were originally owned by Spencer F. Baird, then Assistant Secretary of the Smithsonian Institution, is now in the Museum at Yosemite National Park.

7 These letters are in the Research Library at Yosemite National Park.

8 For biographical information on Muybridge the following sources have been the most helpful: Gordon Hendricks, *Eadweard Muybridge* (New York: Grossman, 1975); *Eadweard Muybridge: The Stanford Years, 1872-1882* (Palo Alto: Stanford University Museum of Art, 1972); Mary V. Hood and Robert Bartlett Haas, "Eadweard Muybridge's Yosemite Valley Photographs, 1867-1872," *California Historical Society Quarterly* 52 (1963) 5-26; and Weston J. Naef, et al., *Era of Exploration* (Buffalo and New York: Albright-Knox Art Gallery and the Metropolitan Museum of Art, 1975).

9 To-coy-ae was the Ahwahneechee name for North Dome. Half Dome is shown in the photograph. Thus, Muybridge misidentified either the dome or the photograph.

Painting, Literature, and Photography, 1880-1920

AFTER 1880 the art of Yosemite changes noticeably. To some extent the difference is qualitative: the art of the period between 1880 and 1920 is not as good as that of the previous decades. The high standards of excellence set by Bierstadt and Hill, by Watkins and Muybridge, and by King and Muir are no longer generally attained. But to say this much and no more is very misleading. It is not that the artists after the eighties tried to match the splendid works of their predecessors and failed. Rather, what they attempted was more modest. Thus, instead of disparaging their art because it will not fit one of Watkins' mammoth frames, one should look at it on its own terms and judge it according to the context in which it was produced. So evaluated, its merits are considerable.

The key question is this: what was happening in Yosemite that made the artists of this period fix their sights on less exalted targets? The answer is that Yosemite the wilderness was being tamed. It was gradually, but ever so surely, being made into a home for valley residents and a park for valley visitors. Galen Clark, Yosemite's first state-appointed Guardian, became a year-round resident in 1874. A year later telegraph cables were laid. In 1876 the Yosemite Valley School District enrolled its first students, and the first chapel was built three years later. The Degnans opened their bakery in 1884, valley residents could talk to the rest of the world by telephone beginning in 1891, and from 1902 generated their own electrical power from a plant built at Happy Isles.

As Yosemite received the comforts of home, some of its photographers and painters began moving in. Up to the 1880s artists had come to the valley to work while living and maintaining studios elsewhere. But George Fiske, formerly an assistant to Carleton Watkins, lived year-round in the valley during 1879-80 and opened his studio for business in 1884. Another photographer, Gustavus Fagersteen, applied for a business permit the following year and from 1886-89 ran a studio in a building originally designed as a laundry. By 1907 three other photographers had set up shop: Daniel Foley in 1891, Julius Boysen in 1900, and Arthur Pillsbury in 1907. In the meantime two painters had opened studios, Christian Jorgensen in 1898 and Harry Best in 1902.

Symbolically, the most important structure built was the chapel. Its construction signaled a fundamental change of attitude toward Yosemite. Galen Clark understood what was at issue. For him Yosemite itself was already a chapel, the

"sanctum sanctorum of Nature's vast mountain temple."[1] Therefore, erecting a manmade chapel was "like building a toy church within the walls of St. Peter's Cathedral at Rome."[2] But Clark's opinion did not prevail, a clear sign that the people who came to live in the valley did not consider it a sacred place, whatever Bierstadt or Muir or Clark might say, but an ordinary place, like any other spot where people live. Ordinary places need sanctuaries in their midst to mark the presence of the divine. So Yosemite needed, and got, its chapel. In other words, with domestication came secularization. Yosemite was, after all, situated east of Eden.

As the valley became a home for residents it was also being converted from a wilderness into a park. Hutchings estimated that between 1855, the year that he himself organized the first tourist party, and 1864 the total number of tourists in the valley was about 700, or an average of only 70 per year. In 1869, the year the continental railroad was completed, the total was 1122. In 1874 rival crews raced to finish the first coach road into the valley, the Coulterville gang finishing just one month ahead of the competition from Big Oak Flat. Both entered from the north, but just one year later the Wawona Road from the south was completed. That year the total number of visitors was 2423. By 1907, when the Yosemite Valley Railroad began service to El Portal, the number had risen to 7102, and between 1914 and 1915, because of the opening of the park to automobiles, the most dramatic increase occurred: from 15,154 to 31,546. Now tourists could ride in comfort all the way into the Sierra Nevada's inner sanctum.

Meanwhile hotels and campgrounds were built to accommodate all these visitors. In 1869 A. G. Black tore down the old Lower Hotel at the foot of Sentinel Rock and replaced it with an elongated shed-like building known as "Black's Hotel." In the same year George Leidig built just west of Black's a hotel of his own. The following year Hutchings, who had in 1864 bought the Upper Hotel near the present Sentinel Bridge, added the Rock and River Cottages nearby, and Albert Snow built "La Casa Nevada" below Nevada Fall. In 1872 James McCauley completed a horse trail from Black's and Leidig's hotels to Glacier Point and before the end of the decade finished his Mountain House to accommodate guests on Yosemite's rim. A year after the Sentinel Hotel was opened in 1876 a Mr. A. Harris organized the first campground facility for private parties. The grandfather of today's public campgrounds, it was situated near the present Ahwahnee Hotel. Yet another hotel, the pretentious Stoneman House, was erected in 1886, and just before the end of the century, in 1899, David and Jennie ("Mother") Curry planted the first hybrid lodging in the valley. A cross between a public campground and a private hotel, their camp served meals and provided maid service for customers living in rustic tents situated among the rocks and trees. The innovation was enormously successful and within a decade the Currys had two competitors, Camp Lost Arrow on the site of the present Yosemite Lodge and Camp Ahwahnee under Sentinel Rock.

Increased numbers of tourists and construction of roads and hotels are important evidence that Yosemite was being transformed into a park. More decisive still are two other tourist-related developments. One is the introduction of "artificial" entertainment. For example, in 1872 the Cosmopolitan House, containing saloon, billiard hall, bathing rooms, and barber shop, opened for business. C. P. Russell, Yosemite historian and Superintendent from 1947-52, says that "the various unexpected comforts provided by [the] Cosmopolitan left lasting impressions that *vied with El Capitan* when it came to securing space in books written by visitors" [italics

mine]³. Or, again, there was the firefall from Glacier Point, introduced by James McCauley perhaps as early as 1871. For McCauley and those visitors who cheered the nightly firefall, nature needed to be supplemented by man-made imitations: on the north rim Yosemite Falls, on the south McCauley's firefall. Just as the chapel shows Yosemite's "fall" from the sacred to the profane, this firefall symbolizes its "fall" from the sublime to the level of a curiosity.

Management of the natural environment also shows the transformation of Yosemite into a park. The activities of Guardian Galen Clark are particularly noteworthy. A recessional moraine stretches across the valley between El Capitan and Cathedral Rock. This moraine so dammed the spring flood waters of the Merced River that meadows remained marshes well into summer. For mosquitoes the morainal dam was a boon, but, needless to say, tourists did not share their view. So Clark dynamited the moraine in 1878. Before the end of the century he began the dredging of Mirror Lake to make sure it stayed a lake, cleared the Mariposa Grove of debris, and put up handrails on some of the mountain overlooks.

Against Hutchings' charges that he had mismanaged the park, Clark defended himself in a letter printed in the San Francisco *Examiner* on February 18, 1894. He stated the case for management clearly and succinctly:

If Yosemite is to be maintained as a Park for Public resort and recreation, a careful and judicious use of the axe and fire will be absolutely necessary.

In Clark's behalf it should be said that he used fire and axe not only to make Yosemite a pleasant place for "public resort" but also to restore it to something like its pristine state. In his final report to the Commissioners, submitted as he retired in 1897, he said that "some efficient system for the protection and preservation of the banks of the Merced River . . . from the strong flood currents . . . is most imperatively needed," and pleaded that the meadows be reclaimed from cottonwoods, willows, and pines until the "whole valley is again restored to its original superior beauty." Yet the banks of the Merced were rapidly eroding and the cottonwoods creeping out into the meadows partly because Clark himself had blasted the moraine. He was caught in the vicious vortex that sucks in anyone who manages nature: fix this and you undo that.

The change in attitude demonstrated by management policies, unnatural entertainment, and building of the chapel was reflected in the eyes of those who beheld Yosemite in the decades from 1880 to 1920: it was more pretty than sublime, more pleasant than paradisiacal, more a place in which to be refreshed than regenerated, more a vacation spot than a temple. And, of course, the art of these decades grew out of and reflected the new attitudes. The document that best illumines the context of Yosemite art during this period is the National Park Service's "File 900: A. C. Pillsbury." Arthur Pillsbury maintained a photographic studio in Yosemite from 1907, when he bought out the firm of Hallet-Taylor, until 1928, when he sold out to the Yosemite Park and Curry Company. The letters between Pillsbury and various officials of the National Park Service were stored in the Yosemite Record Center until 1940, at which time they were transferred to a regional storehouse in San Bruno, California. In 1979 Mary Vocelka, Park Librarian, discovered them there and retrieved them for the Yosemite Library.

"File 900" reads like a long, somewhat tedious Victorian novel. It has characters, three groups of them to be precise. One set consists of the studio photographers: Pillsbury himself, Julius Boysen, Daniel Foley, and Harry Best, who, though a painter, had some photographic work done in his

studio. Pillsbury is, of course the "hero": enterprising, self-promoting, something of a mechanical wizard, stubborn, irascible, almost certainly deceitful on occasion, especially in matters having to do with his own financial welfare. Because he is so complex he gains and holds our attention. The other studio artists remain on the periphery of the action. Usually Pillsbury quarrels with them as he jockeys for a competitive edge. Every so often he urges them to join forces with him against the Enemy.

The enemy is at first two, the Curry Company and the Yosemite National Park Company, and, after their merger in 1925, one, the Yosemite Park and Curry Company. These companies are never as villainous as he makes them out to be. Most of the time, in fact, they are fairer to him than he to them. But, still, they are big and successful whereas he is small and must continually struggle to make ends meet. Moreover, he believes that they are consistently given a strategic advantage by the third set of characters, the officials of the National Park Service. These people are rational, polite, and ostensibly fair, though occasionally two-faced, praising Pillsbury to his face and denouncing him to each other.

"File 900" also has a plot. The regular beat of chronological time is marked by the periodic renewal of Pillsbury's concessioner's license and by the inevitable letter from the government reminding him that payment is due, followed two weeks later by another protesting that he has not yet paid, followed in another week by his payment. Contrapuntal with this beat are the syncopated rhythms of his personal and professional life. Persistently he makes various requests of the Park Service:

to open a branch at Camp Curry (denied)
to stage an open air stereoptican show (granted)

to own pack animals and to pasture them near his studio (denied)
to tether a mule in front of his studio for picture taking purposes (granted)
to pick wild flowers for close-up photography (denied)
to have automobiles stop by his studio to be photographed below Yosemite Falls (granted)
to expand his studio (granted)
to take motion pictures of an automobile on the Fallen Monarch (granted)
to fly into Yosemite taking motion pictures (granted; in fact, Park Service Director Stephen Mather is so excited by this idea that he suggests that he and the state governor be present)
to build a small cabin for himself and his wife (granted)
to build a motion picture studio for the showing of scenic and regular motion pictures (granted)

These are the little matters that demand attention and cause headaches. The two big issues are the length of his lease and the excessive competition. Time and again he pleads for a multi-year lease so that he can make long-range plans without fear of an abrupt termination of his contract. Until the mid-twenties the Park Service turns a deaf ear. In a letter to the Interior Department dated October 30, 1913, Acting Superintendent Major W. T. Littebrant explains why one-year leases are a good idea: "it enables the Government to more easily control the concessionaires." Only when the Park Service demands that Pillsbury move to the New Village (the present Yosemite Village), a move requiring a considerable outlay of capital, does it grant a longer, fifteen-year lease.

Pillsbury's most formidable competition is the Curry Company. It wants independence from the small studios by

95

having the right to sell photographic prints purchased from suppliers outside of Yosemite. This means that the company can reap a financial harvest without having to invest in expensive equipment and facilities. Pillsbury's problems with the Curry Company come to a climax over the move to the New Village. He mounts a multi-faceted offensive: he wants all parties, the company and the studios, to move at the same time; he wants the Curry Company store built beside his studio; he wants not only their photographic but also their curio concession. While the last of these demands is patently unfair, the first is unquestionably reasonable: if the studios are off to themselves in the new location while the crowd-drawing store remains behind, their business will obviously suffer. The Park Service agrees with him and promises that the move will be made in unison. Yet, in fact, Curry does not move when the others do.

"File 900" also has a theme: the swallowing of the small by the big. In 1927 Pillsbury's motion picture theatre burns. He lays down certain stipulations that must be met before he will rebuild, and he threatens to sell if they are not met. The Park Service responds that they cannot be met and asks him for a price. He says $12,000. Donald Tresidder, son-in-law of the Currys, is present and promptly buys him out.

"File 900" reveals the problems that an artist with a studio in Yosemite had to deal with to be successful. Some of these problems were non-artistic, like keeping up with the competition. Artists had continually to elbow their way into new and unexploited areas of the tourist trade and at the same time keep abreast of the opposition's plans and complain vehemently to the Park Service over real or presumed mistreatment. All in all, the competition was, as Pillsbury put it, "beyond all reason in excess of the demands," significantly inhibiting both the taking of profit and the making of fine art.

Other problems were artistic. Chief among them was rendering Yosemite as park. Because they sold their work to tourists and because it was reproduced primarily in books for tourists, they needed to picture Yosemite as the tourists wanted to see it: park-like, romantic, inviting, suitable for a vacation. Bierstadt's paintings hint that Yosemite is too sacred for the dusty feet and inelegant gear of ordinary people. The mammoth-plates of Watkins and Muybridge reveal a landscape that is almost too imposing and impersonal for the casual vacationer. That people are hardly ever in their pictures implies that maybe people do not belong in this place. Pillsbury's "Evening Primroses and the Half Dome" (Plate 37) is an excellent example of a photograph opposite in style and tone to theirs. The imposing feature of the landscape, Half Dome, is put in the far background and tucked romantically under the overhanging branches of a nearby tree. Over half of the picture's space is filled with flowers. Because they are small and lovable, they reduce the immense landscape to human dimensions. A comparison of Pillsbury's "The Gates of Yosemite" (Plate 38) with Muybridge's "Valley of the Yosemite from Rocky Ford" (Plate 39) illustrates graphically the difference between the two styles. Literally and symbolically Muybridge gives us no ground to stand upon. The Merced River has overflowed its banks and covers the entire foreground. To either side El Capitan and Cathedral Rock loom in the distance, seeming, because of the pervading mist, not so much real rocks as mysterious "presences." Pillsbury, on the other hand, makes out of foreground flowers and bushes a scenic place for us to stand. From it we see real cliffs and a picturesque waterfall under mildly dramatic skies. Altogether it is a beautiful place, pleasant to visit. We could camp in the meadows, hike the trails, and stop by Pillsbury's Picture Company and buy this photograph as a memento of

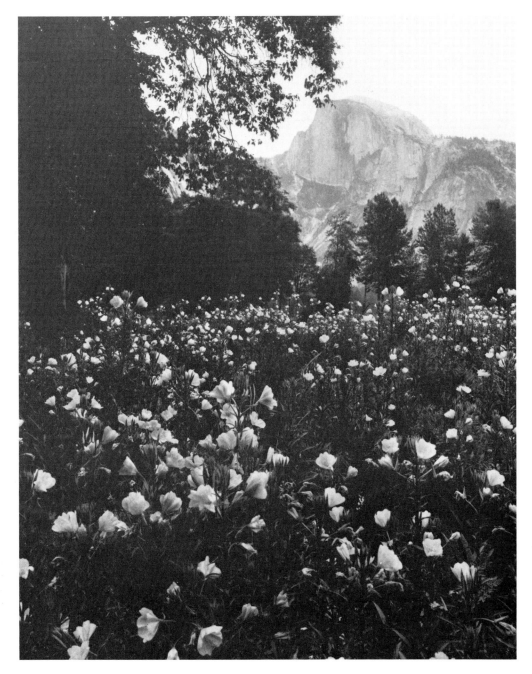

Plate 37. Arthur Pillsbury. *Evening Primroses and the Half Dome.* No date. 13¾ × 10¾ inches. National Park Service, Yosemite Collection.

Plate 38. Arthur Pillsbury. *The Gates of Yosemite.* No date. Reproduced in John H. Williams, *Yosemite and its High Sierra.* San Francisco: John H. Williams, 1914.

Plate 39. Eadweard Muybridge. *Valley of the Yosemite, from Rocky Ford.* 1872. Mammoth-plate. National Park Service, Yosemite Collection.

our vacation.

As the photographs of Pillsbury and his compatriots in the studio business, Fiske, Foley, and Boysen, are to those of Watkins and Muybridge, so are the paintings of studio owners Christian Jorgensen and Harry Cassie Best to the paintings of Bierstadt and the early Hill. Jorgensen and Best portray Yosemite as beautiful but not sublime. A native of Norway, Jorgensen was by 1870 in California. In 1874 he was a member of the first class offered by the California School of Design. Later he himself offered classes and in 1888 married one of his students, Angela Ghirardelli of Ghirardelli chocolate fame. While he was studying in Italy in 1893-94, or so the story goes, he became frustrated with his inability to answer questions about Yosemite and determined to go there upon his return. He was so taken with it that he requested permission to build a summer home and studio. Permission was granted in 1897, he opened the studio the next year, and for the following two decades spent his summers and a few winters in the valley.

Acting Superintendent Littebrant in a letter of October 30, 1913, to the Interior Department reported hearing that Jorgensen executed two classes of painting, "one to sell the general public who either does not appreciate or will not purchase... good paintings, and one for exhibition purposes." Whether true or false the very existence of the rumor attests to the economic constraints on studio artists. Generally tourists did not carry with them money sufficient to buy major works of art, nor did most of them have the expertise to distinguish works hastily done from those painstakingly executed. Thus, Yosemite's studio artists were encouraged and economically rewarded for sloppy work. Because Jorgensen was independently wealthy, he could afford the luxury of doing very fine work for exhibition; neither Best, Fiske, Foley, nor Pillsbury was in a like position.

Jorgensen worked in both oil and watercolor. The oils are a rather drab lot. More consistently than any other Yosemite painter he chose flat lighting and a dark palette. Sometimes the overall tone is blue, sometimes brown. His brush work is extremely broad, so that trees are lost in a mass of forest green and the character of individual cliffs is obscured by haze. Highlights on cliffs and snow on mountain tops are about all that save many of his paintings from being visual bores. Brilliant whites and cool blues, on the other hand, predominate in his watercolors, and individual trees and rocks, although done broadly in the usual watercolor style, stand out with a character all their own. In "Half Dome from Washburn Point Area" (Color plate 12) the eye seeks first the darker colors at the bottom and then rises as the tones gradually become lighter, resting finally on the almost sheer white of Half Dome. A hazy, white sky offers a light, even background for both monolith and trees. One cannot help wondering if Jorgensen did the oils for exhibition (oil is usually considered the medium for a painter's most serious work) and the watercolors for tourist consumption. If so, then it is ironic that close to a century later the watercolors seem fresher, more exciting evocations of the spirit of Yosemite.

Jorgensen's compatriot in paint, Harry Cassie Best, a Canadian by birth, began work as a tinsmith in Winnipeg, became a musician after he heard a band playing for skaters whose rink he was roofing, and changed from band member to painter when bookings brought him to the foot of symmetrical Mt. Hood during an exquisite sunset. After some years of study in San Francisco he accompanied the established landscape painter, Thaddeus Welsh, on an excursion to Yosemite. There he fell in love with the valley and with photographic clerk Anne Ripley. After a whirlwind courtship the couple married that very summer in a ceremony at the foot of,

appropriately enough, Bridalveil Fall. The *San Francisco Call* of July 29, 1901, noted that the wedding had a "rock for an altar" and a "waterfall furnishing the melody of a bridal march." Human musicians were hired as well, but the wedding march from "Lohengrin" was "lost in the roar of the falling waters." The following year Best opened his studio and ran it until his death in 1936, when it passed into the hands of his daughter, Virginia, and her husband, Ansel Adams, who eventually changed its name to the Ansel Adams Gallery.

Best's large panoramas are very broadly painted (Plate 13). The granite cliffs are virtually devoid of surface features. Undoubtedly he was trying to simulate the effects of haze, which, indeed, does obscure details in the middle and far distances. He was not nearly as successful as Hill, however. Consequently, the distant rock-forms seem almost like great areas of vacant, unfinished canvas. His color-work is also disconcerting. The dominant cast in virtually every painting is purple, sometimes reddish-purple, sometimes bluish. He uses for highlights reds and greens that remind one of nineteenth century hand-tinted postcards. More successful are a number of his smaller paintings (Color plate 14). Here his preference for purple works well, since on overcast days the valley is often tinted a purplish-gray. The patterns of light and dark on the cliffs complement the play of the low clouds, and the placement of the trees between the two domes is effective. The lean of their top branches directs our attention to the most important object in the scene, Half Dome. This painting catches rather well the mood of a rainy day in Yosemite.

One of the easiest ways to portray Yosemite as a place fit for a fine vacation was to put the tourists themselves into the picture. The stock in trade of the studio photographers were snapshots of vacationers on the trails or picturesquely arranged below towering pinnacles or cascading waterfalls.

Most of these pictures are formulaic in the extreme: group after group of tourists unimaginatively posed at Mirror Lake, beneath Yosemite Falls, inside the Tunnel Tree, or on top of the Fallen Monarch. The results are about as interesting as the cut and dried arrangements of people in front of an urban studio's artificial scenery. Occasionally, however, a gem was produced. In particular, Fiske and I. W. Taber, much of whose work was done in Yosemite although his studio was in San Francisco, showed real genius in using the park's natural wonders as props. In Taber's "Yosemite Stage by the Fallen Monarch, Mariposa Grove" (Plate 40), the redwood props are the real center of interest and the people distributed throughout the scene add a touch of the bizarre. The very artificiality of their poses is responsible for much of the photograph's charm.

The most artistically successful of all photographs taken from the standpoint of the tourists are a group done by George Fiske. Muybridge went up the slopes and over the cliffs to photograph from unusual perspectives. His prints are magnificent but look at the valley from vantage points casual hikers are unlikely to reach. Fiske came down from the heights to the level of ordinary people and photographed Yosemite's scenery as they saw it driving on the roads or walking along the paths. Hence visitors could experience Yosemite in his photographs as they experienced it in person. "El Capitan and Bridal Veil Fall—From Madera Road" (Plate 41) is typical of Fiske's approach, and shows how incoming tourists might see the valley. Out to the side, in clear view, stands a massive El Capitan, but a group of conifers blocks out the view up the valley and Bridalveil is barely visible through a narrow gap in the limbs. Or again, in "El Capitan—From Milton Road" (Plate 42) it is as if one is riding into the valley along the old Big Oak Flat Road and the coach is just coming

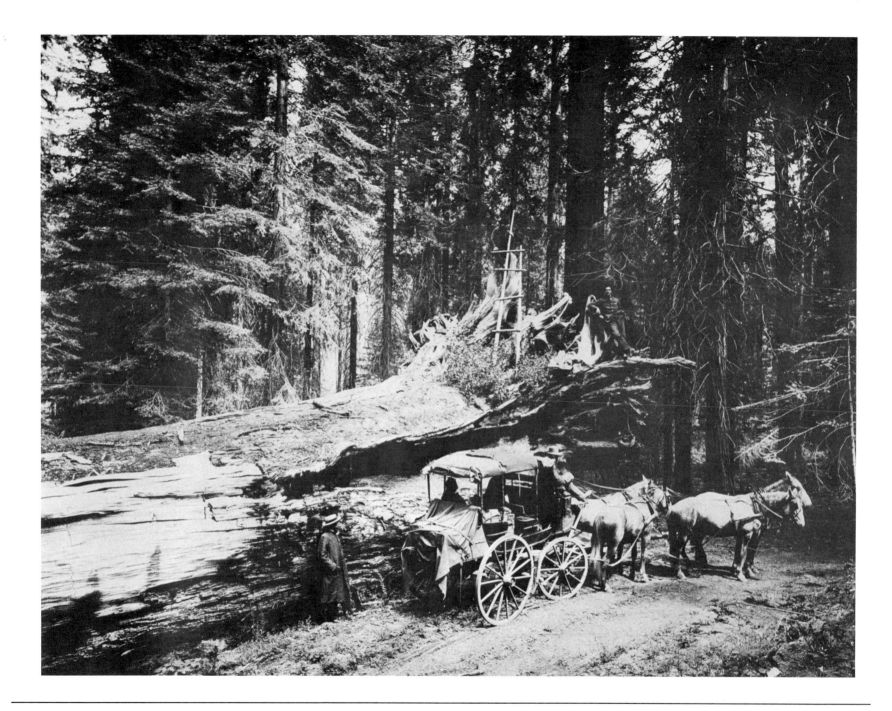

Plate 40. I. W. Taber. *Yosemite Stage by the Fallen Monarch, Mariposa Grove.* 1894. 7³⁄₁₆ × 9⁵⁄₁₆ inches. Courtesy Amon Carter Museum, Fort Worth, Texas.

Plate 41. George Fiske. *El Capitan and Bridal Veil Fall—From Madera Road.* No date. 4½ × 7½ inches. Courtesy Center for Creative Photography, Tucson, Arizona.

Plate 42. George Fiske. *El Capitan—From Milton Road.* No date. 4½ × 7½ inches. Courtesy Center for Creative Photography, Tucson, Arizona.

Plate 43. George Fiske. *Yosemite—Old Road, Horse, and Buggy.* No date. 4¼ × 7½ inches. National Park Service, Yosemite Collection.

out from under a canopy of live oaks, gradually bringing El Capitan into full view. Fiske seems to have habitually strolled with his camera along the trails, stopping to take a picture whenever the pattern of path, rocks, and trees struck his fancy. The results, as in "Yosemite—Old Road, Horse and Buggy" (Plate 43), are among his very best work.

Tourists often prefer the spectacular to the sublime and the theatrical to the beautiful. "Amazing, astounding, believe it or not," read the signs that hawk travelers into "tourist traps." Yosemite has its share of the mind-boggling, like the overhanging rock at Glacier Point and the Fallen Monarch in the Mariposa Grove. To these natural wonders people have added some more, like the Tunnel Tree, a huge redwood (now fallen) out of which Henry Washburn, one of the proprietors of the Wawona Hotel, carved a hole big enough to drive a stage through. Yosemite's artists were smart enough to realize the appeal of these curiosities to tourists and exercised no end of ingenuity in picturing them. Photographer Bert Bruce made his living doing nothing but taking pictures of tourist parties coming through the Tunnel Tree. His speciality was staging mock holdups at the Tree complete with stage frightened vacationers and bandits wielding bottles for guns. Thomas Hill's most grotesque painting shows Ahwahneechees on horseback galloping through this same tree firing at a fleeing deer (Plate 44). Aside from the stereotypical manner in which he portrays "savage" Indians, the painting is amusing, not to say hilarious. Of the many attempts by Yosemite photographers to pose people precariously perched on Glacier Point's Overhanging Rock, none is so visually compelling as Fiske's "Dancing Girls at Glacier Point" (Plate 45). Their position—one foot on a rock cantilevered high in space and one foot high in the air—dramatically conveys both a sense of the great depth of the valley and also the daring of their act.

Plate 44. Thomas Hill. *Big Tree.* No date. Oil, 33 × 88 inches. National Park Service, Yosemite Collection.

Plate 45. George Fiske. *Dancing Girls at Glacier Point.* No date. 4¼ × 7½ inches. National Park Service, Yosemite Collection.

The project that most successfully made a spectacle of Yosemite was Charles Dorman Robinson's giant panorama. Born in Maine in 1847, Robinson first came to San Francisco as a child of three. He went back east in the early 1860s to study and practice painting and did not return to the Pacific Coast until 1875. His first trip to Yosemite, made with James Hutchings as a traveling companion, took place in 1880. Three years later, on a trek to the vicinity of Old Inspiration Point, he first became aware of "the vast expanse, the noble area, of Yosemite, as well as its great vertical height. The sense of *all around largeness* was here more readily understood and acknowledged than from any point" [italics mine].[4] The stillness all about him resembled "that exalted silence the spirit must feel when soaring through space in the ever-light of eternal day."[5]

Right then and there Robinson resolved to show the world the grandeur that he had seen, and further decided that the only way of accomplishing this purpose commensurate with Yosemite's "vastness of scale . . . was to attempt it upon cyclopean proportions, or in other words, to adopt the cycloramic principle."[6] For nearly a decade he had difficulty raising money, but by 1892 he had gathered together a "company of gentlemen" willing to back him. In a building in San Francisco he set up scaffolding to support a circular canvas 50 feet by 380 feet. On the ground he laid railroad track and had built, using streetcar platforms as a base, three towers which artists could ascend in order to reach the canvas (Plate 46). As one section was finished the towers were rolled along the tracks to the next section. The canvas sagged so under the weight of the paint that twice he had to raise its "hem" to keep it off the floor.

Robinson wanted his panorama to be so realistic that viewers would have the illusion of actually standing on

Yosemite's rim gazing at the prodigious scene below. To help create the effect of verisimilitude he furnished the viewing platform with real Yosemite rocks and planted shrubbery of the species actually found there. As he said,

No pains have been spared to have the final result as realistic as it can possibly be made, on the maxim that the ideal panorama should be a *chef d'oeuvre* of realism.[7]

He also liked the idea that the panoramic scale was "too great to admit of any artistic signatures" and did not permit "any display of the artist's favorite technical methods." In other words,

the greatest of abilities are doomed to be swallowed up in their own work, and their performance to stand out like nature, but in a humble way, masterless, as a spontaneous growth in color . . ."[8]

Exactly how he thought that a painting 50 feet by 380 feet would appear humble is not clear. He was caught on the horns of a dilemma. He wanted his work to look natural, but its very size called attention to the fact that it was manmade. He wanted the personality and the techniques of the artist to be invisible, so that the painting would seem to have come into being by spontaneous generation, yet the enormity of the project inevitably made people wonder about the ingenuity of the artist in conceiving it and his artifice in constructing it. In short, the project was self-defeating: the more invisible he tried to make his hand the more evident it became. Robinson is fascinating to the historian because he seems both so much a part of his time and also out of joint with it. His realistic aims and his desire to create a spectacle seem a logical development out of tourist-oriented art. Yet his aggrandizement of

Plate 46. *Working on the Canvas from the Great Staging.* Illustration accompanying article by C. D. Robinson, "Painting a Yosemite Panorama," *Overland Monthly,* Volume 22 (1893) 243-256.

himself and Yosemite make him seem more of an heir of Bierstadt than a brother to Jorgensen and Best.

The fate of the panorama was not a happy one. Its San Francisco showing was a financial failure. Robinson took it to the Paris Exposition in 1900 but was unable to have it displayed. So he cut it up into marketable sizes and sold enough of them to earn passage back to the States. The whereabouts of the pieces is unknown.

Robinson's colossal, ill-fated panorama provides a rather apt metaphor for Yosemite verse. Poets have consistently, from the 1850s to the present, painted the valley on a huge scale with the broadest possible verbal brushes. Those who flourished during the period from 1880-1920 in no way participated in the general movement toward a modest realism, nor did their successors share in the poetic revolution of the early twentieth century. They habitually used big, abstract words, like grand, wonderful, marvelous, sublime, and beautiful. They typically chose to speak in an inflated, oratorical, overly solemn tone of voice. They employed tropes that were too exclusively serious and spiritual: Yosemite was a chapel, a church, a cathedral, paradise, heaven. Not only did they see the valley as a place where humans act out religious dramas and find spiritual repose, but also they imagined that its cliffs, waterfalls, and trees did the same. One reads, for example, of water plunging to its death over Yosemite Falls only to be resurrected in the merciful Merced below. Elevated tones and inflated vocabulary are like leaven: a little is enough. Used by the bushel they produce an airy batter, just like a painting 50 feet by 380 feet overinflates its subject. It is not surprising that people have responded to Yosemite poetry the way San Franciscans reacted to Robinson's panorama: with neglect. They have read a little and become weary. They have chuckled at its pretentiousness. It has been, for the most part, an aesthetic disaster.

Perhaps no single stanza illustrates better the tone of voice adopted by most Yosemite poets than the opening lines of Charles Wesley Kyle's "Yosemite: the World's Wonderland":

> Silence! Emotions new and strange here rise
> And sweep with cyclonic force the breast!
> A new, strange world, all powerful and sublime,
> Enchains, enslaves and fetters all;
> The greatest most of all, are fettered most;
> Only the pigmies chatter, and fools alone
> Find laughter here, where Nature speaks
> In tones of grandeur and sublimity!
> Strong lips are dumb and eyes unused to tears
> Are forced to Yield the highest tribute of the soul
> To these grand thoughts of the eternal mind!
>
> (1915)[9]

Kyle's central metaphor is that Yosemite is the expression of God's thought, and so is a holy edifice, a church. And appropriately enough he is like a preacher ascending the pulpit: "Silence!" he says, "you are in the temple of God. All trivial talk must cease. Listen to my dignified words." How rhetorical he is: note the many exclamation points. How pompous he is: implicitly he includes himself among the great who are most fettered. How serious he is, so serious that he bans laughter. While laughter may indeed be inappropriate in certain places, to call people fools who laugh within Yosemite's sacred precincts is going much too far.

Kyle's vocabulary (cyclonic, enchains, fetters, sublimity, tribute, grand, eternal) matches his ministerial inflection. His poem, like hundreds of similar Yosemite poems, is filled with one grand cliché after another. Clichés, under the guise of

saying a great deal, actually say almost nothing. Adjectives like strange, powerful and sublime can be applied to hundreds of places on earth and so say little about the particular place Yosemite. Clichés are language at its most general. Even worse, they end up having the opposite of their intended effect: Kyle's hackneyed expressions assert that Yosemite is wonderful, but they come closer to convincing us that it is trivial. He wants them to have a profound effect on our emotions, but instead they leave us disappointed.

Below is an anthology of arias on the subject of Yosemite waterfalls. They are arranged in chronological order. When they were written matters little, however. They all share the same vocabulary (note, for example, the repetition of heaven, stream, dream, and crystal), use the same meter (mostly iambic, sometimes trochaic), speak with the same dramatic tone of voice (observe the use of lo, O, Oh, and exclamation points), turn waterfalls into people, whether maidens or mothers, and express, explicitly or implicitly, religious themes. In fact, the theme in all but one is the rest or resurrection that comes after distress or death. In short, as American poetry changed in the course of the decades between the mid-nineteenth and the mid-twentieth centuries, Yosemite poetry did not change. It never pulled up its roots in the soil of English Romantic and Victorian verse and transported itself into the modern world. That is why it seems so quaint and old-fashioned. It is as if the poetic revolution led by Ezra Pound, T. S. Eliot, and William Carlos Williams never happened.

O, under Heaven! is there one
 More lovely offspring of the snow,
So cherished by the constant Sun,
 So fostered by the gale below?

In what far angel-haunted spring
 Hast thou, fair stream, thy happy birth?
What is thy will that thou shouldst fling
 Thy slender form from Heaven to earth?
. .
Forever falling, and to fall
 Forever from that cloudy gate,
And crying with incessant call
 Against the tumult of thy fate.

The valley takes thee, trembling stream,
 In smoky fragments on its breast;
Wake, giddy leaper, from thy dream.
 Here is at last some peaceful rest.

(from Charles Warren Stoddard, "Yo-Semite Falls," 1867)[10]

Lo! where the "Virgin's Tears" all silent
 glide,
Wearing the strong walls, with their solemn tide
Like noble Mary, weeping at the cross,
While Heaven and Earth quaked 'neath their
 fearful loss
And through all centuries these tears shall roll
'Till this Globe's spent—and man becomes a
 soul!

(from Jean Bruce Washburn, "Yo Semite," 1877)[11]

A burst of molten silver, born
 Of mountain snow,
That bears the beauty of the morn
 Within its flow.

A wave of streaming white that falls,
 And, falling, flings
Against the gray old granite walls
 Its silver wings.

A whitened fire from out the sky,
 Whose arrowed strands
In sunlight gleam and flash and die,
 Like earth-hurled brands.
. .

A river turned to cloud mist, blown
 By every breath,
Yet coming to its crystal own,
 After death.

(from Harold Symmes, "Cloud Mist: Yosemite Falls,"
1911)[12]

I

Such a stupendous leap! The mighty stream
 Aghast with that achievement staggers in
 distress,
Becomes a shadowy thing of dream
 Upon the brink of nothingness.
Some giant archipelago of air
 Obtruding from the clouds descends
With wavering outline . . .
. .

It floats between the earth and sky,
For sky too low, for earth too high,
 A marvel and a wonder
 Of color and of thunder.
. .

III

Blue and pink and amethyst
The sun-transformed mist
Drop by drop is reassembled, caught
 Upon the giant crags. The thing of dream
Is still of crystal beauty, taught
 Once more the use of earth; a limpid stream
Rolls through lush meadows, emerald green,
 Green as the moon in Oriental night,
 Blooming with flowers, starry bright,
 The heaven above transposed . . .

(from Caroline Hazard, "The Yosemite: The Waters,"
1917)[13]

Oh, the laughing of the waters
As it dashes wild and free,
As it thunders down and crashes
As it lashes and it splashes,
Every heartstring seems to vibrate
And a joy comes over me.

Oh, the smiling of the rainbow
As it plays at hide and seek,
In the mist there it advances,
It shimmers and it dances,
Like the dimples and the blushes
On a lovely maiden's cheek.
. .

When it [the falls] takes you to its bosom,
As your mother used to do,
And it hugs you up the tighter,

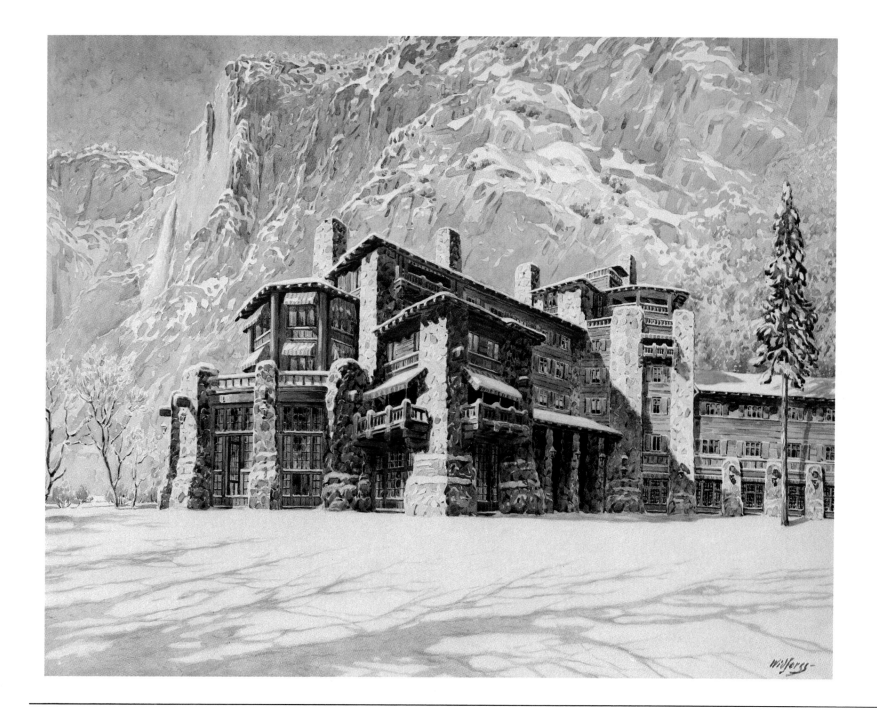

Color Plate 17. Gunnar Widforss. *The Ahwahnee*. No date. Watercolor. 17 × 21 inches. Courtesy Yosemite Park and Curry Company.

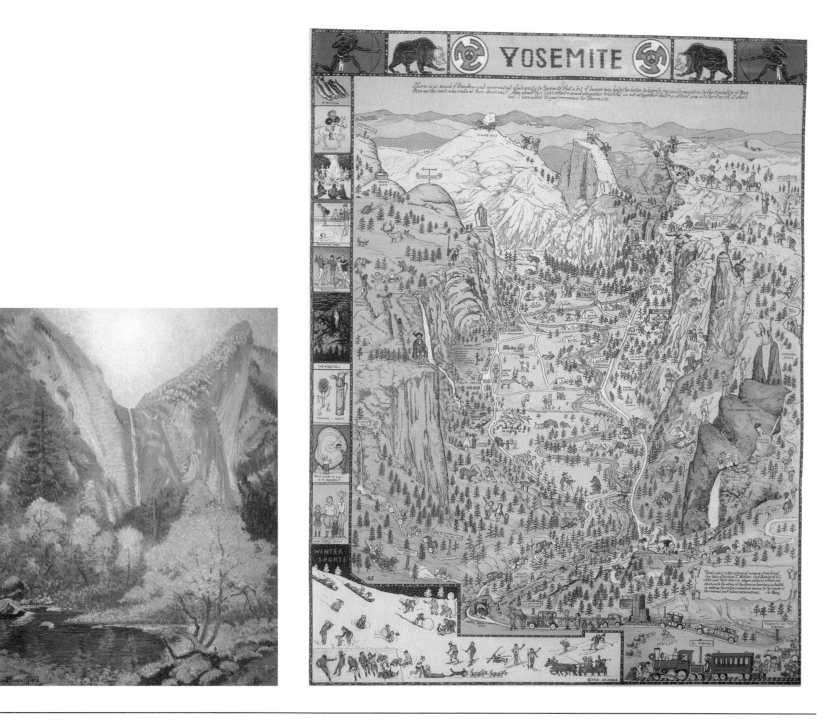

Color Plate 18. Ferdinand Burgdorff. *Bridalveil Fall, Leaning Tower, and Dogwood in Autumn.* 1952. Oil on canvas. 29¼ × 23¼ inches. National Park Service, Yosemite Collection.

Color Plate 19. Jo Mora. *Yosemite.* 1931. Map poster. 17¾ × 14 inches. National Park Service, Yosemite Collection.

Color Plate 20. Ted Orland. *One-and-a Half Dome.* 1976. Hand-colored silver print. 13¾ × 7¼ inches. Private collection.

Color Plate 21. Dana Morgenson. *Yosemite Falls . . . Cooks Meadow.* No date. 35mm slide. Courtesy Esther E. Morgenson and Yosemite Park and Curry Company.

Color Plate 22. William Neill. *Aspen Reflections, Lundy Canyon.* 1979. Courtesy William Neill.

Color Plate 23. Howard Weamer. *Muir's Primrose, Clouds Rest.* 1980. 2¼ × 3¼ slide. Courtesy Howard Weamer.

Color Plate 24. Roger Minick. *Sightseer Series, Yosemite National Park.* 1980. Courtesy Roger Minick.

Color Plate 25. Jane Gyer. *Yosemite Falls—Winter.* 1982. Watercolor. 22×30 inches. Courtesy Jane Gyer.

Color Plate 26. Wayne Thiebaud. *Yosemite Ridge.* 1975. Oil. 72 × 36 inches. Courtesy Wayne Thiebaud.

Color plate 27. Harry Fonseca. *The Legend of the Lost Arrow.* 1981. Illustration in *Legends of the Yosemite Miwok* (Yosemite: Yosemite Natural History Association, 1981).

Then your heart just beats the lighter,
While it sings to you in gladness
Til it thrills you through and through.

There the rainbow's ever smiling,
And the water's singing true,
And you feel their welcome given
Is as grand as comes from heaven.
Fills your heart clear full of gladness,
For you know its meant for you.

You will there forget your troubles
And the cares along the way,
For a happy sense comes stealing,
In your heart there is a feeling
That you're a child once again
And you want to run and play.

(from I. W. Priest, "Yosemite Falls," 1928)[14]

Without doubt the most sensitive and creative artist of the period from 1880 to 1920 was George Fiske, several examples of whose work we have already seen. He learned photography during the wet-plate period, and, in fact, served as an assistant off and on during the late 1860s and throughout the 70s to no less a wet-plate master than Carleton Watkins. Although he visited Yosemite several times during these years, he did not settle there as a year-round resident until 1879. Except for brief absences he lived in the valley from then until his death in 1918. Lonely, having outlived both his closest friend, Galen Clark, and his second wife, discouraged by business losses, and in severe pain from a brain tumor, he took his own life. A suicide note read:

Plate 47. George Fiske. *Vernal Fall.* No date. 4¼ × 7½ inches. National Park Service, Yosemite Collection.

To all who have been so kind to me, a thousand thanks. May God bless every one of them.

What is the use of trying to live, when you have so much pain life is a burden, and there is no possible relief, a burden to all your friends. I am worn out and want a rest.

Fiske came into his own as an artist after his move to Yosemite in 1879 and after the introduction of dry-plate photography to California in 1883. Perhaps the easiest way to explain the essential nature of his achievement is to say that he brought time into the Yosemite picture. The cloudless skies and the ubiquitous light of Watkins' prints made the valley seem weatherless, and therefore timeless. Muybridge did more with directional light and sometimes captured momentary cloud effects; yet weather played at best only a supporting role in his views. Moreover, both Watkins and Muybridge photographed mainly in the Sierra's dry season, which lasts from late spring to early fall. In their prints, consequently, Yosemite seems to exist in a perpetual summer of sunshine. But because Fiske photographed also in the wet season, Yosemite is subject in his prints to the seasonal moods caused by the earth's annual journey around the sun. He captured falling water frozen into ice by a cold winter night (Plate 47), and skies full of a storm (Plate 48).

The availability of dry-plate film after 1883 allowed Fiske to make time important in his pictures in another way. Because it was much faster than wet-plate film (it could record in about 1/50 of a second what took several seconds with the older method), he could stop time. In the work of Watkins, Muybridge, and their contemporaries waterfalls often looked like clear tubes filled with a solid, white liquid. Fiske, on the other hand, presented to the public a series of instantaneous views of Yosemite water caught in the act of falling (Plate 49).

To sum up the essential nature and quality of Yosemite art from 1880 to 1920 I have chosen three of my favorite works from this period: Charles Dorman Robinson's painting, "Advertisement for Bernard's Hotel" (Plate 50), the newspaper, "Yosemite Tourist," and the book, *Yosemite Illustrated.* Each one is aimed at and takes its shape from the tourist trade. Robinson has employed the composite view often found on postcards and other souvenirs. As we living in the age of advertising know all too well, ad art must be competent but need not, indeed ought not, be great enough to call attention to itself; it should be more illustrative than profound. Robinson's painting fits the bill perfectly. It describes competently the superficial look of Yosemite; it does not probe for deeper meanings, nor does it arouse profound emotions within us.

D. J. Foley began publication of "Yosemite Tourist" in 1891. It was a cross between an information sheet, like the present-day "Yosemite Guide," and a small town newspaper. It dispensed information about the park, printed articles calculated to arouse the tourist's interest in exploring it, and ran advertisements for valley hotels and shops, including, of course, Foley's own photographic studio. It also printed, somewhat in the fashion of a gossip column, long lists of tourist parties, complete with names and anecdotes. It generally consisted of four pages. The content of pages one and four, which contained the news, the gossip, and the ads, changed fairly frequently. Foley used only a handful of plates for pages two and three, however, printing them over and over again. Plate 51 reproduces one of them. The mix of photographs, some scenic and some anecdotal, poetry, and descriptive prose is fascinating. Each piece is designed to trumpet Yosemite's praises to an audience eager to listen.

Yosemite Illustrated was published in 1890.[15] It is a big, handsome book, with pages measuring approximately 10¼

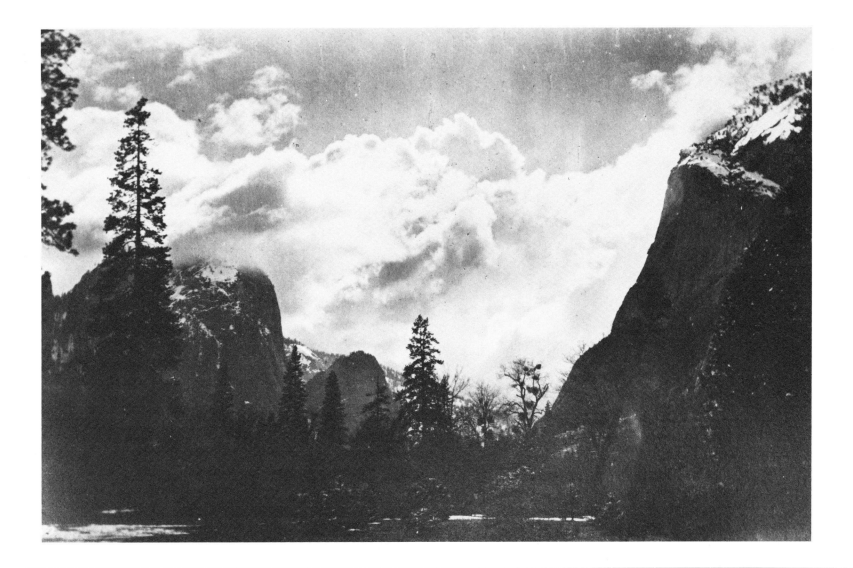

Plate 48. George Fiske. *Spirit Land.* No date. 4¼ × 7½ inches. National Park Service, Yosemite Collection.

inches by 13½ inches. It contains a short poem, a brief prose piece, and a painting about each of the major landmarks of the valley. The poems, written by Harry Dix, are in the typical Yosemite style, overblown and sentimental. The prose, by Warren Cheney, contains matter-of-fact information about each site. Most of the paintings are watercolors by W. H. Hansen, although Carll Dahlgren contributes a couple of oils. In these paintings the domestication of Yosemite is complete. In his poem on El Capitan Dix says that it has a "rugged" face and is "a weird, majestic mass of grey / That fronts you, gaze wher'er you may." In the accompanying painting, however, (Color plate 15) it is merely a pleasantly large rock, colored light brown and turquoise blue, neither rugged nor majestic, much less weird. At its foot, beneath a tall conifer, two men cook their meal on an open fire. They seem perfectly at home. And well they should, for, as this and other paintings in the book make clear, Yosemite is no vast and threatening wilderness, but a place where people can hunt and fish and look around in admiration at the lovely scenery.

1 Quoted in Shirley Sargent, *Galen Clark: Yosemite Guardian* (Yosemite: Flying Spur Press, 1981), 11.

2 *Galen Clark,* 59.

3 C. P. Russell, *100 Years in Yosemite,* 3rd edition (Yosemite National Park: Yosemite Natural History Association, 1968) 103.

4 Charles Dorman Robinson, "Painting a Yosemite Panorama," *Overland Monthly,* New Series 22 (1893) 245.

5 P. 246.

6 P. 247.

7 P. 254.

8 P. 255.

9 Charles Wesley Kyle, *Yosemite the World's Wonderland* (San Francisco, 1915).

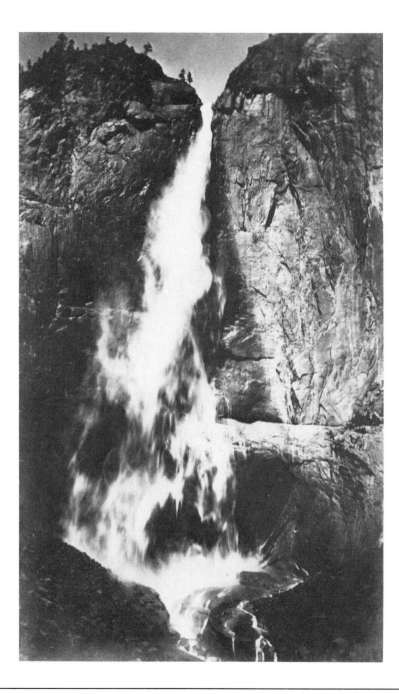

Plate 49. George Fiske. *Instantaneous View of Upper Yosemite Fall.* No date. 4¼ × 7½ inches. National Park Service, Yosemite Collection.

Plate 50. Charles Dorman Robinson. *Advertisement for Bernard's Hotel.* No date. 23¼ × 15¼ inches. National Park Service, Yosemite Collection. (Photograph by I. W. Taber)

10 In Charles Warren Stoddard, *Poems* (San Francisco: A. Roman and Co., 1867).

11 In Jean Bruce Washburn, *Yo Semite a Poem* (San Francisco: A. Roman and Co., 1877). Portions of this poem were written as early as 1864 and published in issues of the *Mariposa Gazette*.

12 In Harold Symmes, *Songs of Yosemite* (San Francisco: Blair-Murdock Co., 1911).

13 In Caroline Hazard, *The Yosemite and Other Verse* (Boston and New York: Houghton Mifflin Co., 1917).

14 In I. W. Priest, *Songs of the Wildflowers, Wildwoods, and School Days* (San Francisco: The Crandall Press, 1928).

15 San Francisco: H. S. Crocker Co.

Plate 51. *Yosemite Tourist.* Volume 18, 1906, page 3. National Park Service, Yosemite Collection.

Ansel Adams and Contemporaries

Moses said, "I pray thee, show me thy glory." And he said, "I will make all my goodness pass before you, and will proclaim before you my name 'The Lord'." . . . "But," he said, "you cannot see my face; for man shall not see me and live." And the Lord said, "Behold, there is a place by me where you shall stand upon the rock; and while my glory passes by I will put you in a cleft of the rock, and I will cover you with my hand until I have passed by; then I will take away my hand, and you shall see my back; but my face shall not be seen."

(Exodus 33:18-23, Revised Standard Version)

ALTHOUGH NO ONE could look upon the face of God and live, it was possible for mortals to behold his glory. He might reveal it directly, as he did to Moses on Sinai, or it might be "seen" as an aura surrounding objects associated with him. So one of the psalms says that "the heavens declare the glory of God," and Isaiah exclaims that "His glory fills the whole earth." During the Middle Ages the halo on angels and saints became a stylized visual representation of their glory, and today we speak of the "presence" that great people and objects have, our way of witnessing to the power that seems to irradiate from them and fill the air.

One way to think about and judge a work of portrait art is to ask how fully it captures the glory of the "sitter," whether person or landscape. Judged by these terms Ansel Adams is Yosemite's consummate artist. He holds up a photographic mirror to Yosemite that reflects its radiance just as the face of Moses shone with the glory of the Old Testament god. Bierstadt caught its refulgence occasionally, but more often he tried too hard and so turned brilliance into a gaudy show. Hill caught it sometimes, Watkins and Muybridge often. But no one has reflected it as consistently and as brightly as has Adams.

The medium he chose was the right one. From the beginning of Yosemite art, photography has glorified the valley and at the same time satisfied our desire for realism, our insistent wish to see it as it is. And the time was right. In the early decades of the twentieth century technological advances in the making of cameras, lenses, and film and increased

sophistication about photographic chemicals prepared the way for photographic experiments, conducted by Adams himself, that allowed him to heighten reality without drastically distorting it. These experiments enabled him to polish his photographic mirror precisely to the point at which the glory of Yosemite could be reflected most intensely without blinding us to the actual nature of the place.

"El Capitan, Half Dome, Clearing Thunderstorm" (Plate 52) is a fine example of a photograph that lets the glory of Yosemite show through. By comparing it with pictures by Watkins (Plate 23), Muybridge (Plate 39), and Pillsbury (Plate 38) we can get a synoptic view of the history of Yosemite photography and also grasp visually the difference Ansel Adams makes. In Watkins' print the contrast is not between light and dark but between the near tree and the far canyon. Rather than presenting itself to us, Yosemite recedes from us, inhuman in scale and inaccessible to human reach. Muybridge's work pulls down a veil of fog over the valley. Its great granite masses looming mysteriously above us are like deities hiding themselves from direct human gaze. Pillsbury's picture presents us with an ordinary Yosemite, a valley more pretty than powerful, one the average tourist might see on a typical summer day.

The vision in "El Capitan, Half Dome, Clearing Thunderstorm," on the other hand, is one that no tourist, without extraordinary luck, will ever see. It is as if Adams, in the tradition of Moses, stationed himself at the west end of the valley one stormy day and asked Yosemite to reveal its glory to him. And it obliged. He has, in turn, passed the revelation on to us. The light coming from El Capitan seems not the reflected light of the sun, although we know intellectually that it is the case. It seems, rather, to emanate from within the mountain. The illusion that objects generate their own light is one that Adams creates often. Opposite "El Capitan, Half Dome, Clearing Thunderstorm" in *Yosemite and the Range of Light*[1] is a close-up shot of Sequoia bark. A scar making a giant V across the picture glows with a light that seems to emanate from deep within the tree. Both scar and El Capitan are translucent windows transmitting the glory that dwells within tree and rock. Consequently, they, unlike the objects in the photographs of Watkins, Muybridge, and Pillsbury, come out to meet our gaze. They "speak" directly to us. This sense of immediacy, of coming face to face with powerful natural objects, is perhaps the most important aspect of Adams' photography. With most artists we have the feeling that objects are presented to us only after they have been filtered through a human personality. Not so with Adams. The objects in his prints seem to reveal themselves directly to us without the intervention of the photographer.

But, of course, this sense of immediate revelation is an illusion. It cannot be overemphasized that we do not see in his pictures exactly what he saw when he snapped the shutter. He surveys a landscape with his outer eyes and then interprets it with his inner eye, deciding how he wants it to look in the print. He calls this process of interpretation "visualization," and says that it is utterly crucial to the way he practices the art of photography. He then exposes and develops in a way that allows him to reproduce on paper the image his mental eye has "visualized." Accordingly, an Adams print is the product of an acute eyesight, a potent imagination, and mastery of the technical aspects of black and white photography. Appearances notwithstanding, he is in all of his prints presenting the landscape to his audience.

The method Adams devised to control contrast illustrates one way he realizes on paper a "visualized" image. He has codified his knowledge of how to manipulate contrast in the

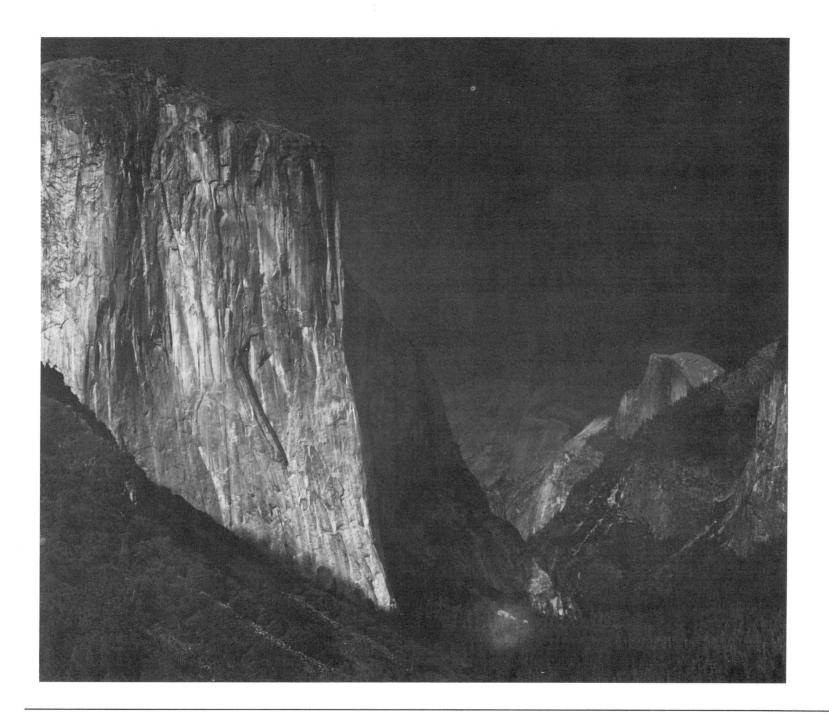

Plate 52. Ansel Adams. *El Capitan, Half Dome, Clearing Thunderstorm.* ca. 1972. Courtesy the Ansel Adams Publishing Rights Trust. ©

119

now famous "Zone System."[2] Pure black and pure white are arbitrarily assigned the values of Zone 0 and Zone 10 respectively. In between are nine shades of gray, ranging from the deepest black in which detail is visible (Zone 1) to the lightest white in which detail is visible (Zone 9). These zones are in turn calibrated with f-stops and shutter speeds. If in a given situation an exposure of f/8 will render an object as Zone 5 (middle gray), then an exposure of f/5.6, one stop larger, will raise it to Zone 6, whereas an exposure of f/11, one stop smaller, will lower it to Zone 4. Similarly, if a shutter speed of 1/125 of a second gives Zone 7, than 1/60 of a second will yield Zone 8 and 1/250 Zone 6. Thus Adams need not settle for the absolute brightness of an object in nature. By varying f-stops and shutter speeds he produces in the print the brightness he chooses.

He is usually concerned, however, not so much with the absolute brightness of an object as its brightness in relation to other objects in the scene. By correlating exposure with development he learned that he could lengthen or shorten the tonal scale. More specifically, he discovered that underexposure of the negative combined with overdevelopment would lengthen the scale (yield more contrast than was present in the scene) whereas overexposure together with underdevelopment would shorten it (yield less contrast than was present in the scene).[3] Assume that on a very bright day Adams is photographing a scene composed of Yosemite Falls, the adjacent cliffs, and some conifers in the foreground. His light meter tells him that with normal exposure and development the water will fall into Zone 9, the cliffs into Zone 5, and the trees into Zone 1. He is not pleased with these relative values because he "visualizes" a print with more detail in the water and the trees than Zones 9 and 1 will yield. By overexposing the film and underdeveloping it he can lower the falls to Zone 8 and raise the conifers to Zone 2, all the while keeping the cliffs approximately at Zone 5.

The difference that control of the tonal scale makes can be seen by comparing "El Capitan, Half Dome, Clearing Thunderstorm" with a Mode Wineman photograph from Inspiration Point (Plate 53). In terms of dates (he first came to Yosemite in 1902) Wineman belongs back in chapter 5. But he is such an effective foil to Adams that I have delayed mentioning him until now. Born in Chicago, he came to the mountains of the west seeking solace for the death of his fiancée. He took such fine pictures that he began to devote more time to photography than to his job as music teacher. Eventually hobby replaced profession, and he spent most of the initial decades of the twentieth century taking pictures of the western national parks. Both Wineman and Adams have eyes for spectacular beauty; the photographs of both are characterized by elegant composition and an expansive feeling that suits Yosemite well. Wineman, however, transcribes rather than alters the tonal values present in the landscape he is photographing. Adams, alternatively, raises or lowers tonal values and expands or contracts the tonal scale, not in order to match print with sight, but to match print with vision. Rather than make Yosemite look like the valley we normally experience, he strives continually to present it transformed by the alchemy of his imagination and the chemistry of photography into the perfect "Place, with a capital P."[4] The difference between Wineman and Adams is the age-old distinction between the real and the ideal. We might send a postcard of Wineman's photograph with the comment, "Yosemite is marvelous. It actually looks like this postcard." But it is unlikely (and a perusal of *Yosemite and the Range of Light* will confirm this) that we have ever seen Yosemite from Adams' angles clothed in his light and shadow.

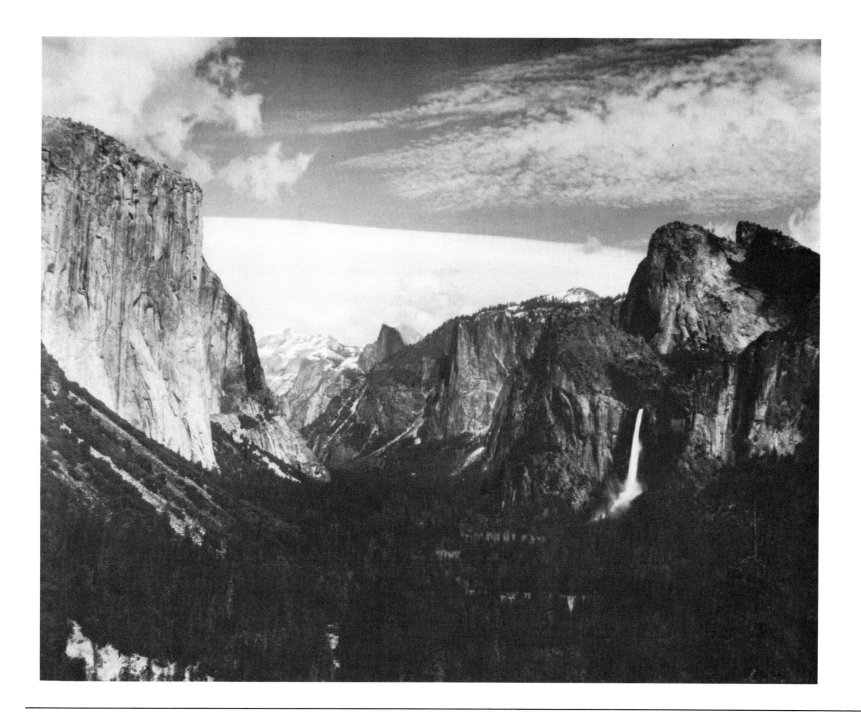

Plate 53. Mode Wineman. Untitled [Yosemite Valley from Inspiration Point]. No date. National Park Service, Yosemite Collection.

Manipulation of the tonal scale goes a long way toward explaining the difference Ansel Adams makes, but it cannot account for all the difference. Another way his mind is at work interpreting a scene is framing. Everything in the picture that belongs, everything left out that does not—that is the goal toward which he works. One hardly ever finds in his prints something that distracts the eye or disrupts the mood, not a tree, nor a limb, nor a twig, not even a leaf. The danger of such "perfect" photographs is oversimplification: neatly framed pictures that quickly bore because they subtract from the land too much of the diversity and helter-skelter of real life. Adams again and again avoids this danger by finding the golden mean: enough included to make the picture visually and emotionally complex, enough excluded to preserve balance and harmony. "Juniper, Cliffs and River, Upper Merced River Canyon" (Plate 56) and "Eagle Peak and Middle Brother, Winter" (Plate 57), because they include so little, are especially good illustrations of his practice of including everything necessary for a complete picture. Each is composed of just three elements: in the first are a tree, a stream, and a cliff face; in the second, three trees, two peaks, and fog. Yet neither the eye nor the mind tires quickly of exploring the spatial and thematic relationships between these elements.

Still another way Adams organizes a scene is to prohibit "mergers," or "interferences."[5] He habitually refuses to allow any object to infringe on the two-dimensional space of another object and so mar the integrity of its outline and shape. Tree limbs, the most frequent culprits in the work of other photographers, are not permitted to interrupt the fall of water or cut into the outline of cliff or sky. He even keeps clouds from interfering. The clouds in "Half Dome, Tree, Clouds, from Olmstead Point" (Plate 54) move in from the right, curl perfectly around Half Dome, mimicking its curves

and leaving its summit exposed, and lift themselves up over the highest part of the tree. That they just skirt its top, leaving it an integral whole rather than bisected by a line through its midsection, is of incalculable importance to the success of the photograph. It is a little matter, seemingly, and yet painstaking attention to minutiae is one of the things separating Adams from the crowd of Yosemite photographers. Exceptions to his prohibition against interference are remarkable for their rarity. Sometimes he consciously decides to permit interference and so makes it an important element in the overall design.[6] Other times he is unable to prevent it because of physical obstacles. The cliff face visible on the left side of "Yosemite Falls and Point" prevented him from moving a few feet to the left in order to remove the tree limb from the path of the water.[7]

Again and again Adams' images convince us by their composition that he was in precisely the right place to take the picture, not an inch off to the right or left. This is only half the story, however. Being in the right spot does him no good, given his perfectionism, unless he is there at precisely the right moment. Minutes, much less seconds, were not precious to Weed, Watkins, or Muybridge. Their prints speak of eternity rather than of time. Minutes, and occasionally seconds, were vital to Fiske, who captured storms moving in and drops of water falling. Adams habitually works within parameters that extend from milliseconds to, at most, a few seconds. "Half Dome, Tree, Clouds, from Olmstead Point" (Plate 54), for example, had to be taken at exactly the moment the clouds were right for Half Dome and for the tree. Early Yosemite photographers were preoccupied with space. Fiske introduced a concern with time, though it remained subordinate to space. Adams continues and completes what Fiske began by making time equal in importance to space. As a result he

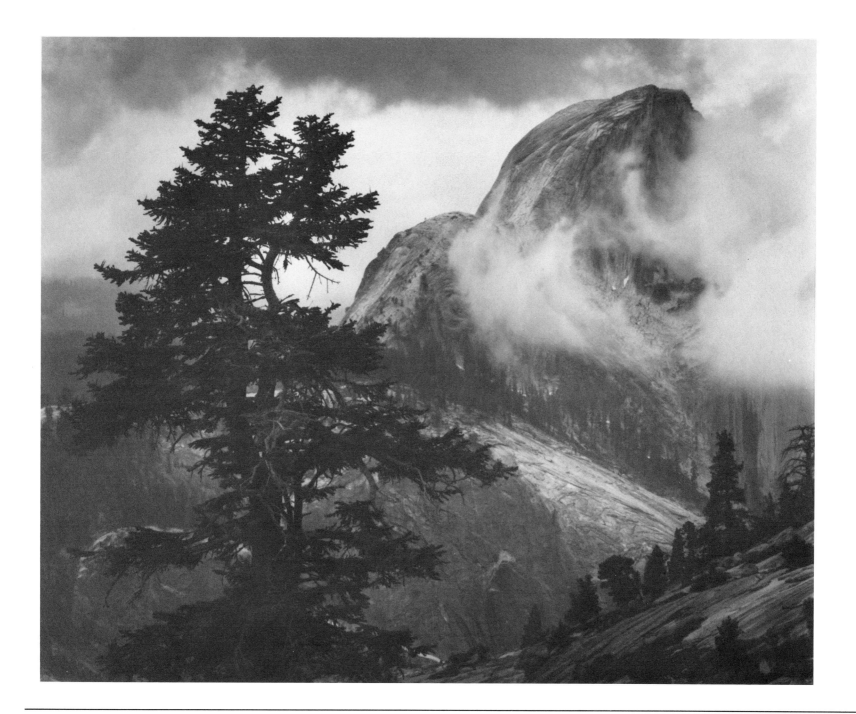

Plate 54. Ansel Adams. *Half Dome, Tree, Clouds, from Olmstead Point.* ca. 1970. Courtesy the Ansel Adams Publishing Rights Trust. ©

acquired the reputation of waiting endlessly in the right place for the right moment to arrive. He contends that this reputation is undeserved, insisting that he agrees with Edward Weston, who reportedly said he was afraid to tarry here lest he miss something over there. However that may be, because Adams weds so equally time and space, his photographs are ultimately about those occasions when the temporal and the eternal intersect.

The subject of time leads into a matter more difficult to deal with. I have commented upon several Adams prints in terms of "visualization" and composition. But technique is only the prologue to the great drama of meaning his photographs enact. To stop here would be like buying a ticket to a play only to turn around and leave after handing it to the usher. Yet in the doorway stands an obstacle—Adams himself. He politely but adamantly refuses to usher us to our seats. In public and in private he will talk freely of technique but will not discuss the meaning he intends for us to find in his images. When I tried to persuade him to talk of meaning, he demurred, saying:

You are asking me to talk about things I can't talk about. You never explain why you take a certain picture; you just do it. Something excites you and you do it. Photographs have different effects on different people; better to present a photograph and say, "This is it." I think photograghs just stand by themselves, like music without words.[8]

I said I would report to my readers his position, but also insisted that part of my responsibility as critic is to say what I think his photographs mean. So I am now serving as usher in his stead. Whether I am the fool and he the angel the reader can judge. I take some comfort in the fact that he himself once said:

I have been trained with the dominating thought of art as something almost religious in quality. As I look back on it now I realize a certain "unworldly" quality about the point of view that was drilled and dynamited into me.[9]

Perhaps the "unworldly" dimension of Adams' photographs can best be put in two words: majesty and mystery. Again and again he directs our gaze upward through haze and fog, mist and clouds to the summits of Yosemite's great monoliths.[10] "El Capitan, Winter, Sunrise" (Plate 55) was taken early one morning with Polaroid negative film. Out of the dark, deep, human-trodden snow of the foreground a resplendent El Capitan rises through the fog. The feeling this photograph arouses in us, if not explicitly religious, is certainly religious-like. It is as if El Capitan were a throne fit for gods. Maybe talk of gods limits too narrowly the meaning of this print. It is definitely true that no explicit symbolism, much less religious symbolism, is present in Adams' work. He is careful to keep our attention focused on real things and scrupulously avoids making them signs pointing to spiritual truths. Admitting all this, however, it must also be said that the El Capitan of this print possesses a glory we normally associate with extramundane things. People come to Yosemite for many reasons, but surely one value they get from its great monoliths is a transforming vision of a cosmic order that contains and maintains us and our world. We are a small, if significant, part of this larger whole. Our power to make or to endure is miniscule compared to its energy. No artist in Yosemite history has so effectively as Ansel Adams let us glimpse the majesty of this order; no other artist has so enabled us to sense its glory and partake of its power.

One also senses a mystery in Adams' prints. Here as before it is important not to overstate the case. Adams himself is not comfortable using a word like "mystery." It reminds him

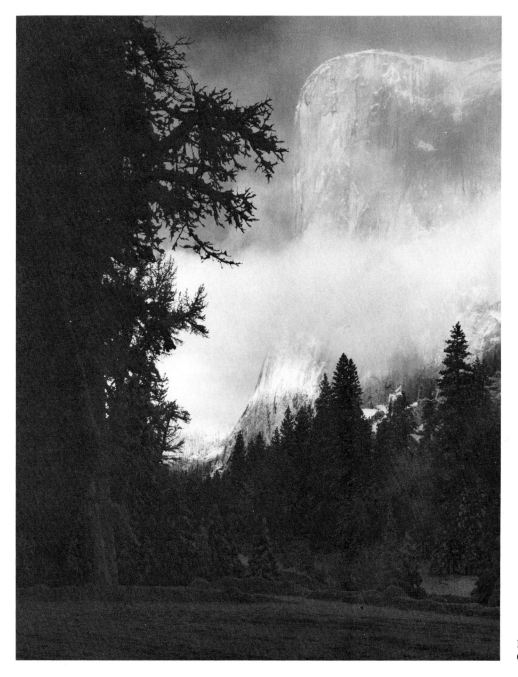

Plate 55. Ansel Adams. *El Capitan, Winter, Sunrise.* ca. 1968.
Courtesy the Ansel Adams Publishing Rights Trust. ©

125

of the movement in photography, popular in America during the early 1900s, known as "pictorialism." Its adherents, like composers who write "program music," love to produce prints that tell stories, depict moods, and illustrate abstract concepts like anxiety, beauty, and passion. Adams, on the other hand, practices and helps promote "straight" photography, which focuses on real things, uses glossy paper, and eschews soft focus, romantic and literary themes, and darkroom sleight-of-hand. His titles, for example, are always factual: place or thing pictured, together with notations of time of day and season.

So one could say that "Juniper, Cliffs and River, Upper Merced River Canyon" (Plate 56) is a photograph of a tree, a rock, and a river. And so it is. Yet it has a peculiar power, partly because, as is true of so many Adams prints, its contents seem to point to elemental forces and structures inherent in the world. Rock is hard and of earthly things endures the longest. Tree is fragile and transient. Water, like time, moves past these two stationary forms in a smooth everflowing stream. The tree is perched tenaciously and alone on the rock, suggestive of the place the living occupies on the non-living. In other Adams photographs the moon and pairs of objects also share this capacity to remind us of the elemental and the unworldly.[11]

Majesty and mystery meet and embrace in "Eagle Peak and Middle Brother, Winter" (Plate 57). No photograph in Adams' entire corpus so taxes the critic, for it seems to consist of so little and yet mean so much. Far away are two white peaks. In the foreground are three dark trees, the middle two so close that they make one mass. Because of the spacing, trees share twofoldness with the peaks. Between them is the winter fog. It gently cloaks one of the peaks, whispering of mystery. The other peak shouts out majesty. The trees bear the weight of the heavy snow with graceful dignity. To be

more explicit is awkward, for the photograph states so eloquently what words say rather clumsily. This print embodies the best of Ansel Adams: the metaphysical implied by the physical, the preternatural contained in the natural, the unworldly in the this-worldly.

So far we have discussed what is present in Adams' photography. For a full understanding of his work it is necessary to mention also what is absent. People, for one thing. One would hardly know from looking at his pictures that anyone other than Adams himself had ever been in Yosemite. He gives the impression that he is looking through his lens at a virgin landscape. Yet he does not exclude people because he cannot successfully work them and their paraphernalia into the composition. In his magnum opus, *Images 1923-1974*,[12] people, buildings, fences, bridges, and even grave markers are harmoniously integrated with non-Yosemite natural landscapes. [13] In *Yosemite and the Range of Light*, however, except for an early (1920) snapshot of the Le Conte Memorial and some footprints in the snow in "El Capitan, Winter, Sunrise" (Plate 55), no mark of mankind is present. Nor is it possible to flip through the book and imagine how people could be inserted into the pictures. Their presence would violently disrupt the mood. So in the book that summarizes his entire career, *Images 1923-1974*, people are present; in his Yosemite book people are effectively absent. The message is clear. Adams is attracted by wild nature undefiled by human touch, and Yosemite is its embodiment and symbol. Like Eden Yosemite is innocent and pure. Unlike Eden it is wild and imposing. It is permissible for human beings to live in the midst of other landscapes; Adams is even willing to take their pictures there. It is not all right for humans to inhabit Yosemite. If they do, he will pretend that they do not. In this respect Adams is a throwback to Watkins and Muybridge,

Plate 56. Ansel Adams. *Juniper, Cliffs and River, Upper Merced River Canyon.* ca. 1936. Courtesy the Ansel Adams Publishing Rights Trust. ©

Plate 57. Ansel Adams. *Eagle Peak and Middle Brother.* ca. 1968. Courtesy the Ansel Adams Publishing Rights Trust. ©

128

whose photographs were also mostly peopleless. Not for him the domesticated Park of Fiske and the other studio artists.

Another item missing from Adams' pictures is debris. Or to be more accurate, debris is either absent, or if present, made un-debrislike by being skillfully coordinated with the overall design of the photograph. In other words, Adams either excludes the accidental, the casual, and the ungainly or makes them beautiful. Their absence, like the absence of people, reinforces the idea of Yosemite as a magically and romantically pure land. But some of Yosemite's wildness may be lost in the process. If one manages too successfully to make beautiful patterns out of the random and unruly in Yosemite, then it may look managed, tidied up, too pretty. "Siesta Lake" (Plate 78 in *Yosemite and the Range of Light*) is interesting to consider in this context. Its careful composition almost contradicts its subject: grass, trees, and uncomposed natural litter on the edge of a lake. I prefer Muybridge's practice of letting debris lie casually about. Yosemite looks more naturally wild in his photographs than in many of Adams'.

Nevertheless, while Adams will aesthetically compose the haphazard with his viewfinder, he refuses under any conditions to rearrange nature. He believes in the "found" object rather than the "contrived" object, and he is willing to search until he find it. "You proceed until something happens, when it happens you recognize it and do [photograph] it."[14] He calls these occasions, appropriately enough, "happenings." At the conclusion of my interview with him, as we discussed what I would include in this book he said, "Just say that I am interested in happenings." Nature makes the first move. Adams responds. An "external event, what is going on out there" is met and embraced by an "internal event, what you feel about it."[15]

In this regard Adams has remained outside the main-

stream of "modern" art. Edward Weston, one of its devotees, recorded in his daybook:

How little subject matter counts in the ultimate reaction [to a photograph]: I have had a back . . . taken for a pear, knees for shell forms, a squash for a flower, and rocks for almost everything imaginable.[16]

Adams, on the other hand, jotted down on an undated piece of paper:

If I have any *credo*, it may be this: if I choose to photograph a rock, I must present a rock . . . the print must augment and enlarge the experience of a rock . . . stress tone and texture . . . yet never, under any conditions, 'dramatize' the rock, nor suggest emotional or symbolic connotations other than what is obviously associated with the rock. [italics and ellipses his][17]

Francis Farquhar made the point that the design in Adams' photographs is the design of the thing itself:

In [Adams'] mountain studies . . . the dominant characteristic is the way in which the structure of the mountain mass is expressed. The composition in each case shows an analysis of the thing itself. Stark, powerful, the direct lines of force are unmistakable. The result is a design, but it is a design inherent in the mountain, not an abstraction upon the surface of a sheet.[18]

These astute comments sum up a difference between Adams and those of his contemporaries who took as axiomatic the notion that nature could and should be altered for the sake of composition. For them it was not the function of artists to copy nature's design but to make their own. Eventually they freed themselves from representational subject matter altogether. What went on canvas or paper came hardly from nature at all but almost entirely out of their heads. Instead of seeking the fact and glory of nature through their work, people sought the artists' own refined sensibilities. Adams, on

the contrary, wants people to seek in and through his photographs the shape of rock and mountain and not the shape of his personality:

What happens out there is far more important than what happens in here [pointing to himself] and far more important than any image I or anybody can make of it![19]

Because Yosemite is grand, great Yosemite art must attempt the grand. Keith, Muir, Fiske and the other studio photographers and painters were too modest. Too frequently they duplicated nature without duplicating its power. Bierstadt, King, and the poets were too immodest. They made up too much, so that in their work Yosemite was in danger of becoming a fictitious place. C. D. Robinson sought a novel solution: paint realistically on a huge scale. The result was, however, an aesthetic disaster. Adams chose the most realistic of artistic media, the camera, and has used it to magnify reality. His photographs let us recognize the literal reality of Yosemite and at the same time give us an extraordinary vision of its emotional and spiritual power.

Adams was born in San Francisco in 1902. He survived the earthquake with nothing worse than a broken nose and frightening memories. From his earliest childhood he was, as he later said, "more responsive to wild environments than to urban."[20] His first trip to Yosemite came in 1916. Before the trip he read James Hutchings' *In the Heart of the Sierras*[21] and during it he took pictures with a No. 1 Box Brownie and had them developed at Pillsbury's studio. Many years later in the introduction to a collection of John Muir's writings,[22] he reminisced about his first encounter with Yosemite:

That first impression of the Valley—white water, azaleas, cool fir caverns, tall pines and stolid oaks, cliffs rising to undreamed-of heights, the poignant sounds and smells of the Sierra, the whirling flourish of the stage stop at Camp Curry with its bewildering activities of porters, tourists, desk clerks, and mountain jays, and the dark green-bright mood of our tent—was a culmination of experience so intense as to be almost painful. From that day in 1916, my life has been colored and modulated by the great earth-gesture of the Sierra.[23]

He returned to Yosemite every summer for the next decade, taking pictures, exploring canyons, serving as custodian of the Sierra Club's Le Conte Memorial. In 1920 he decided to become a professional pianist. Since the household of Harry Best had the only piano, he often went there to practice and gradually fell in love with Best's daughter, Virginia. The two were married in 1928.

In the meantime Adams was receiving high praise from artists and patrons of art in San Francisco and from members of the artist colony in Taos, New Mexico. There in 1930 he met Paul Strand and was astonished at the clarity and precision of his negatives. This event was crucial in his decision to pursue photography instead of music as a career and in pointing him away from the pictorialist manner of his early prints toward "straight" photography. In 1932 along with Edward Weston and others he founded "Group f/64," an association dedicated to exploring "straight" photography's aesthetic potential.

In 1929, the year before he decided upon photography for a profession, Adams began nearly a decade-long association with the Yosemite Park and Curry Company. That winter and the following summer he took pictures of seasonal sporting activities for Curry advertising brochures. In 1931 a more comprehensive arrangement was negotiated. He devoted 100 days during that year to the following activities:

1) Christmas and New Year festivals, and others
2) Publicity pictures on demand

3) Albums
4) Winter Pictures
5) Summer Pictures
6) Supervising printing of menus, etc.
7) Placing prints
8) General Publicity
9) Motion Pictures, both Winter and Spring
10) Attention to all miscellaneous details[24]

In return he received $1000 plus an allowance for travel and materials. He maintained ownership of the negatives but agreed to furnish Curry with prints upon request. Adams always dealt directly with Don Tresidder, President of the Company and son-in-law of David and "Mother" Curry, not only in negotiating a contract but also in deciding what kinds of pictures to take. Occasionally Tresidder's instructions were exceedingly explicit:

It is my idea that the pictures [of the skating rink] should be made while carefully selected skaters are on the rink with everyone else excluded. My reason for this is that in pictures to date they have always shown some awkward beginner in a position which immediately attracts attention, promotes mirth, and causes a loss of value. By carefully selected pictures I mean that the best skaters of the Valley should be on the ice. Those with the greatest skill should make the foreground. I have already discussed with Paul the making of costumes for them. . . . We should get shots of Mr. Pearson in solo work, also some of his class in waltzing, remembering to get some pictures of youngsters like Mrs. Hoffman's little girl, Barbara Van Housen, Leroy Rost, etc.[25]

Adams often presented working proofs to Curry in the form of albums on a single theme. Plates 58 and 59 are from the album "High Country Scenics." In 1930 Adams took an extended horseback trip to the High Sierra Camps owned by Curry, accompanied by Virginia Adams, Jane Paxson, and Jules Eichorn. Each camp and the surrounding scenery were photographed extensively. Since he wanted people in these publicity pictures, he employed his travelling companions as models. In Plate 58 he has arranged (from the left) Virginia Adams, Eichorn, and Paxson before a granite ridge "Near Fletcher Lake." His attempt to make them appear natural is so conventional (how many times has someone on a ridge gazed into the distance, leaning slightly forward with hand raised to forehead) that they look quite posed for the occasion. While the judgment of one critic, that Adams "photographs rocks as if they were heads, and heads as if they were rocks,"[26] is too harsh, the Curry albums do show his ineptitude in integrating people with the landscape.

"Boothe Lake Camp" (Plate 59) is a precursor of Adams' mature style. The composition is perfectly balanced. Clouds arch above the centered granite ridge. Below the ridge Boothe Lake on the right is balanced by the curve of tent cabins on the left. On the shore far below, two people in beach chairs tell of the ease and pleasure that can be ours if we pay a visit to this Curry-owned High Sierra Camp. This message is the main point of the photograph, one it makes with great effectiveness.

The 1931 contract was renewed with minor alterations for several years. Clearly both parties benefited from the arrangement: Adams received much needed work during the lean years of the Depression; Curry received superior advertising prints. But in 1937 dissatisfaction on both sides became serious. Curry felt it needed greater freedom in the use of prints than Adams was willing to give; Adams felt that his prints were included in brochures of inferior quality. The next year the two settled their respective claims against each other and went separate ways. By that time Adams was living year-round in the valley. Upon the death of her father in 1936,

Plate 58. Ansel Adams. *Near Fletcher Lake.* 1930. Proof print in album entitled *High Country Scenics.* Courtesy Yosemite Park and Curry Company.

Plate 59. Ansel Adams. *Boothe Lake Camp.* 1930. Proof print in album entitled *High Country Scenics.* Courtesy Yosemite Park and Curry Company.

Virginia Adams inherited Best's Studio. She and her husband moved to Yosemite the following year to run it.

During the war Adams photographed the Japanese-Americans interned at Manzanar Relocation Center in Owens Valley, California, and later published the results in *Born Free and Equal.*[27] After the war he began writing his famous series of technical books on Photography, *Basic Photo Books,*[28] and in 1949 started a long-term association with Edwin Land and the Polaroid Corporation. He pioneered the use of Polaroid equipment for expressive purposes, and in 1963 wrote *Polaroid Land Photography Manual.*[29] Twelve views included in *Images 1923-1974* were taken on Polaroid film. In 1962 he and Virginia moved to Carmel, California, where they now live.

In July of 1937, shortly after Ansel and Virginia Adams made Yosemite their home, Edward Weston and Charis Wilson arrived as guests. Weston had earlier in the year received a Guggenheim Fellowship, the first ever awarded to a photographer, to travel throughout the American west with his camera. *California and the West* was the result of their joint labors, Weston supplying the prints and Wilson the prose.[30] This was their first trip ever to Yosemite. After a few days exploring the valley, Weston, Wilson, and Adams spent a week taking pictures in the area of Mt. Ritter. The two photographers got along famously, the differences in their philosophy and technique acting as catalyst to creative work. Their most formidable foe was the mosquitoes. Adams, the experienced backpacker, promised that they would abate when the party reached 10,000 feet. He explained away the swarms that greeted them at that elevation: they had followed the group up. After enough time passed to prove that hypothesis in error, he said they did not like smoke. So a fire was built. Wilson comments wryly that the mosquitoes hated smoke so much they "just had to call all their uncles and cousins to come play in it, too."[31] Weston "worked away like mad, on icebergs, lakes, minarets, tree stumps, snow and rocks," wearing "a pair of gloves to protect his hands" and "a bandanna pendant" fixed to his sun helmet and stuffed under his shirt collar to protect his face and neck from the ever-present enemy.[32]

On the way back to Yosemite valley Weston so fell in love with the Sierra junipers above Tenaya Lake that he and Wilson returned there in August. In five days he "photographed all the junipers in reach—some single trees accounting for eight or ten different negatives."[33] Because line and shape are the most important elements in a Weston print—whether it is of sand dunes, bare vegetables, or nude bodies—the junipers made ideal subjects for him (Plate 60). He found their contorted shapes, twisted limbs, and grasping roots so enchanting he could hardly bring himself to leave. Only after a night of "engaging in duets" with a "brace of bears" ("Edward roared at them, they growled back") was he finally ready to depart.[34] In February the two returned to Yosemite yet again. After two days of snow Weston "went berserk." When he saw something he wanted to shoot, his son Neil and Wilson would plow a path through the snow and pack it down so "the tripod legs wouldn't go through to China." He exposed negative after negative until at last he was weary of winter's cold world.[35] The photographs that resulted from this labor and fun do not form an important part of the Weston canon. Beside his Carmel prints they are relatively insignificant. Yet a few of them are unquestionably among the finest views of Yosemite ever taken.

The tenure of Ralph Anderson as Park Photographer for the National Park Service coincided with the major period of Ansel Adams' productivity. A native of Ohio, Anderson came to Yosemite in 1929 as a temporary park ranger. The

Plate 60. Edward Weston. *Lake Tenaya Country.* 1940. 8 × 10 inches. © 1981 Arizona Board of Regents, Center for Creative Photography, University of Arizona.

following year his job was made permanent, and in 1932 he was promoted to the position of Park Photographer and Information Clerk. During the ensuing two decades his duties were sometimes redefined (for the indefatigable Anderson this usually meant the addition of new ones without the subtraction of old ones), but he remained Park Photographer until he left Yosemite in 1953 for a job in the office of the Director of the Park Service in Washington.

Anderson's approach to photography was similar to Adams'. He used a large-format view camera, composed his pictures according to classical rules of harmony and balance, and indulged in a minimum of darkroom manipulation. Clearly the end result he desired was a handsome, fine-grained print in which the personality of the photographer was subordinate to the character of the scene presented. Despite this similarity of approach, however, his pictures are strikingly different from Adams'. Moreover, even though communicating accurate information (of necessity the main aim of any official photographer) was more important to him than personal expression, he achieved a style of his own. Perusing the voluminous files the Research Library maintains on Yosemite places and people, one learns quickly to spot an Anderson print. The time has come for him to emerge from obscurity and receive the plaudits due him.

Fiske added Time to the Yosemite landscape, and Adams made high drama out of Time's presence by highlighting the clouds, deepening the shadows, and snapping the shutter at precisely the right moment. In many of Anderson's most distinctive photographs he factors Time back out of the scene. As official Photographer he made the rounds of virtually all of Yosemite's basins and ranges, taking pictures of its lakes, ridges, and peaks. He habitually photographed during midday, so that shadows are entirely absent or at least play no effective role in the composition. His skies are usually light gray, and clouds, if present at all, merge indistinctly into the background. Consequently, Yosemite's stark granite stands accurately and serenely forth, bathed in a pure white and omnipresent light (Plate 61).

Anderson liked to include people in his pictures. Often he had models assume relaxed, ordinary poses in the middle of a scene and backed far off and up so that he looked down and out upon them (Plate 62). They seem to inhabit, casually and unafraid, a vast amphitheater of space and to share this space with gigantic, towering domes that dwarf but do not daunt them. They seem to belong and to be safe.

A few years after his arrival Anderson was assigned the duty of escorting visiting dignitaries around the Park. Not surprisingly, he used these opportunities to photograph them. But instead of bringing them front and center, a position one might think their rank entitled them to, he typically moved them back in among the trees, rocks, and cliffs. Sometimes they got equal billing with Nature's cast of characters; more often they are so far away that they are unrecognizable. They recede into anonymity, becoming little more than foils to accentuate the indomitable character of Yosemite's massive domes and giant Sequoias. It is as if Anderson were saying to them, "In society you stand out; in Yosemite you are no different from anybody else. Here all of us are small and must take our places at the foot of Nature's colossal monuments." So when President Franklin D. Roosevelt visited the Park in 1938, Anderson found a spot above the road and back in the trees and photographed the President's limousine touring the Mariposa Grove of Big Trees (Plate 63). Except for the title we might think that it is Everyman's car.

The most exciting "modern" art of Yosemite was done by William and Marguerite Zorach. They belonged to the

Plate 61. Ralph Anderson. *Thompson Canyon, Upper End.* 1942. National Park Service, Yosemite Collection.

Plate 62. Ralph Anderson. *Half Dome and Washington Column in Autumn.* 1941. National Park Service, Yosemite Collection.

Plate 63. Ralph Anderson. *President Franklin D. Roosevelt in the Mariposa Grove of Big Trees.* 1938. National Park Service, Yosemite Collection.

American avant-garde in the 1910s, both contributing paintings to the famous Armory Show of 1913, the exhibition that introduced Franch fauvism and cubism to an incredulous American public. William Zorach's creed was thoroughly modernist. He wrote:

The modern movement has freed art from the idea of reproducing nature, an idea which has been persistently followed since the Greeks and which has been suddenly found to have nothing to do with art. The *essential contribution* of modern art to aesthetics is the building and development of purely abstract forms and colors. (italics his)[36]

His practice, however, was far more conservative. As his biographer, John I. H. Baur, notes:

His pictures have none of the cerebral qualities of French cubism, nor do they deal with the same emotionally neutral subject matter. Instead, they interpret easily recognizable events and themes which moved the artist, and they are filled with a warmth of sentiment totally alien to pure abstraction.[37]

In 1920, before he abandoned painting for sculpture, he camped for five months in Yosemite, his wife joining him for part of that time:

Every now and then in life we have an experience that moves us so deeply, that holds us with such sheer, transcendent beauty, that it takes us completely out of this world. It is this feeling that only an artist in his art can convey. It is a journey into infinity. This has happened to me twice in my life. The first time came after seven days on the endless expanse of the Atlantic Ocean with nothing in sight but the constellations in the heavens, the sun's rising on the horizon in the early dawn, and the evening sunset's magnificent splendor. . . . The other vision was Yosemite. . . . I climbed all over the mountains, with a sixty-pound pack of sketching materials and blankets on my back, and slept out under the stars, naively undressing at night and putting on my pajamas and freezing until I had to get up and build a fire. The loneliness and vastness were overpowering. This was the garden of Eden, God's paradise. I sketched and painted in ecstasy.[38]

In "Bridal Veil Falls in Yosemite Valley" (Color plate 16) the abstract lines and planes augment the power of the still-recognizable falls. They are Zorach's attempt to raise the falls to the level of "transcendent beauty." Baur comments:

In [his Yosemite work Zorach] abandoned the paraphernalia of cubism—its angularities, dislocations and multiple views—in favor of a fluid handling which caught the essential lines and motion of the landscape, simplified them in a kind of decorative shorthand and wove them together into handsome designs marked by a dynamic play of light and heavy accents, of sweeping linear passages and irregular shapes.[39]

The year after the Zorachs visited Yosemite, Gunnar Widforss arrived.[40] Born in Stockholm, Sweden, in 1879, he was already a painter with an established European reputation when he visited California in 1921 on a proposed excursion to the Orient. But he was so moved by the scenery on the west coast, and especially by the "Yo-se-mighty," as he called it, that he cancelled the remainder of his trip and with great enthusiasm set about painting the valley. While in Yosemite he met Stephen Mather, first Director of the National Park Service, who persuaded him to specialize in the National Parks. His American reputation was established with a one-man exhibition at the National Gallery of Art in Washington in 1924. Included were paintings of Yosemite, Yellowstone, Zion, Bryce, and the Grand Canyon. He came to love the last of these places best and during the last decade of his life spent most of his time there, where he was a familiar and beloved figure.

Widforss was a realist in the heyday of abstraction. The swirling currents of "modern" art did not deflect him from the

mainstream of romantic realism practiced by every Yosemite painter from Bierstadt to Jorgensen. Almost exclusively a watercolorist, he used a special pebbled mat board and first sketched the entire scene in outline. Then he filled in the details of rock, water, and vegetation area by area, putting the paint down in thin washes of transparent color and building up the intensity by layering one wash on top of another. Finally, he superimposed on the whole an atmosphere appropriate to a particular time and place.[41]

Widforss has put his watercolor technique to good use in "The Ahwahnee" (Color plate 17). The different varieties of granite, the variously colored species of lichen, and the clumps of snow combine to give cliffs a mottled appearance that his layered washes effectively express. Use of the same method on the columns of the hotel causes them to blend perfectly with the background. Placement of the base of the hotel high in the composition reinforces this harmony between nature-made and man-made. Because our eyes are level with the ground the hotel seems to tower over us, and its grand gesture is completed by the cliffs. The effect of the whole is to unite and ennoble both hotel and cliffs. The thin, tangled shadows of black oaks contrast with the heavy masses that rise above them and fill up what would otherwise be a large area of unarticulated white.

Zorach was an abstract painter; Widforss was a realist. Ferdinand Burgdorff, who arrived in Yosemite in the early 1930s, claimed that he too was a realist:

My aim is always to make the picture like Nature and not an egotistical demonstration of the different colors sold by the art material dealers.[42]

"Bridalveil Fall, Leaning Tower, and Dogwood in Autumn" (Color plate 18) shows that Burgdorff had a very poor under-standing of his own art. While the drawing in this picture is realistic, it is abundantly clear that the colors come from tubes and not from nature. Similarly his brush strokes, somewhat reminiscent of Van Gogh's, are highly expressive, and his composition, with the sun centered between the peaks on either side of the fall, is vaguely symbolic. These are not faults, of course. Cezanne taught us that objects may be distorted for the sake of artistic form; Matisse taught that things need not have their natural color. We are back to Twain's distinction between portrait and picture. Artistic liberties are legitimate if they help convey meaning and feeling.

The important question is not whether Burdorff is realistic but whether his painting leads us to a fresh vision of Bridalveil Fall. Taken in isolation the rendition of conifer limbs by a single long brush stroke, the centered sun glowing pale-green, and the garish red foreground tree are attention-getting. It is not easy, however, to see how limb, sun, and tree enlarge our understanding of the fall. We may go from his painting to take a fresh look at it. Or we may conclude that his work is "an egotistical demonstration" of the artist's style.

Yosemite has seen too little artistic fun. Few artists have satirized the park and spoofed the zeal of its "true believers." Jo Mora's map poster, "Yosemite," is, therefore, like a late-summer shower clearing away an oppressively stuffy atmosphere (Color plate 19). At the top of the page he states his purpose:

There is so much of Grandeur and reverential Solemnity to Yosemite that a bit of humor may help the better to happily reconcile ourselves to the triviality of Man. Give me the souls who smile at their devotions! Now, should this light effort—not altogether truthful, so not altogether dull—afford you a tithe of mirth I shall feel I have added to your reverence for Yosemite.

His humor consists almost entirely of obvious puns and over-worked situation comedy, yet the end result is delightful:

a ribbon unravels to form "Ribbon Falls"

a Spanish don stands on the summit of El Capitan and George Washington atop Washington Column

a woman applies make-up using Mirror Lake

a cloud sleeps in an easy chair on Clouds Rest, while a man whispers "sh-h-h-h" bears are all over the map, dining, posing, robbing picknickers of their lunch, and scaring neophyte hikers

a husband urges his wife to test the chilly Merced waters.

Down the left side of the poster is a graphic depiction of activities available to tourists: fishing, riding, gathering around the campfire, tennis, golf, and learning the incredible facts of ancient Sequoias. The last cartoon is the best: a family of four with mouths agape staring at "that FIRST view." Charles Wesley Kyle, you were wrong when you said, "fools alone / Find laughter here."

1 Boston: New York Graphic Society, 1979.

2 For a detailed explanation of the Zone System see Ansel Adams, *The Negative*, Basic Photo 2 (Hastings-on-Hudson, NY: Morgan and Morgan, 1968) 15ff.

3 These results obtain largely because the dense portions of a negative (those receiving the most light) take longer to develop than the less dense portions. Hence overexposure allows more light from the shadows to reach the negative and under-development keeps the also overexposed highlights from losing all detail. Alternatively, underexposure allows less light from the shadows to reach the negative and overdevelopment keeps the also underexposed highlights from becoming murky.

4 See Public Broadcasting System's Television special, "Ansel Adams: Photographer." 1981.

5 These are Adams' terms, mentioned in a personal interview, March 17, 1980.

6 See Nancy Newhall, *Ansel Adams*, Vol. 1, *The Eloquent Light* (San Francisco: Sierra Club, 1963) 30.

7 See *Yosemite and the Range of Light*, Plate 47. Adams commented on his difficulties with this picture in interview of March 17, 1980.

8 Personal interview, March 17, 1980.

9 Letter to Willard Van Dyke, quoted in *The Eloquent Light*, 126.

10 See Plates 1, 16, 26, 46, 68, 82, 91, and 113 in *Yosemite and the Range of Light*.

11 For the moon see Plates 84, 112, and 115, for pairs of objects Plates 37, 68, 71, and 85 in *Yosemite and the Range of Light*.

12 Boston: New York Graphic Society, 1974.

13 See pages 44, 47, 79, 65, 74, 83, 86, 87, and 110.

14 Personal interview, March 17, 1980.

15 Personal interview, March 17, 1980.

16 Quoted in *Eloquent Light*, 68.

17 Pp. 68-69.

18 *Touring Topics* (February, 1931); quoted in *Eloquent Light*, 66.

19 Quoted in *Eloquent Light*, 18.

20 P. 23.

21 Even after his death Hutchings continued indirectly to figure in bringing artists to Yosemite!

22 *Yosemite and the High Sierra*, Writings by John Muir edited by Charlotte Mauk, Introduction and photographs by Ansel Adams (Boston: Houghton Mifflin, 1948).

23 Quoted in *Eloquent Light*, 29.

24 Letter Ansel Adams to Don Tresidder, January 22, 1931. Archives of the Yosemite Park and Curry Company.

25 Letter Don Tresidder to Ansel Adams, January 19, 1931. Archive of the Yosemite Park and Curry Company.

26 Quoted by Wallace Stegner in the Foreword to *Images, 1923-1974*, page 15.

27 New York: U.S. Camera, 1944.

28 1. Camera and Lens, 1948; 2. The Negative, 1948; 3. The Print, 1950; 4. Natural Light Photography, 1956. New York: Morgan and Morgan. Revised editions have recently been issued.

29 New York: Morgan and Morgan, 1963.

30 Revised edition (Aperture, 1978).

31 P. 79.

32 P. 80.

33 P. 111.

34 P. 111.

35 Pp. 157-158.

36 Quoted in John I. H. Baur, *William Zorach* (New York: for the Whitney Museum of American Art by Frederick A. Praeger, 1959) 14.

37 P. 14.

38 William Zorach, *Art Is My Life* (New York: World, 1967) 60.

39 *William Zorach,* 17.

40 I have taken biographical information on Widforss from Bill Belknap and Frances Spencer Belknap, *Gunnar Widforss: Painter of the Grand Canyon* (Flagstaff, Arizona: for the Museum of Northern Arizona by the Northland Press, 1969).

41 Charles Eckart of San Francisco, California, has been extremely helpful to me in analyzing Widforss' style.

42 Letter to Mrs. Elizabeth Godfrey, October 22, 1942. Yosemite Research Library.

Artists and Writers of the Present Day

IS THERE LIFE after Ansel Adams for Yosemite photographers? The frustrations of working in the same place a generation after an acknowledged master are considerable. The almost irresistible temptation is to imitate the master, a strategy sure to win approval from him and from critics under the magic of his spell. One's own notion of what an outstanding photograph ought to look like is also satisfied. But the cost is high. For the individual it is relegation to the status of satellite and consequent loss of self-esteem. For art it is stagnation. In the last two decades photographers have printed thousands of images of Yosemite in the Ansel Adams tradition. Many are extremely good, good enough to be inserted surreptitiously into *Yosemite and the Range of Light* without raising suspicions. Because not only the photographic method but the vision of Yosemite is identical to Adams', however, the creative edge is lost, and without it most of these imitative prints seem fine technical accomplishments that are emotionally and spiritually malnourished. What in Adams is high drama becomes too often in his followers melodrama.

The creation of a different and individual style is not easy. It takes an adventuresome spirit, an emotional constitution able to bear the tension inevitably accompanying any significant deviation from an accepted norm, and the patience to wait for critical acceptance of a new style. Fortunately Yosemite is not lacking in such spirits. Chief among them is Ted Orland. Orland began photographing in Yosemite after participating in an Ansel Adams workshop in 1966, and for several years afterwards was an assistant in these workshops. Before long, however, it became apparent to him that

"straight" landscape photography ha[d] been creatively dead for decades, in part because popular sites ha[d] been photographed so much, and in part because of the contrivance involved in driving hundreds of miles . . . for the privilege of photographing a piece of landscape with no telephone poles in it.[1]

His prints from this period, though handsome, were, he felt, derivative in style and content. He wanted to go in a new direction and gradually, during the 1970s, he developed his own style. "I became my own man,"[2] he said.

When Orland is his own man, he is above all else witty, something Adams never is. Sometimes that wit is very subtle. *Self-Portrait, 1977* (Plate 64: Frontispiece) is in every respect but one a "straight" photograph: the view is magnificent, the

composition classic, the camera large-format, and the grain fine. But there is Orland himself in the picture, a minute figure posing on the "beak" of Half Dome. Part of the humor comes from our imagining how the picture was made. Of course, Orland may in fact have arranged for a friend to snap the shutter. But in this day of electronic gadgetry it is difficult not to imagine him composing the scene on the ground glass of his view camera, setting an electric timer to delay the shutter release, and scurrying over the boulders to a pre-selected spot marked with an X. On two counts this photograph is a self-portrait: it portrays the contours of his playful personality as well as the silhouette of his bodily form.

Orland can also be outrageously funny. One way to break away from the overpowering influence of an illustrious predecessor like Ansel Adams is to satirize him, and in this task Orland uses his sense of humor to great advantage. "One-and-a Half Dome" (Color plate 20) belongs to his "Ansel Adams Memorial Equivalent Series." In this masterpiece of wit and invention he parodies the "straight" tradition by including along with Half Dome a bear-proof garbage can whose top mimics its rounded back and a metal map that replicates it. Thus the photograph contains three one-half domes, adding up to "One-and-a Half Dome[s]" altogether. Orland has further violated the canons of "straight" photography by hand-coloring the sign, thereby making it stand out dramatically against the gray background, and by dual toning. Sepia toning gives the background the warm, brownish cast of a 19th century photograph while selenium toning makes the foreground resemble a colder, modern print. Thus, Orland's picture recapitulates the history of Yosemite photography by integrating the look of the old with the look of the new, by overlaying black and white with color, and by wryly satirizing the work of the Park's most renowned artist, Ansel Adams.

The infrared photographs Orland took in 1978 also represent a significant break with the past. Mild deviations from the norm are his use of a hand-held 35mm camera for "serious" photographic work, his choice of an exotic, grainy film, and the soft, warm "feeling" of the print. Of far greater importance is his attitude toward people and their paraphernalia. No Yosemite artist prior to Orland depicted human beings and the things they make as beautiful in and of themselves. Fiske and Anderson routinely included people in their pictures but moved them around as props in a show put on by nature. In the years after World War II photographers of the school of social realism made people themselves the subject of their art. But invariably they seemed to think that members of the human species were ugly and their behavior disgusting. A favorite subject matter were Recreation Vehicles, their occupants and accouterments. An untitled photograph by Bruce Davidson (Plate 65) is typical. Davidson combines aspects of the formally posed group portrait (people are dispersed throughout the scene, everyone visible, everyone facing the camera) with aspects of the snapshot (the space is cluttered, some objects are half in and half out of the frame). His subjects are comfortably sprawled in lawn chairs in back of their "mobile" homes. If the location were a trailer park in Los Angeles, they would be "in place." In Yosemite they look "out of place": middle-weight, working-class Americans bringing all the comforts of home to the wilderness. These people look bored and alone, all in their separate seats, not related to each other or to the place, a group only because a strange photographer happened by and wanted to take their picture.

Orland takes the human as his subject matter, and he makes it beautiful:

Rather than try to avoid the people, I came to view Yosemite more as a

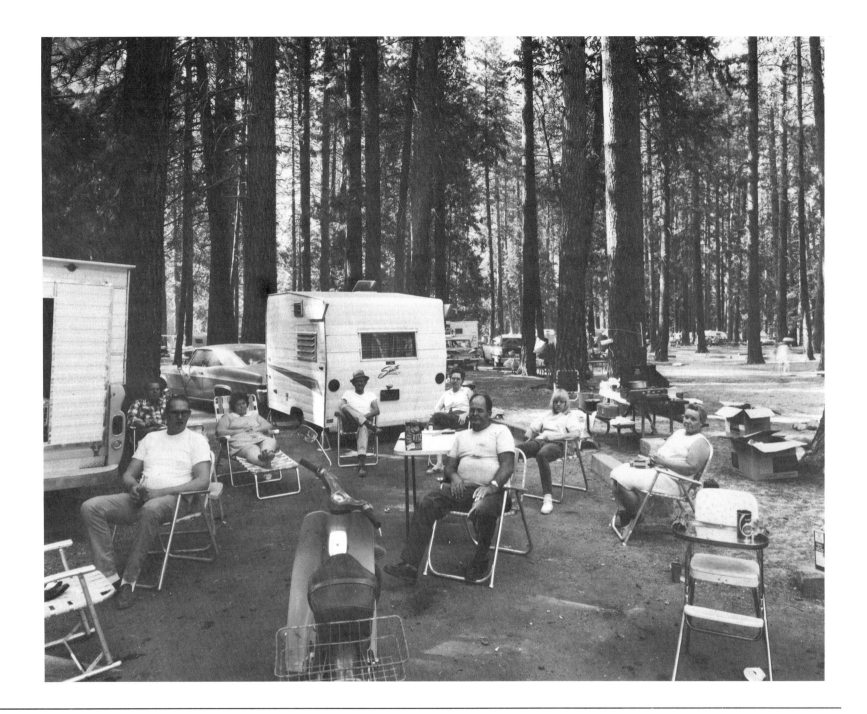

Plate 65. Bruce Davidson. Untitled [Campers, Yosemite Valley]. No date. Courtesy Magnum Photos, Inc., New York.

sociological phenomenon than a natural wonder—like a cruise ship that takes on thousands of new passengers every few days. I'd wander around until I came across something I responded to intuitively, then take a picture. And those photos say Yosemite looks o.k. the way it is, that there's nothing evil in the human presence in the valley.... I'm saying that's a nice landscape, whether or not integral parts of it were shaped by tractors instead of flash floods.[3]

The camper in Plate 66, by virtue of the infrared film, looks enchanted, the wilderness counterpart of the castle in fairyland. Its spindly supports contrast wonderfully with the dark, more substantial tree trunks, and the horizontal, folded canvas offsets the vertical thrust of the trees.

Orland's concern with people in the Park is shared by a number of his contemporaries, leaving little doubt that integration of the human and the natural will be a major goal of Yosemite photography in the coming decades. Tom Millea's photograph of swimmers in the Merced River moves in that direction (Plate 67). These children frolic in the hazy ambient light of an Edenic playground. Innocent and spontaneous, they are the modern counterparts of the deer in Bierstadt's "Valley of the Yosemite" (Color plate 3). Millea uses paper coated with a solution of platinum and palladium. Once one of the most popular of photographic processes, platinum printing is virtually never used today. The solution is no longer made commercially and so has to be prepared from scratch. The paper must be hand coated. Enlargement is impractical since the light of the sun must be used to expose the paper. This very light, moreover, magnified by the glass covering used in contact printing, causes irretrievable damage to modern gelatin-based negatives in a relatively brief time, making the manufacture of a large number of prints from a single negative impossible. Platinum printing offers in return for all these disadvantages a soft, subtle rendering of the tonal gradations in the negative and a physical product that is exceedingly handsome. Even ordinary children, softened in the platinum light and dignified by being the center of attention of a print so laboriously and finely wrought, take on a mysteriously romantic effect.

Jeff Nixon, Brian Grogan, Ray McSavaney, and John Sexton have also taken Yosemite into new visual and emotional territory. Nixon began his career searching for broad vistas and dramatic light. Recently, however, he has sought a more inward, personal vision of Yosemite. Sometimes he walks around on the valley floor slowly and meditatively, without his camera, so that he will attend closely to all the sights, not just to the ones he habitually photographs. He wants not so much to "capture" a scene as to let fresh perspectives come to him. When a subject presents itself, he tries to forget the rules and follow his inclinations, paying attention to what that subject seems to call for. Once, when low clouds were snuggling up against the valley walls, he went to El Capitan Meadow. The way a sharp line of trees at the bottom and soft, gray clouds at the top framed the vertical lines on El Capitan's face kept claiming his attention. Disregarding voices from the past which told him to dramatize and to include the entire megalith in the picture, he cropped the scene until only the essentials remained. Then he printed the negative to express the gentle, diffused light and the intimacy of the occasion (Plate 68).

Nixon has taken a step away from the monumental toward the modest. Brian Grogan has taken several additional strides in the same direction. Grogan came to Yosemite because of the nature of the place and remains for the same reason. Since 1975 he has held a number of different positions with the Yosemite Park and Curry Company and the Ansel Adams Gallery and pursued photography on his own

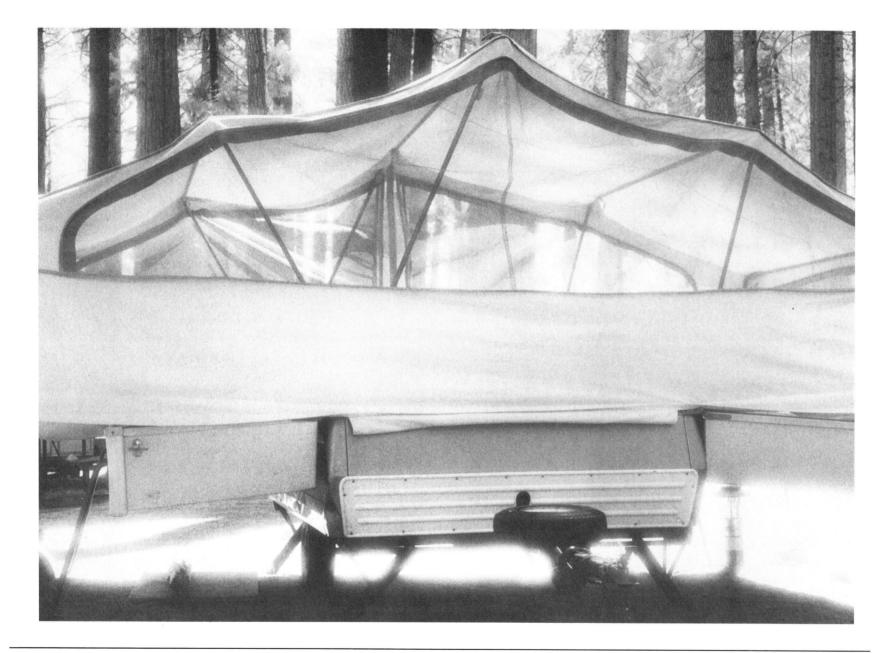

Plate 66. Ted Orland. Untitled [Tent Trailer]. 1978. Print from a 35mm infrared negative. 9¼ × 13³⁄₁₆ inches. Courtesy Ted Orland.

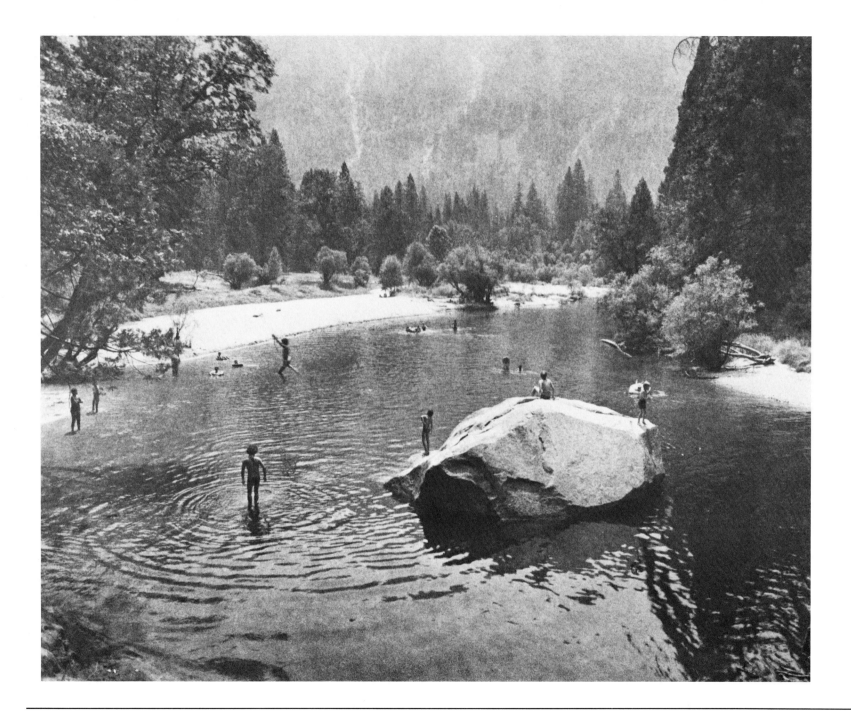

Plate 67. Tom Millea. Untitled [Swimmers in the Merced River]. No date. Platinum and palladium print. Courtesy Tom Millea.

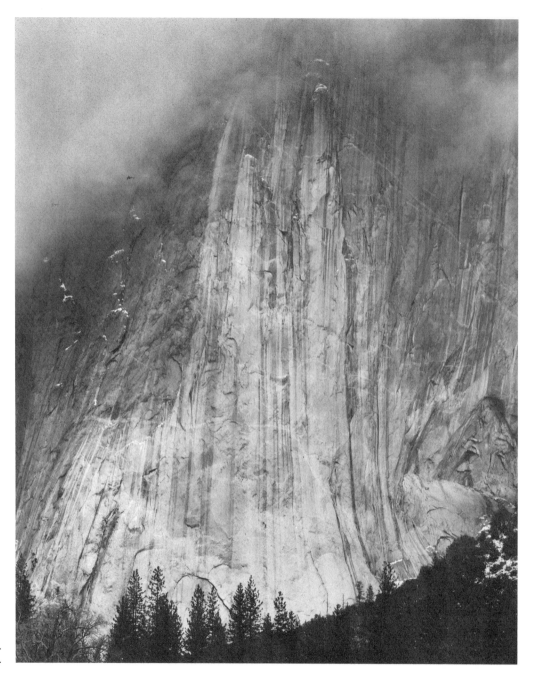

Plate 68. Jeff Nixon. *El Capitan, Clouds.* 1983.
Courtesy Jeff Nixon.

150

time. His deliberate but unpretentious work is a mirror of his reflective, unassuming personality. He keeps his prints small and untitled, eliminates any recognizable landmark, and works in middle grays to avoid the spectacle created by pure whites and blacks. His images, as a result, do not reach out and grab you but gently take you in with subtle harmonies of dark and light, ground and sky, trees and rocks (Plate 69). The danger is that his prints will speak with too quiet a voice. So far, in order to remain faithful to his own, intensely personal vision, he has turned a deaf ear to the temptation to make noisier photographs.

Ray McSavaney and John Sexton have remained more in the mainstream of the Ansel Adams tradition by producing large, handsome prints of exquisitely beautiful Yosemite scenery, which they compose on the ground glass of their view cameras with fastidious attention to detail and a meticulous concern for precisely the right perspective. Emotionally, too, they share Adams' sensitivity to the presence of mystery in the landscape. Until 1972 McSavaney used his camera as most tourists do: to make a "visual diary" (the phrase is Adams') of his experiences. In that year he participated in a Yosemite Workshop under Adams, and ever since his primary concern has been to express a complex set of feelings about the world through photographs that exhibit extremely complicated spatial patterns. His Yosemite work falls into two periods. During the mid-Seventies he depicted the valley's more quiet and somber moods in contrast to Adams' preoccupation with its dramatic and visionary moods. He returned to Yosemite in the early Eighties with new ideas based on his work with the urban landscape of Los Angeles.

Plate 70 illustrates one set of these ideas. Trunks of fallen trees in the foreground provide a firm horizontal foundation for the stumps, snags, and still living trunks that stand in almost casual array above them. The qualifier "almost" is important, for the large, solid snag just off center, once the eye has become fixed upon it, actually functions as a pivot around which the other vertical objects revolve. The longer one looks, the more it becomes the hub of a ritual-like drama wheeling about it. Visions of Stonehenge come to mind. Trees living and dead suggest the archaic round of seasons, as do Stonehenge's slabs by pointing to the solstice. The photograph gradually reaches in and releases primal emotions within us.

Participation in Ansel Adams Yosemite Workshops in 1973 and 1974 was also decisive in the career of John Sexton. Since then he has worked with Adams in several capacities, most recently testing film and checking procedures for the revision of *Basic Photo Books* and making proofs of heretofore unprinted negatives. Sexton feels that he does not compose his images but isolates patterns nature has already composed. The arrangements his eye selects are usually as simple as McSavaney's are complex: a rock and limb mirrored in water, a tree or two against an opaque background. He likes to photograph at dusk, when the uncanny in nature comes out, making him ever so slightly uncomfortable. The forest becomes impenetrably dark, and the branches of alders and aspen glow with an unnatural light. "Forest Detail, Dusk, Crane Flat" (Plate 71) was taken under such conditions. The counterpoint of the delicate limbs of the growing young conifer with the jagged twigs of the broken dead branch (the former rising up from the bottom of the picture, the latter falling down from the top), is strange, almost preternatural. Isolating them in front of a soft, furry background produces an intriguing combination of beauty and mystery. The scene both entices and disturbs.

Although scientists and enterprising inventors produced color transparencies and prints well before the turn of the

Plate 69. Brian Grogan. Untitled [Tuolumne Meadows]. 1979. Polaroid Positive, Type 52 Film. 3½ × 4½ inches. Courtesy Brian Grogan.

Plate 70. Ray McSavaney. Untitled [El Capitan Meadow]. ca. 1981. Courtesy Ray McSavaney.

Plate 71. John Sexton. *Forest Detail, Dusk, Crane Flat.* 1980. Courtesy John Sexton.

century, practical methods of taking color photographs in Yosemite were not available until the 1930s. Since then advertisers of the valley have profitably exploited the possibilities of color, especially on postcards and in travel books, and tourists have taken home many a colorful memento of the Park. Verisimilitude is what tourists want most of all, and modern color films are extremely adept at duplicating eyesight. A good example is the work of Dana Morgenson. In *Remembering Yosemite*[4] the Park is accurately rendered and yet also appears romantic and inviting. In "Yosemite Falls... Cooks Meadow" (Color plate 21) gold at the bottom and blue at the top frame cliffs darkened by shadows from the setting sun. A vertical format and a composition in which the ascending path complements the descending water of the upper fall offset the strong horizontal lines of cliff tops, trees, and ground. Until his death in 1980 Morgenson was a phenomenally successful leader of camera walks for the Yosemite Park and Curry Company. He was gifted with speech as colorful as his pictures and taught his followers as much about Sierra flora and fauna as he did about photography. Heir of the studio photographers, he wanted to entice the public to the Park and provide them with souvenirs of their stay.

No photographer working in color has yet produced prints comparable in expressive power and emotional depth to those of Yosemite's great black and white photographers. Perhaps the valley's most creative artists have shied away from color because it has been so heavily used for commercial purposes. Maybe they have not committed themselves heart and soul to color because until recently they have been unable to produce prints that would not fade within a decade or two. The weight of tradition is another likely factor: black and white has been the accepted medium for producing fine art. But surely the decisive reason is that photographers have relied too heavily on color alone to get their expressive message across, neglecting contrast, framing, form, and composition. Historian Beaumont Newhall put the problem succinctly, "It is not the colorful object itself, but the photographer's handling of it, which is creative."[5]

Yosemite photographers most successful with color have used it to express their own personal visions of nature. The valley's mammoth landmarks are not well suited to this purpose, so small objects and intimate, anonymous landscapes are habitually selected. Over the Sierra crest in Lundy Canyon, William Neill, currently photographer at the Ansel Adams Gallery, found a marvelous stand of aspens. Color plate 22 consists of two major keys offset by two minor ones. Compositionally, the vertical format emphasizes the bold vertical lines of the tree trunks and their reflection in the lake. At the top of the picture the horizontal lines of downed trees make a jumbled counterpattern. Colorwise, the rosy glow from an early morning sun and a few green sprigs of grass complement the predominant light blue. In making the aspens blue Neill has run counter to traditional color photography, which would have left them their natural white. By this color shift and by the bold patterning of lines, he has produced a semiabstract print. Looking at it closely we see a real scene: aspen trunks reflected in a beaver pond. Stepping back to get the overall effect we see patterns of lines and color. The capacity to make us jump back and forth from reality to abstraction unites his print with the best of Yosemite black and white photography and separates it from the great mass of one-dimensional work in color.

Howard Weamer is a modern color photographer with the personal habits and mountaineering stamina of John Muir. He spends the summer half of each year in Lafayette, California, printing his work, and the winter half as caretaker of the

Yosemite Natural History Association's Ostrander Ski Hut. While many of his prints create an abstract surface pattern out of a limited number of colors, others, like "Muir's Primrose, Clouds Rest" (Color plate 23), attempt to juxtapose the near and the far, the small and the big. This picture is the descendant of studio photographer Arthur Pillsbury's "Evening Primroses and the Half Dome" (Plate 48). Each picture attempts to capture both the beautiful and the sublime within the compass of a single frame, but their perspectives are different. Pillsbury looks at the valley from the vantage point of the average tourist, whereas Weamer adopts the physical and attitudinal frame of mind of the backcountry hiker. Accordingly, in Pillsbury's picture we see Half Dome from the valley looking up; in Weamer's we look down at it from the high country. In the latter the precarious perch of both flowers and photographer on the side of Clouds Rest gives a vertiginous sense of the great depth of Tenaya Canyon and the immense space opening out beyond its mouth.

Neill and Weamer tend to exclude people, but other color photographers are following the lead of their black and white colleagues by including them in the scenery. Roger Minick, for example, has recently toured the National Parks working on a "Sightseers Series." One of his Yosemite prints (Color plate 24) uses a favorite device among contemporary avant-garde photographers: inserting a picture within a picture. In a photograph of the valley from the Wawona tunnel parking lot he has included a woman wearing a scarf printed with various Yosemite scenes. His gentle wit is a sophisticated cousin of Orland's more outrageous humor.

Watkins, Muybridge, Fiske, and Adams have established for photography a Yosemite tradition and a Yosemite style that are world renowned. In no other art form is there an identifiable Yosemite style nor has a single figure risen to prominence during this century. Contemporary Yosemite photography can be understood in terms of a continuation of or a revolt against the basic tradition. Unfortunately no comparably neat way exists to organize contemporary painting, poetry, or prose. Practitioners of these arts have generally worked in relative isolation, with little communication with and even less influence upon one another. Given this situation I will discuss in serial fashion a number of artists who have developed their own individual styles.

Jane Gyer, a native Californian born in San Francisco and raised in Los Angeles, first visited Yosemite in 1934. Although only a child, she knew then that one day she would paint the valley. It was not until 1973, after she had moved to Wawona, that she began in earnest to realize her lifelong ambition. Born with the ability to draw, she received almost no formal training and is familiar only in a general way with the history of world art. Uppermost in her mind when she paints is the expression of her own emotion, "I have no background. I paint my feelings."[6] Her earliest successes were with scratchboard. Whereas in normal sketching colored pen is applied to white paper, in scratchboard the paper is first coated a solid black (using India ink or the like) and the design is scratched out with a sharp instrument. She uses this technique with great effectiveness in her haunting illustrations for *Discovering Sierra Trees.*[7]

In the early 1970s she was introduced to and immediately fell in love with watercolor. The soft, semi-abstract romanticism of "Yosemite Falls—Winter" (Color plate 25) is typical of her work in this medium. Sometimes she works from sketches of actual places in Yosemite and sometimes her scenes, although conveying a feeling of Yosemite, are entirely unreal. Despite the trend toward abstraction, she wants "to keep a little realism so I don't lose people. I want to say some-

thing meaingful to them, yet have a little imagination in my paintings, a little excitement. I try not to overstate it so that people can make up their own minds about how they feel. I don't like to tell the whole story."[8]

Wayne Thiebaud is an internationally famous painter whose Yosemite works form an interlude in a career devoted mainly to depicting modern urban culture. During the 1970s he became intrigued with "displacement of point of view," with "mak[ing] paintings work which did not have a clear horizon, a horizontal stabilizing element."[9] He wanted to disorient his viewers by eliminating the most predictable ingredient in a landscape painting, the horizon line, and by this omission to communicate a sense of nature as "imposing" and "overwhelming." Ridges seemed an appropriate subject matter for these experiments, and he went to Yosemite because it contained the most dramatic ridges he could think of. Driving up into it out of the rather "plain, not too spectacular, sort of ordinary" San Joaquin valley, he found Yosemite itself "displacing, surreal." As El Capitan came into view he found himself in a different psychological context, one that was somewhat "scary" and that made him feel "apprehensive in a kind of wonderful way." He realized that the great nineteenth century painters of Yosemite had resorted to canvases of huge scale partly to communicate a feeling of nature as overwhelmingly imposing. "Yosemite Ridge" (Color plate 26) is his own effort to convey afresh to modern viewers this same feeling. The huge mass of red and black does not represent the inside of the ridge but the interior of the self. It is an outward manifestation of the inward dislocation and apprehension Thiebaud experienced in Yosemite.

Traditionally scientific illustrators of nature depict the general rather than the particular. The use of their work in textbooks and handbooks demands that they abstract from,

say, many *Sceloporus occidentalis* individuals (Western Fence Lizard) the typical look of this species. On the other hand, David Wilson, Professor of American Studies at the University of California, Davis, using the age-old method of contour drawing, traces a particular *Sceloporus occidentalis* (Plate 72). Rather than looking at the lizard and then down at the paper to draw its figure, he keeps his eyes on the lizard while moving the pen on the paper along its edges, or contours. K. Nikolaides in his book, *The Natural Way to Draw,* explains the method this way:

Get a pencil, or pen, and paper. . . . Sit up close to the thing you plan to draw. Fix your eyes on a point, any point along its edge. Put the pencil point on the page and imagine that its tip touches the point on the object. Move your eyes slowly along the contour and, without looking down, move your pencil along the same edge. You may find that your eyes leave the edge and follow a contour in and stop. Fine. Glance down now and reposition your eyes and pen at a new point and go on.[10]

Wilson believes "by pretending to touch his pen to the object while really keeping it on the paper"[11] he is able to capture the "genuine feel of the thing."[12] An essential characteristic of every individual western Fence Lizard is frequent and abrupt movement. Not surprisingly Wilson was unable to finish any one contour before the creature he was drawing darted to a new position. Rather than complete the figure from memory, he merely moved his pen down the page and began again. The resulting five incomplete sketches add up to a complete experience with an actual lizard.

Harry Fonseca in his illustrations for *Legends of the Yosemite Miwok,*[13] unquestionably the most handsome book ever published in Yosemite, introduces for the first time native American motifs into the graphic art of Yosemite (Color plate 27). Born in 1946, Fonseca grew up in the Sacramento area of

Plate 72. David S. Wilson. *Western Fence Lizard.* 1981. Felt-tip pen on paper. 5⅛ × 8½ inches. Courtesy David Wilson.

California and studied art at the California State University there. Because of the peculiar and highly individual combination of modern and primitive elements in his style, he is able to communicate to modern people some of the wonder Yosemite's native inhabitants must have felt in its presence. The squiggly lines of the snakes and the water and the more jagged lines of the trees are especially effective in conveying an elemental and holistic feeling for Yosemite.

Similar feelings for Yosemite are expressed in the poetry of Gary Snyder, one of the major poets of post-World War II America and the only poet with an international reputation ever to write a significant body of work about the Park. A native of Washington State, Snyder was a charter member of the Beat Generation, having participated in their now famous "coming out party": a poetry reading at the Six Gallery in San Francisco in the fall of 1955. Jack Kerouac and Kenneth Rexroth were there, as was Allen Ginsberg reading "Howl" for the first time. The very next year, much to the dismay of his fellow poets, Snyder left California for Japan, where he became an initiate in a Zen monastery in Kyoto. During this time he rigorously disciplined his meditative habit of mind and laid a Taoist and Buddhist foundation for all his future thinking to build on. He returned to the United States in 1964 and eventually purchased land in the northern Sierra Nevada, where he settled down to live the ecological life in body and mind, taking spiritual as well as physical nourishment from mountain soil, rock, and water. The most ecologically oriented of his books of poetry, *Turtle Island,*[14] won the Pulitzer prize in 1975.

Back in the summer of 1955, only a season away from the Six Gallery reading, Snyder had given up the idea of being a writer. Wanting out of the city and needing relief from his graduate studies in oriental languages at the University of

California, Berkeley, he accepted an offer from the National Park Service to join one of its trail crews in Yosemite. After a week doing odd jobs in the valley, the crew spent the summer north of the Grand Canyon of the Tuolumne working the trail near Piute Creek between Pate Valley and Benson Lake. This was Snyder's first trip to the High Sierra. Accustomed to the dark forests, soft light, and frequent storms of the Cascade and Olympic ranges, he found the Sierra's vast stretches of hard, white granite exciting but "scary."[15] He was "unsettled" by the starkness of its contrasts and the intensity and steadiness of its "blinding, too bright" light. One night, sitting under a juniper tree high up in the Piute Creek drainage and letting the character of the Yosemite Sierra sink into his mind and heart, he found himself as a poet:

I wrote some notes down in my little note pad that became the poem "Piute Creek." Within three or four days I wrote "Above Pate Valley," "Milton by Firelight," "Riprap," and several other poems, all of which surprised me. I wasn't sure where they had come from. Looking at the whole of them, I realized that I had started writing my own poetry. I date myself as a poet from then.

In mid-September he quit his job, went to the valley to pick up some groceries, and then headed out alone from Tuolumne Meadows on a ten-day backpacking trip that took him up and around Banner Peak, into the headwaters of the San Joaquin, and back to Tuolumne:

That whole experience in the summer of '55 in the Sierra Nevada was a pivotal experience. Being up there and working and then being totally alone for ten days was like a retreat into another realm, like some kind of initiation. It was a real turning point for me.

Snyder eventually published twelve of the poems written in Yosemite during that summer, six in *The Back Country* and six in *Riprap and Cold Mountain Poems.*[16] In "Riprap," the title poem of the second book, he makes a symbolic equation between constructing a trail by means of riprapping (in the Sierra Nevada "riprap" has the vernacular meaning of a path of more or less even-sized rocks laid down on a slick glaciated rock to provide purchase for horses' hooves), making a poem out of words, and building a life out of that which is around us:

> Lay down these words
> Before your mind like rocks,
> placed solid, by hands
> In choice of place, set
> Before the body of the mind
> in space and time:
> Solidity of bark, leaf, or wall
> riprap of things:
> Cobble of milky way,
> straying planets,
> These poems, people,
> lost ponies with
> Dragging saddles—
> and rocky sure-foot trails.[17]

This comparison of poem-making with trail-building is more than an apt metaphor. It is the key equation in solving the style and meaning of the poems Snyder wrote in Yosemite. They take us along on the trail, in a quite literal way, by narrating hikes he took. They are written in what might be called a "hiking" style: the rhythm of the words mimics the cadence of walking, running, and leaping along the trail or across the countryside, and they arrive at a destination. The end of the poem is the end of the trail, and there we find what we have come for. It might be an insight into the nature of existence, a meeting with fellow creatures, or merely rest and ease. The

poem "Water" illustrates all these characteristics of Snyder's trail taking:

> Pressure of sun on the rockslide
> Whirled me in a dizzy hop-and-step descent,
> Pool of pebbles buzzed in a Juniper shadow,
> Tiny tongue of a this-year rattlesnake flicked,
> I leaped, laughing for little boulder-color-coil—
> Pounded by heat raced down the slabs to the creek
> Deep tumbling under arching walls and stuck
> Whole head and shoulders in the water:
> Stretched full on cobble—ears roaring
> Eyes open aching from the cold and faced a trout.[18]

The unexpected destination of "Water"—man meets fish—is an instance of a recurrent goal in Snyder's poetry: encountering the Other. "Burning the Small Dead," composed one night while he camped beneath Mt. Ritter, narrates a "hike" that takes place wholly within the mind:

> Burning the small dead
> branches
> broke from beneath
> thick spreading
> whitebark pine.
>
> a hundred summers
> snowmelt rock and air
>
> hiss in a twisted bough.
>
> sierra granite;
> mt. Ritter—
> black rock twice as old.
>
> Deneb, Altair
>
> windy fire[19]

The words of this poem are riprapped: laid out on the page to form a stable foundation for mind travel as stones are fitted on the ground to make a firm base for foot travel. The journey begins in the present (note the use of the gerund "burning") and starts from a particular spot on earth. The mind goes backward in time by imagining the century of years recorded in the growth rings of the burning branches and by remembering its geology lesson: the rock of Mt. Ritter is older than the granite batholith underneath it. Simultaneously the mind sweeps upward in space past Mt. Ritter to the stars (Deneb and Altair). That they also burn reminds it of the windblown fire nearby and brings it back to earth. The Other encountered in this poem is the Universe itself:

The experience from which these Yosemite poems come is the experience of interacting with the Other—of constantly trying to be aware of the Universe as all one body, of trying not to be separate from it but recognize every part of it as part of yourself. There is nothing alien in it at all. Sometimes interacting with the Other remains theoretical. Even then it is interesting. Sometimes it is an experience. When it is, I can make a poem out of it. It takes on the force of poetry.

Before Snyder came to Yosemite, he had already logged hundreds of hours of hiking. In Yosemite he built trails and took one long backpack trip that set the direction of his future life. When, therefore, he scribbled in his notebook poems that read like the rhythm of his boots and looked like the riprap of his trails, is it any wonder he knew he had "started writing [his] own poetry." These poems took him where he wanted to go by the means he wanted to use to get there.

In the late 1970s Snyder took his family and Japanese parents-in-law to Yosemite. It was his first trip to the valley proper since 1955. One morning, before dawn, he went to the bottom of Yosemite Falls:

I meditated by the falls from different angles. I had just finished writing a poem about the water cycle in the Sierra Nevada, so I was full of thinking in those metaphors. And so the [following] poem just came, I was moved very deeply to actually pray somehow by being there:

Over stone lip
　　the creek leaps out as one
　　divides in spray and streamers,
　　lets it all: go,

Above, back there, the snowfields,
　　rocked between granite ribs
　　turn spongy in the summer sun
　　water slips out under
　　mucky shallow flows
　　emmeshed with roots of flower & moss & heather
　　seeps through swampy meadow
　　gathers to shimmer sandy shiny flats
　　then soars off ledges—

Crash and thunder on the boulders at the base.
　　painless, playing,
　　droplets regather
　　seek the lowest, and keep going down.
　　in gravelly beds.

There is no use, the water cycle tumbles round—

Sierra Nevada
　　could lift the heart so high
　　fault block uplift
　　thrust of westward slipping crust—one way
　　to raise and swing the clouds around—
　　thus pine trees leapfrog up on sunlight
　　trapped in cells of leaf—

nutrient minerals called together
　　like a magic song
　　to lead a cedar log along, that hopes
　　　　to get to sea at last, a great canoe,

A soft breath, world-wide, of night and day.
　　rising, falling,

The Great Mind passes by its own
　　fine-honed thoughts,
　　going each way.

Rainbow hanging steady
　　only slightly wavering with the
　　swing of the whole spill
　　　　between the rising and the falling,
　　　　　　stands still.

I stand drenched in crashing spray and mist,
　　and pray.[20]

Many of the images are similar to those used by the Yosemite poets quoted in Chapter 5: water gathering from melting snow and leaping out over the cliff's edge, the thunder of its fall, the regathering of drops and spray in Yosemite Creek. Gone, however, is the inflated rhetoric and the forced religious imagery. Snyder speaks not the highblown language of poets but the dialect of a modern, ecologically aware Californian. He lets religious matters flow directly out of mundane affairs. The path of water through its cycle leads inevitably and naturally to the cyclical course of thoughts in the "Great Mind." His prayer does homage to Matter and to Mind.

　　Yosemite's most recent poet is, of all things, an English-woman. June Dwyer was attendant to the late Mary Curry Tresidder during the early 1970s and so spent a brief but

intense part of her life in the park. Her poems, collected in *The Discipline of Crevices,*[21] are fresh and witty, and even though sometimes ornately rhetorical, they are remarkably free of the stale, overinflated clichés served up by typical Yosemite poetasters. The point of "Rock Pines" is an old one: a life tested by adversity and lived by a strict code is noble and inspiring. The way she makes this point is new and interesting:

> Tenacious to a fault
> they root a ledge, aspire,
> complete the discipline of crevices,
> conduct the elements—
>
> Accredited to life lines
> that disown the lax;
> fringe benefits traced to a frown[22]

The brevity, the use of "root" as a transitive verb, the rhythmical use of near repetition (for example, "complete," "conduct," and "accredited" at the beginning of three successive lines) are modern in feeling. Her use of alliteration, while not distinctively modern, is effective: "complete . . . crevices . . . conduct . . . accredited"; "life lines . . . lax"; "fault . . . fringe . . . frown." The poem's success depends, most of all, on her ability to turn a phrase; "discipline of crevices" and "fringe benefits traced to a frown" are the best examples. Again and again she catches in her phrases an essential aspect of the human experience of Yosemite and its creatures. The experience may be of Half Dome:

> Man will fall again to get a second bite
> tempted by the better half, tortured by the missing
> driven by the urge to power and dazzled by position[23]

or trying to photograph a lizard:

> Though short his stride jerked sudden-swift—
> a living dart at speed of light
> by whipped-up Frenzy out of Haste—
> to span the sun-struck granite slab;
> as sudden, stopped, U-turned
> sped back the same from zig to zag
> and so forth up and down the beat
> until I shot him at five-hundredth
> with an aperture of one-point-eight.
> But whether he'd a bellyful of blue
> I'll never know who never saw the like again
> much less the underneath.[24]

or of ferns:

> I know ferns
> after strange fashion
> as I fancy they know frogs:
> nodding acquaintanceship—
>
> Yet has my pulse leaped
> to spot an early crook uncoil
> a frond fan cool a splitting rock
> green fingers frame a section[25]

Whatever the subject her facility with words and her humor combine to recreate and offer fresh insight into experiences that are common to many and yet special to each.

In the 1950s Jack Kerouac (chronicler of the Beat Generation), Gary Snyder, and John Montgomery climbed Matterhorn Peak on Yosemite's northeast rim. Later Kerouac

included an account of the trip in *The Dharma Bums,* a novel based largely on Snyder's life and ideas.[26] Kerouac's theme is the freedom from fear that high mountains can bestow. Thus, we have come full circle. We began this narrative journey through Yosemite art with Lafayette Bunnell, who, upon seeing Yosemite for the first time, experienced a strange unconcern for his own immediate welfare. We end it with Jack Kerouac who, although very different from Bunnell in temperament and thought, nevertheless experienced on Matterhorn Peak a similar unconcern.

Smith (Kerouac), Japhy Ryder (Snyder) and Morley (Montgomery) begin their ascent of Matterhorn about noon. They are hardly out of base camp before Smith begins to worry about falling off the mountain. By the time they reach 11,000 feet his anxiety is reaching considerable proportions:

Now we were at about eleven thousand feet and it was cold and there was a lot of snow and to the east we could see immense snowcapped ranges and whooee levels of valleyland below them, we were already practically on top of California. At one point I had to scramble, like the others, on a narrow ledge, around a butte of rock, and it really scared me: the fall was a hundred feet, enough to break your neck, with another little ledge letting you bounce a minute preparatory to a nice goodbye one-thousand-foot drop.[27]

They rest at a small lake just above timberline. Morley decides to wait there; Ryder and Smith go on:

At every few steps we took it seemed we were going higher and higher on a terrifying elevator, I gulped when I turned around to look back and see all of the state of California it would seem stretching out in three directions under huge blue skies with frightening planetary space clouds and immense vistas of distant valleys and even plateaus and for all I knew whole Nevadas out there. It was terrifying to look down and see Morley a dreaming spot by the little lake waiting for us. "Oh why didn't I stay with old Henry?" I thought. I now began to be afraid to go any higher from sheer fear of being too high. I began to be afraid of being blown away by the wind. All the nightmares I'd ever had about falling off mountains and precipitous buildings ran through my head in perfect clarity.

Ryder gradually leaves Smith far behind:

He didn't sit down any more. Soon he was a whole football field, a hundred yards ahead of me, getting smaller. I looked back and like Lot's wife that did it. ... *"This is too high!"* I yelled. ... But with nutty desperation I followed him. Finally I came to a kind of ledge where I could sit at a level angle instead of having to cling not to slip, and I nudged my whole body inside the ledge just to hold me there tight, so the wind would not dislodge me, and I looked down and around and I had had it. *"I'm stayin here!"* I yelled. ... "Oh what a life this is, why do we have to be born in the first place, and only so we can have our poor gentle flesh laid out to such impossible horrors as huge mountains and rock and empty space," and with horror I remembered the famous Zen saying, "When you get to the top of a mountain, keep climbing." The saying made my hair stand on end. ... "Well this old philosopher is staying right here," and I closed my eyes. "Besides," I thought, "rest and be kind, you don't have to prove anything."

Upon reaching the top Ryder gives out "a beautiful broken yodel of a strange musical and mystical intensity" and then

suddenly everything was just like jazz: it happened in one insane second or so: I looked up and saw Japhy *running down the mountain* in huge twenty-foot leaps, running, leaping, landing with a great drive of his booted heels, bouncing five feet or so, running, then taking another long crazy yelling yodelaying sail down the sides of the world and in that flash I realized *it's impossible to fall off mountains you fool* and with a yodel of my own I suddenly got up and began running down the mountain after him doing exactly the same huge leaps, the same fantastic runs and jumps. ... With one of my greatest leaps and loudest screams of joy I came flying right down to the edge of the lake and dug my sneakered heels into the mud and just fell sitting there, glad. ... I took off my sneakers and poured out a couple of buckets of lava dust and said, "Ah Japhy you taught me the final lesson of them all, you can't fall off a mountain."

1 Bill Northwood, "Landscape Photography in the '80s," *The Museum of California,* Vol. 4, No. 6 (May-June, 1981) 11.

2 Telephone interview, September 10, 1981.

3 Quoted in Northwood, pages 10-11.

4 Yosemite: Yosemite Park and Curry Company, 1980.

5 *The History of Photography,* revised and enlarged edition (New York: Museum of Modern Art, 1964) 194.

6 Personal interview, July 24, 1980.

7 Stephen F. Arno (Yosemite: Yosemite Natural History Association and Sequoia Natural History Association, 1973).

8 Personal interview, July 24, 1980.

9 All quotations in this paragraph are from a personal interview, February 23, 1982.

10 Adapted by David Wilson and quoted in *The Impulse to Draw* (Davis: ReproGraphics, University of California, Davis, 1982) 4.

11 David Robertson and David Wilson, *Signs of Life in the Valley,* An Exhibition of Bioregional Photographs and Drawings, Sacramento Science Center and Junior Museum, Sacramento, California, 1981 (Davis: ReproGraphics, University of California, Davis, 1981) 2.

12 David Wilson, *Beyond Mediation* (Davis: ReproGraphics, University of California, Davis, 1979) 3.

13 Yosemite: Yosemite Natural History Association, 1981.

14 New York: New Directions, 1974.

15 All quotations are from a personal interview, October 6, 1983.

16 *The Back Country* (New York: New Directions, 1957); *Riprap and Cold Mountain Poems* (San Francisco: Four Seasons Foundation, 1969). A poem about his experiences in Yosemite in 1955 but written much later is published in *Axe Handles* (San Francisco: North Point Press, 1983).

17 *Riprap,* 30.

18 *Riprap,* 10.

19 *The Back Country,* 22. Copyright © 1968 by Gary Snyder. Reprinted by permission of New Directions Publishing Corporation.

20 *Conjunctions I and II* (Double Issue) James Laughlin Festschrift. Edited by Bradford Morrow (Winter, 1981-82).

21 Yosemite: Yosemite Natural History Association, 1982.

22 Page 1.

23 Page 5.

24 Page 19.

25 Page 49.

26 Viking Compass Edition (New York: Viking Press, 1971).

27 This and the following quotations are taken from pages 80-86.

The John Muir Trail

AMONG THE MOST intriguing of works of art are those, like Gothic cathedrals, that house the divine, and those, like stations of the cross, that make a liturgy. The Ahwahneechees believed Yosemite full of "power places," spots, like waterfalls, where great good might come to human beings, or great harm. Their myths informed members of the tribe about these places and taught them how to behave in their presence. From the time of the valley's discovery by the Mariposa Battalion in 1851 artists have considered it a church, a cathedral, a temple, paradise, heaven. In Ahwahneechee terms they have taken the valley as a whole to be a "power place." Through their works of art they have responded to this power and tried to pass it on to us.

Each of their works deals with only a part of what today is Yosemite National Park. But a work of art exists that attempts to make immediate to visitors the power of the park as a whole. It does not reside in a museum. To see it we must "do" it. Like stations of the cross, it is liturgical art. The work, available to every able-footed visitor, is the John Muir Trail.

Conceived on a 1914 outing of the Sierra Club, the John Muir Trail was executed in the years immediately following as a cooperative "artistic" effort by the National Park Service, the Forest Service, and the State of California. Strictly speaking it begins at Happy Isles, an area of rock and trees below the junction of the Merced River and Illilouette Creek.

But as liturgy the real beginning is the turn eastward off California's north-south axes, Highway 99 and Interstate 5. To get on it we must get off of avenues designed for speed and comfort. We motor across the flat San Joaquin Valley and up through the Sierra foothills, past a town with the symbolic name of El Portal to a real entrance station. The dark tunnel of rock just beyond it signals that the world we are entering is no ordinary one. Through that passageway are new realms of physical, emotional, and spiritual possibility that we can, if we are willing, be initiated into.

The next six miles are negotiable by car—down a one-way road past stations where we can stop momentarily and view the major "power places" of the Park, like El Capitan and Yosemite Falls. Eventually we arrive at Curry Village, where we must park the car and board public transportation. Only National Park Service-owned shuttle buses are allowed on the next mile of the trail. They take us deeper into the forest, to the Happy Isles station. From here we must walk. A sign directs us to Happy Isles; once there another points across a bridge over the Merced to the trailhead. Now we receive the first unambiguous indication of where we are headed. A sign reads, "Entering Yosemite Wilderness." Certain rules are laid down, certain prohibitions imposed. "No pets allowed on trails." A domesticated animal has no place in the wild. It will keep at a distance the untamed creatures we need to become

acquainted with. Besides we most readily learn wilderness lessons if alone. Pets are civilized baggage to be left behind. Also here at the trailhead are the first intimations of danger ahead. This hike may be hazardous:

> WARNING—DANGER
>
> ICE AND ROCK
> FREQUENTLY FALL ON TRAIL
> HIKERS ASSUME
> THEIR OWN RISK

The next stage of our journey is from the trailhead up to the bridge below Vernal Fall. The most important of many signs along the way contains a quote from the trail's namesake, John Muir. It tells of our ultimate destination:

> As long as I live
> I'll hear waterfalls and birds and winds sing.
> I'll interpret the rocks,
> Learn the language of the flood, storm, and
> the avalanche.
> I'll acquaint myself with the glaciers and
> wild gardens,
> and get as near the heart of the world
> as I can.

And where is the heart of the world? In the wilderness. Another sign reads:

> Each step along this trail
> is a step away from the road . . .
> a step closer to wilderness.

To arrive there we must awaken senses dulled by urban living:

> Search with more than eyes.
> Fragrant laurel leaves . . .
> Can you find them?
>
> Listen . . .
> to water sounds
> changing with each step.

We must also understand the underlying structures of the Yosemite wilderness, how it came to be and is always changing, how the past, present, and future are part of one intelligible process. Science, more particularly geology, is our instructor in these matters. Successive signs explain with charts and pictures "Yosemite's Rounded Scenery," "Patterns in Angular Scenery," "Master Joints," and "Crumbling Mountains."

Once out on the bridge we can look up river and see the effulgent Vernal Fall. The sign on the bridge is divided into four parts, four ways of seeing the Vernal Fall Gorge. We can record it with cameras:

> Vernal Fall
> Through a camera's eye . . .
> Vernal's moments are captured.

We can look into its past:

> Through a geologist's eyes:
> ". . . the ice stream tumbled
> in magnificent chaos down the
> great stairway, whose great
> steps are now marked by the
> Nevada and Vernal falls . . .
> Broken into fantastic blades and
> pinnacles . . . the cascading por-
> tion of the glacier must have

> presented the appearance of a
> tumultuous cataract frozen into
> immobility.
>
> Francois Matthes

We can become as little children and enter the wilderness seeing with eyes curious and wondering:

> Through children's eyes . . .
> "I see things that do surprise me!
> The Water
> slashing, rushing, crashing over the fall
> round the bridge and granite rocks.
> Down through the valley it goes day and night.
> It's always there carrying with it stones and
> tones."

Most important of all we must see through our own eyes:

> Through your eyes . . .
> You briefly encounter this natural scene.
> Yet your senses may record this moment
> to be remembered your entire life.

Over the bridge the stakes increase. Signs broadcasting danger abound:

> EMERGENCY TELEPHONE

> STAY ALIVE
> It is dangerous to climb on rocks
> next to the river. They are slick
> wet or dry.
> Deaths have occurred here.
>
> STAY ON TRAIL

> CAUTION
> slippery rock surface

We are leaving civilization behind. A final restroom and water fountain are provided. A quote from Muir states the essential doctrine of the wilderness, the interrelatedness of all things:

> When we try to pick out anything by itself,
> We find it hitched to everything else in the
> universe.

Shortly we come to the final sign:

> You have taken the first step to wilderness.
> The next step is through the mist to the
> top of the fall.
>
> But wilderness does not lie that close,
> Steps to wilderness increase, as more people
> reach out for solitude.
>
> Continue . . .
>
> If you are prepared.

In the early days wilderness began in the valley proper. But with the coming of tourists en masse wilderness, though symbolized by mighty monoliths and boulder-strewn talus slopes, retreated up the canyons. Now it can be reached only by proceeding through the valley and up the John Muir Trail into the high, back country. As we read the final sign of this open-air, cross-country work of art, we understand fully that our goal is: an experience in and with Wilderness. It is the goal toward which much of the art of Yosemite has been leading us.

Index